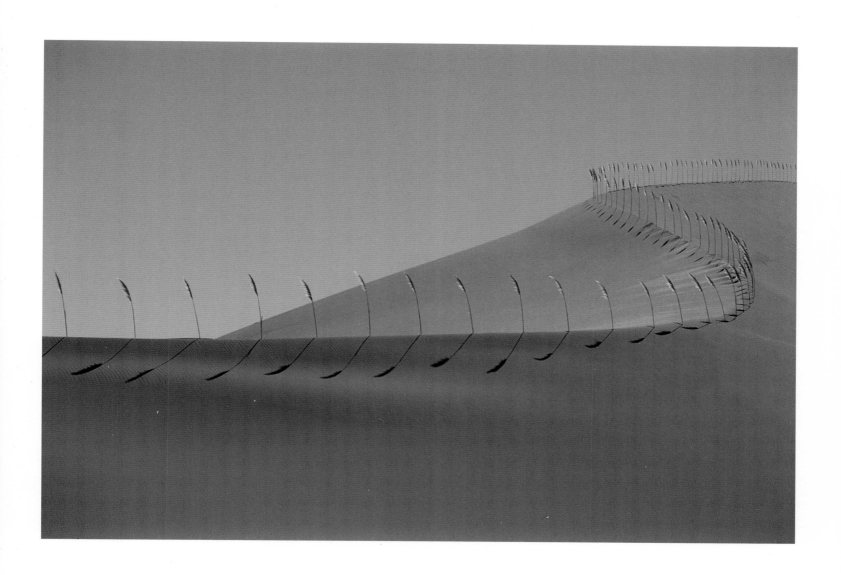

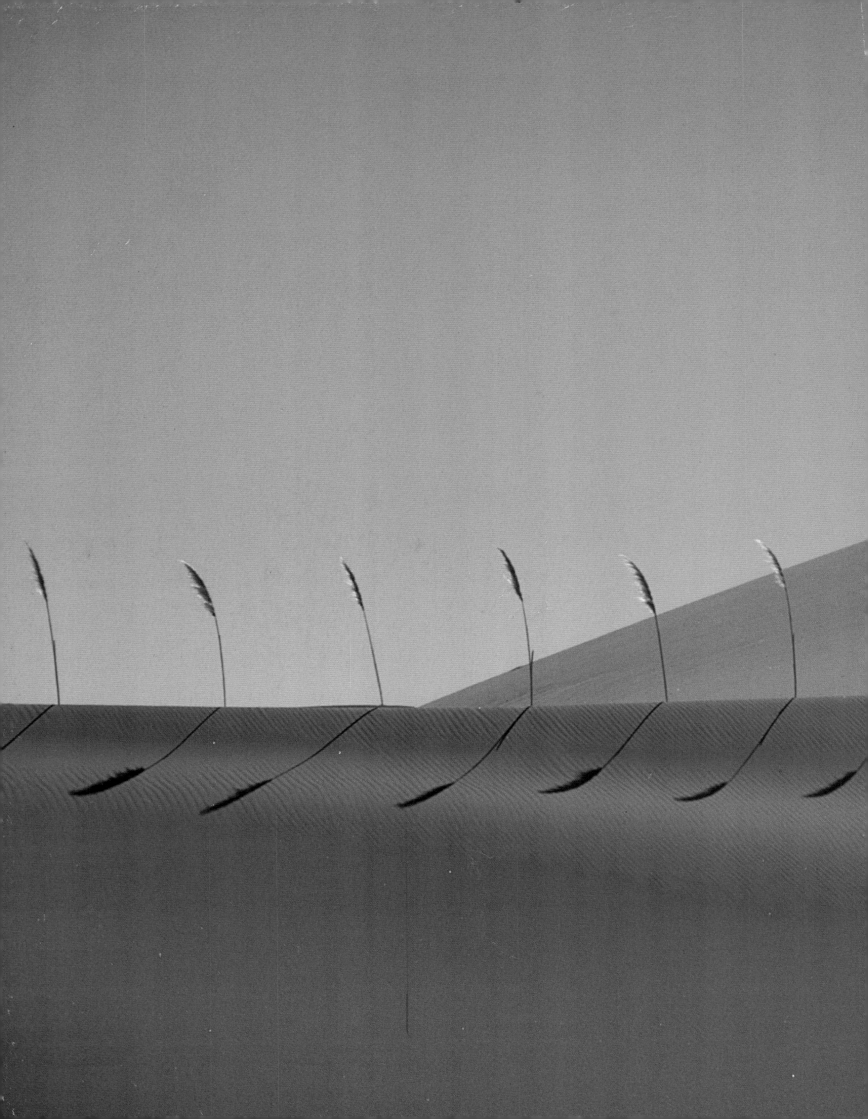

NILS-UDO
art in nature

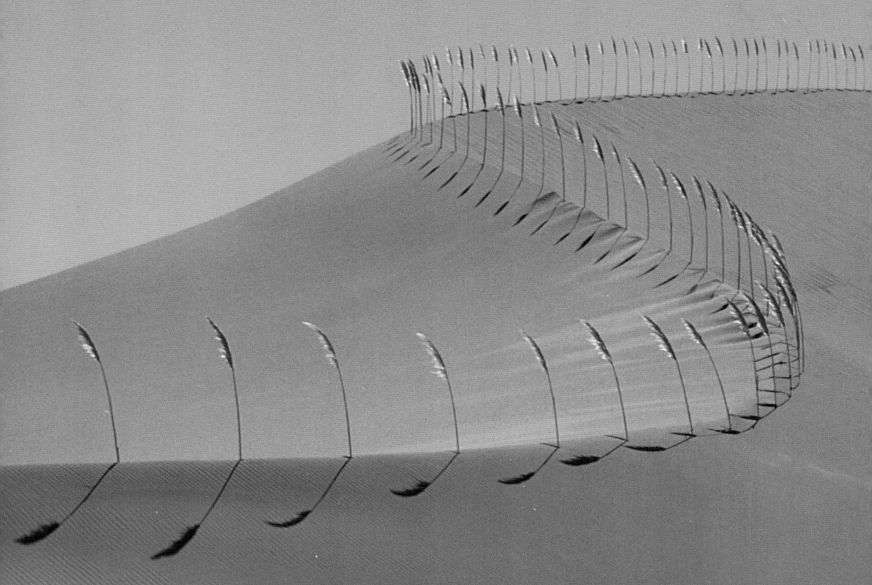

text by Hubert Besacier

Flammarion

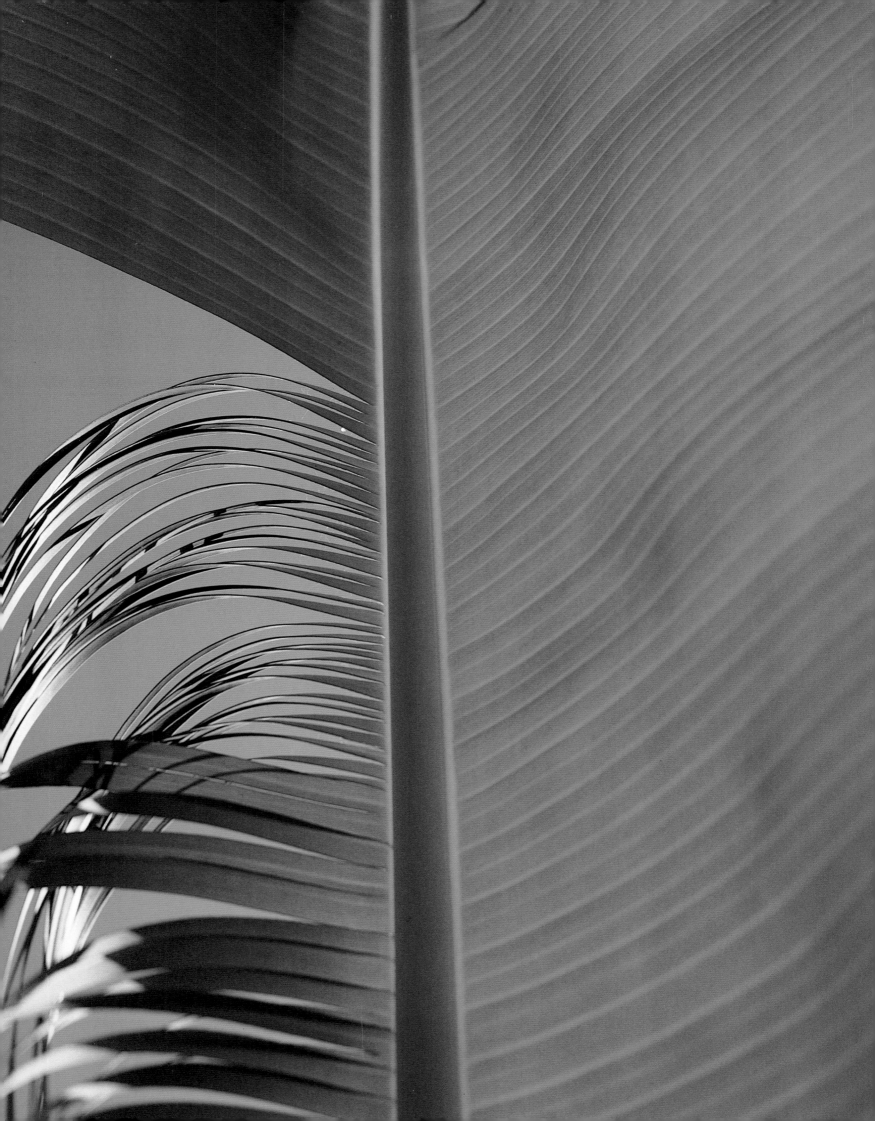

contents

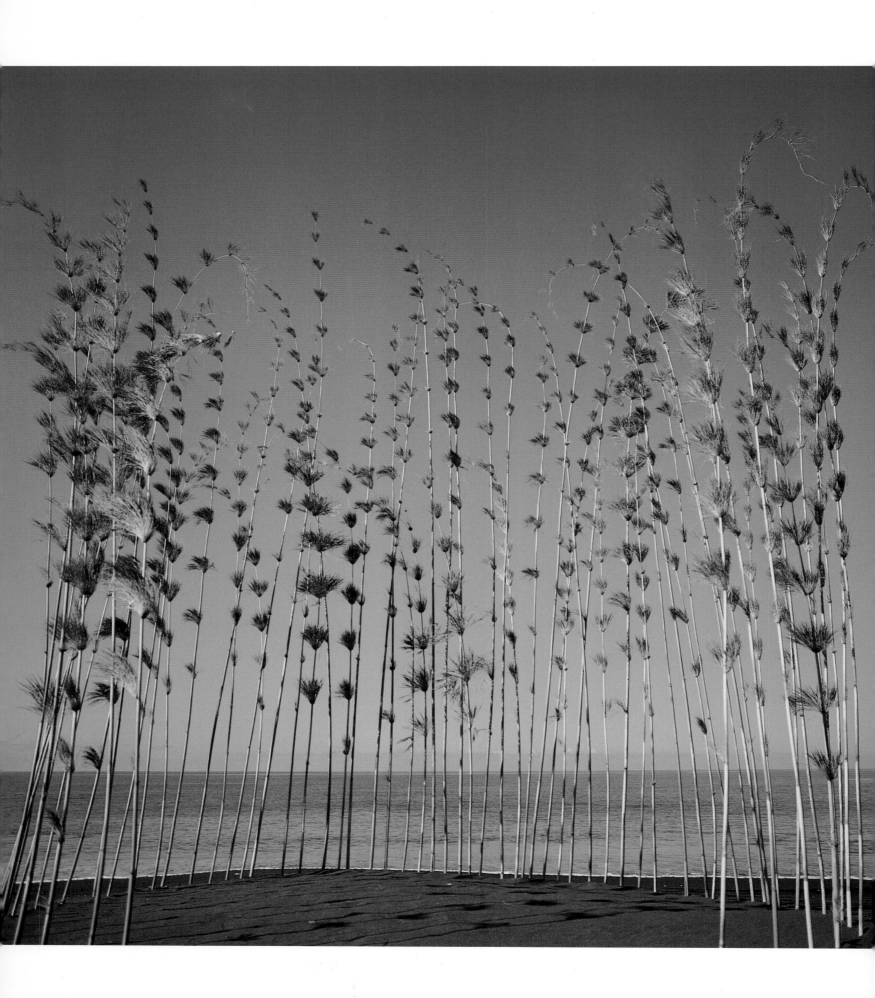

NILS-UDO / spirit of the landscape

CIRCLE OF CALUMET BAMBOO

Réunion, Indian Ocean, 1990

(facing page and right)

Bring together all the specific potential of a

landscape in one given season, condense

it, and fuse it into one single moment of zenith,

the apotheosis of that season in that particular

landscape. Create something that is potentially

possible, awaken something that is latent in

nature: literally create something that has

never existed, but which has always been

present: a utopia made real.

water

*Finally, a rare opportunity to work
with the slender, symmetrical form
of robinia leaves, which have
fascinated me for such a long time.
A small pond in the mountains. Horsetail
swimming under the surface. Reflections.
I selected a leaf, removed the leaflets
from one side of it, and hung the bisected
leaf in the small forked branches
of two ash switches that I had stuck
into the bottom of the pond.*

ROBINIA LEAF SWING

robinia leaf split in two, ash twigs

Valle di Sella, Italy, 1992

(left and facing page)

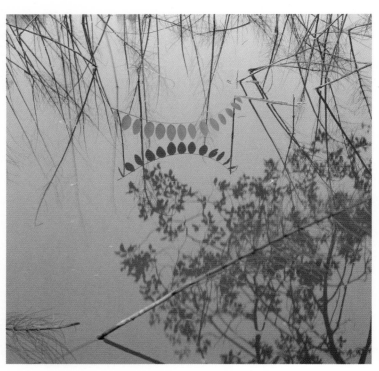

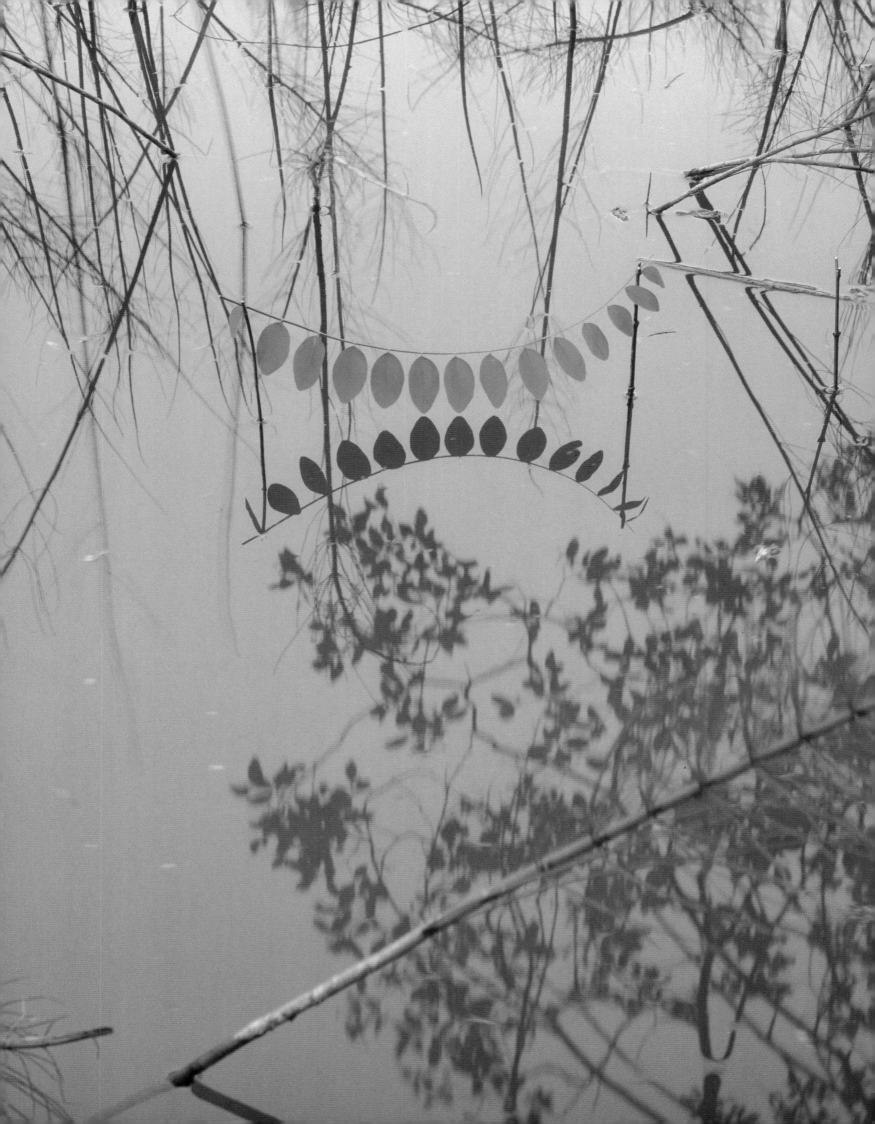

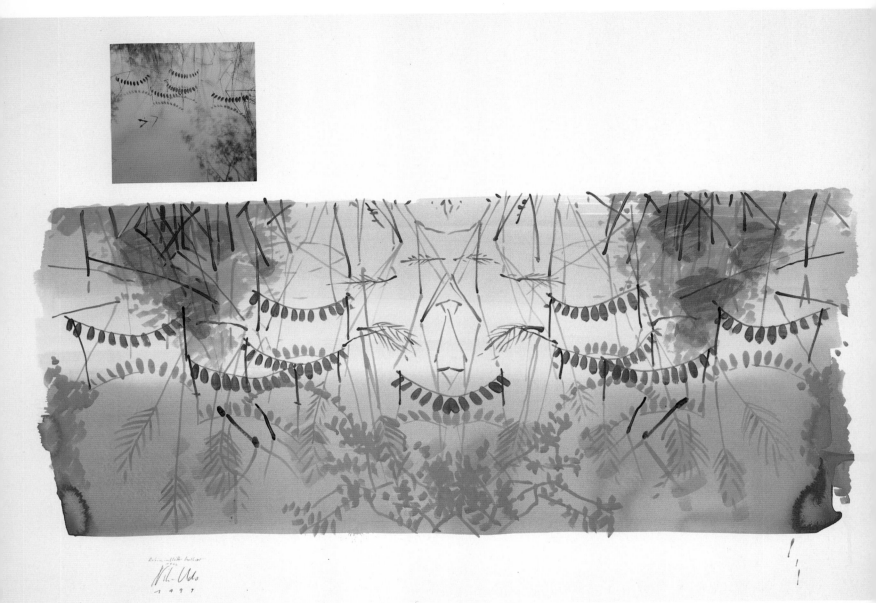

*Why do I pick up on and develop
some of my ideas for projects or for finished
nature installations in paintings and drawings?
The possibilities, laws, and rules of painting
broaden my spectrum of means of expression.
Through painting, another wider field of
potential themes opens up—one that
to me seems immeasurable.*

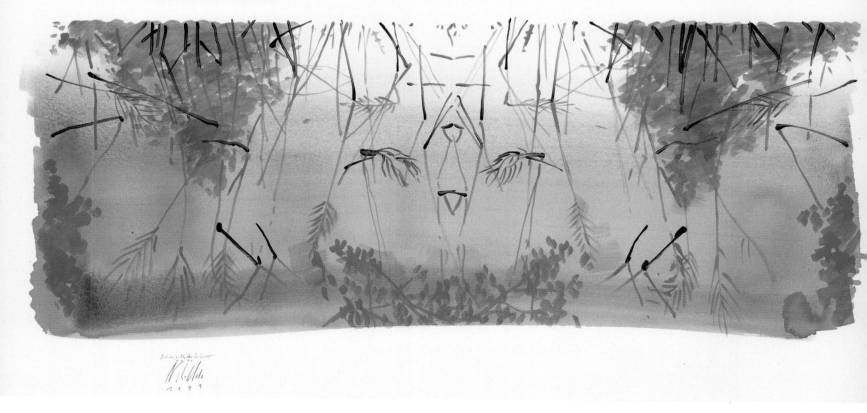

ROBINIA LEAF SWINGS

robinia leaves split in two, ash twigs

acrylic and ilfochrome on Rives paper, 80 x 120 cm

Valle di Sella, Italy, 1992/2000

(facing page and above)

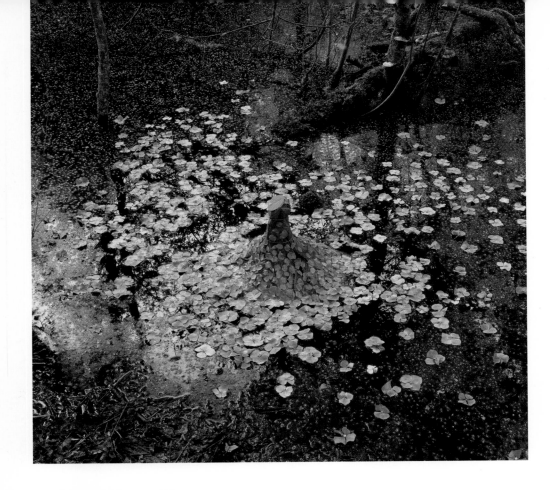

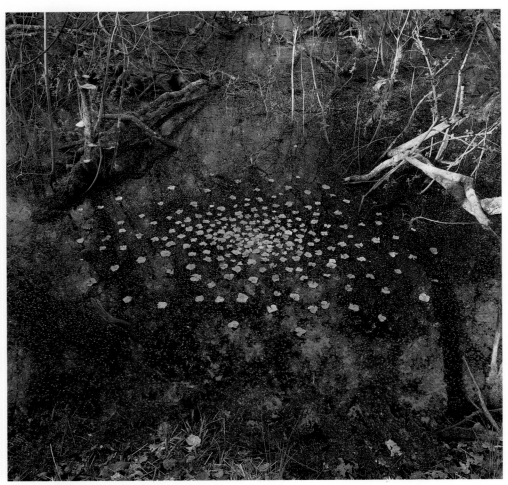

UNTITLED
pond, leaves, hortensia flowers
Bois des Marcelots, France, 2000
(left)

UNTITLED
pond, hortensia flowers
Bois des Marcelots, France, 2000
(left)

SMALL LAKE
earth, water, hazel branch,
bluebells, dead leaves
Vallery, France, 2000
(facing page)

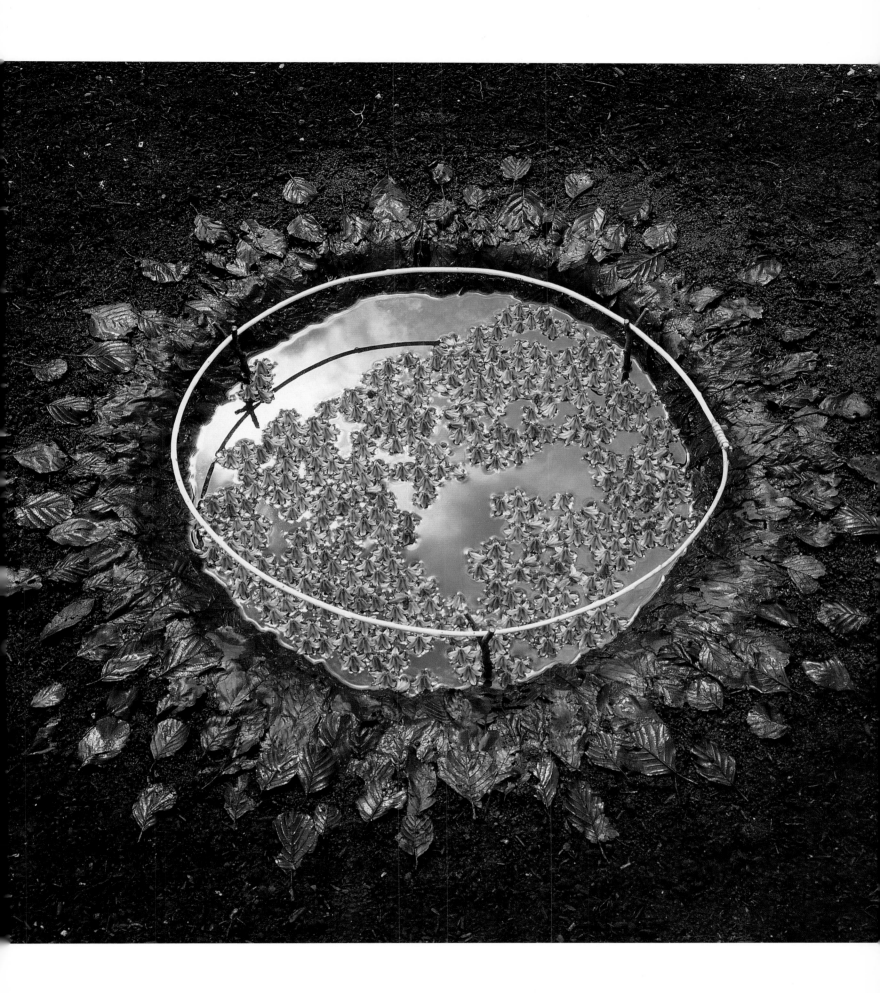

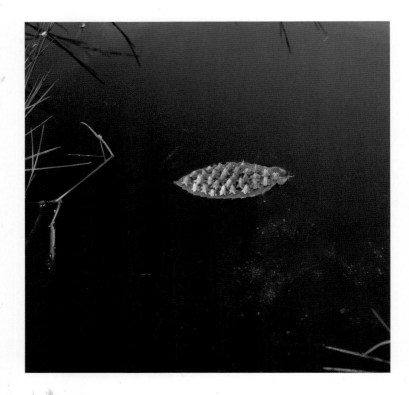

Can anyone give me one good reason why—on
a peaceful summer evening in the Limousin
in 1986—I should not have scattered small
bellflowers on a robinia leaf floating on a pond?
Of course not. I simply had to.
The leaf was crying out for me to do it.

UNTITLED

chestnut leaf, bellflower blossom

Vassivière, Limousin, France, 1986

(left)

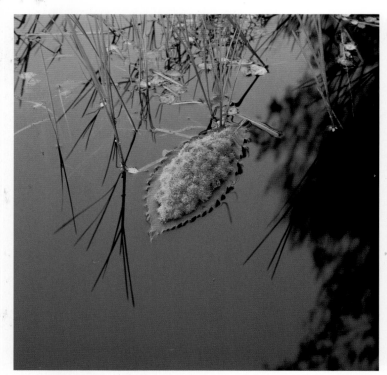

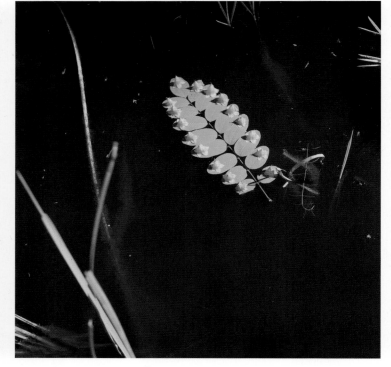

UNTITLED

chestnut leaf, vetch flowers

Vassivière, Limousin, France, 1986

(above)

UNTITLED

robinia leaf, bellflower blossom

Vassivière, Limousin, France, 1986

(above and facing page)

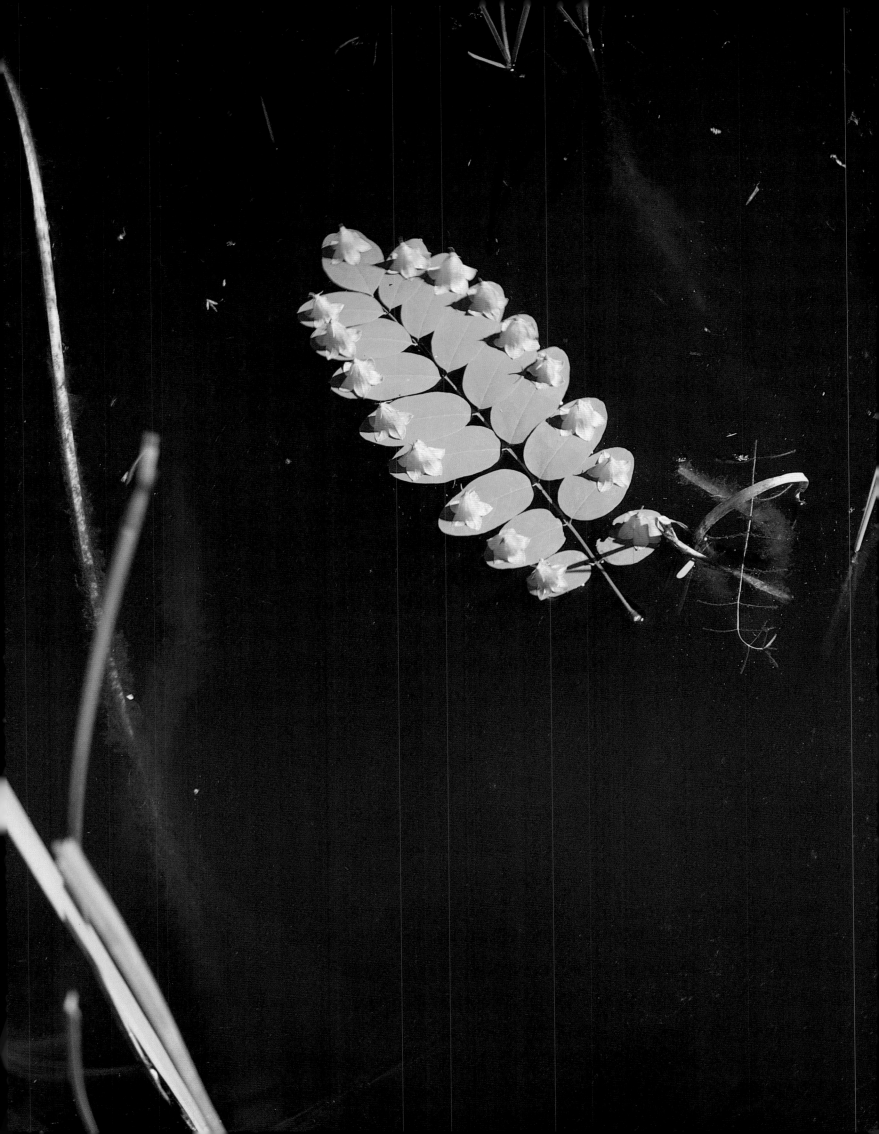

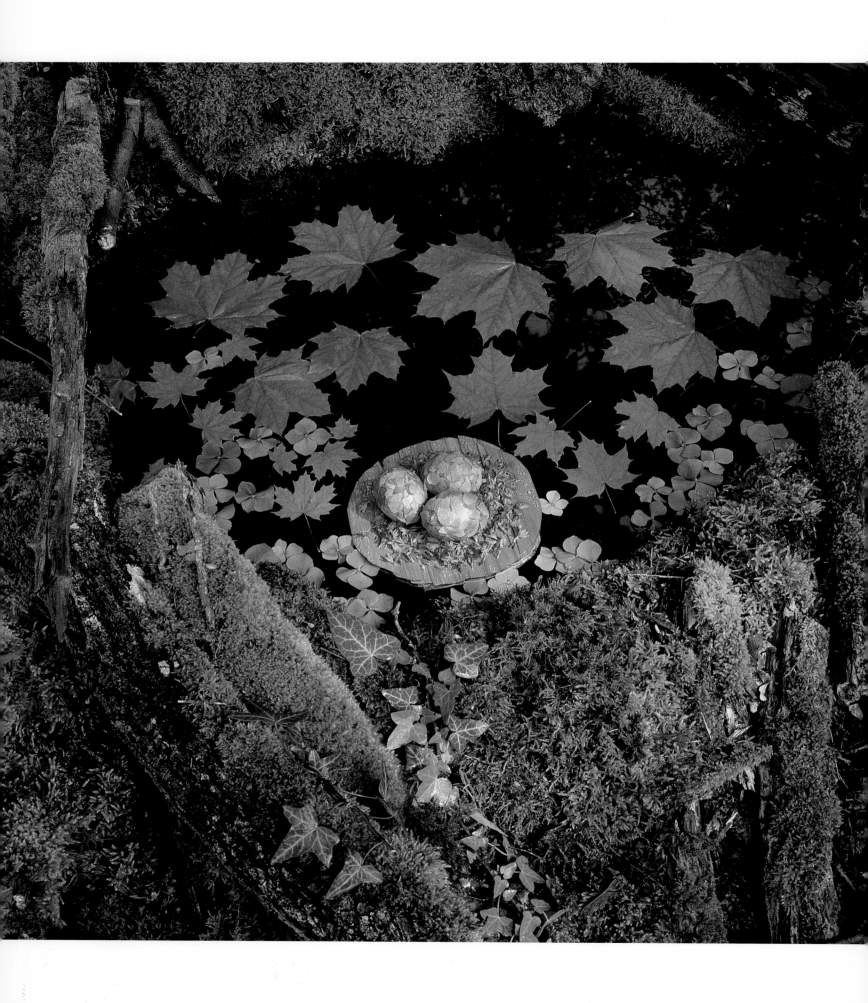

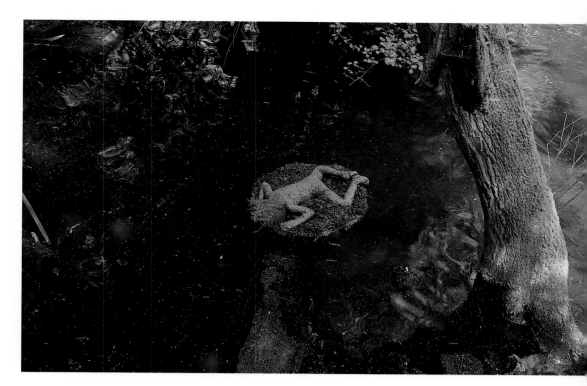

THE FROG

child, raft of spruce trunks,

withered leaves, duckweed, fern stalks

Marchiennes Forest, France, 1994

(right)

UNTITLED

plant stem wrapped in petals

Hintertal, Austria, 1985

(right)

BLACK POND

maple leaves, wild duck eggs,

hortensia flowers, iris leaves

Vallery, France, 2000

(facing page)

UNTITLED

volcanic stream bed,

foxglove flowers

Réunion, Indian Ocean, 1990

(above)

SERPENT

foxglove flowers on willow

Marchiennes Forest, France, 1994

(facing page)

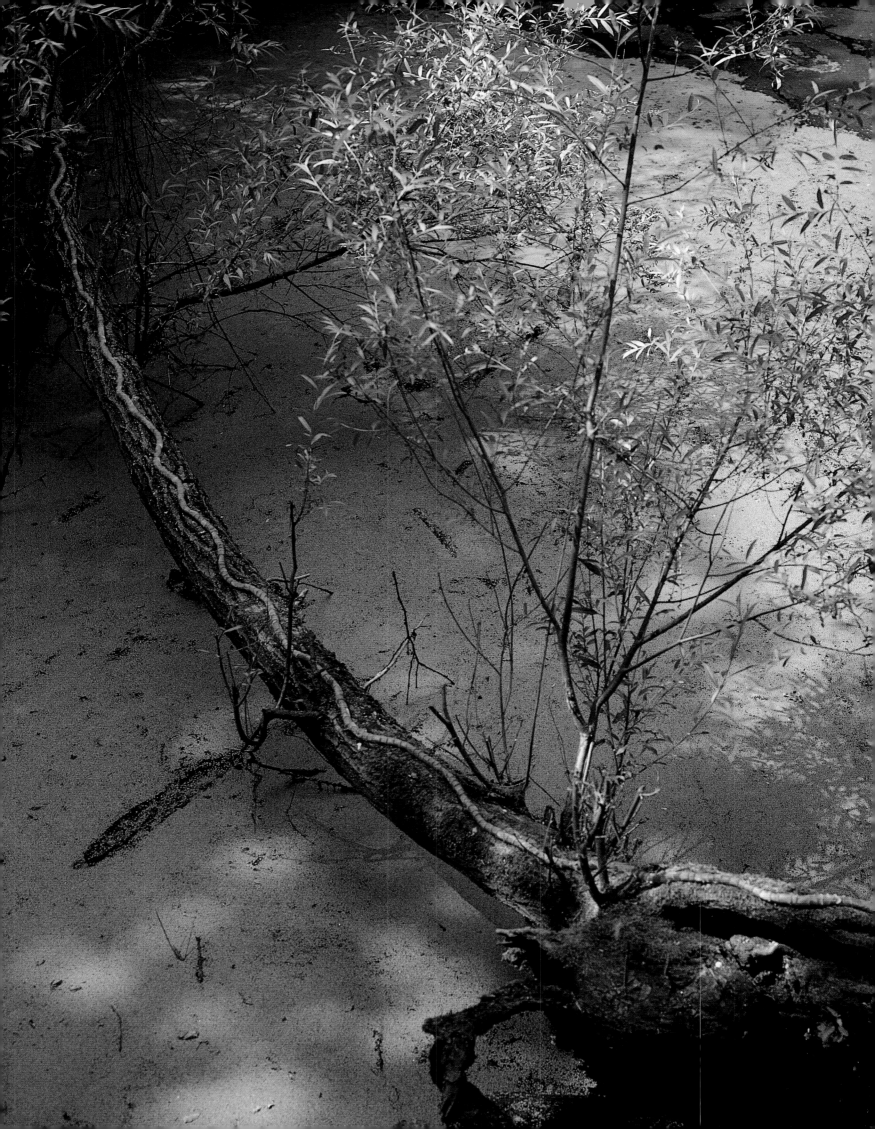

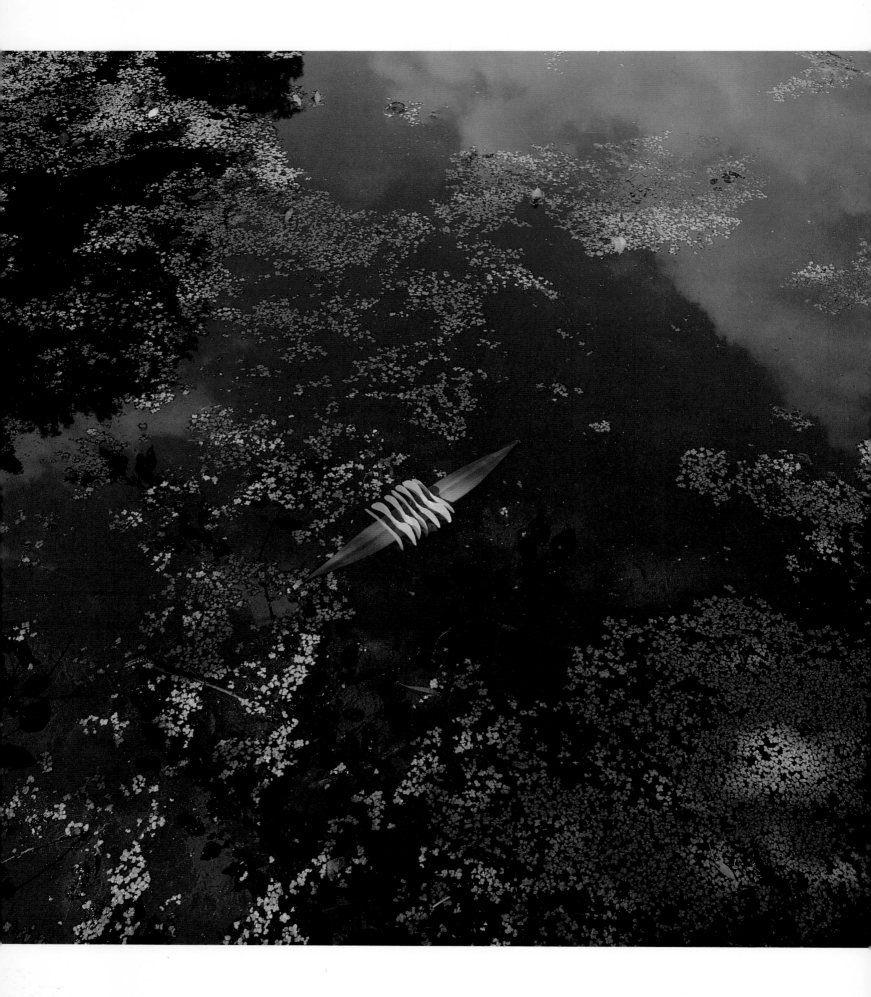

A pond in Central Park,
covered in duckweed.
Reflections, the sky, clouds.
Microcosmos and macrocosmos
in the burning mirror of the pond.
A cut iris leaf scattered with
maple seeds. (The "helicopters"
we played with as children).
Claude Monet in New York?
With Nils-Udo in Central Park.
Yes!

UNTITLED

cut iris leaf, maple seeds

Central Park, New York, USA, 1991

(facing page and right)

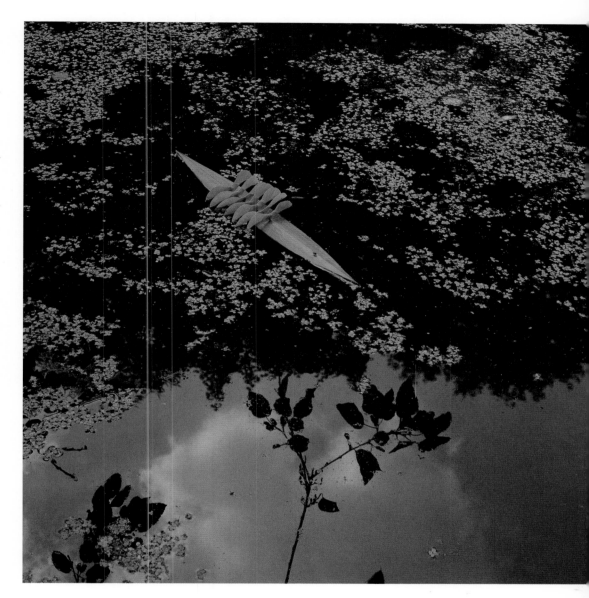

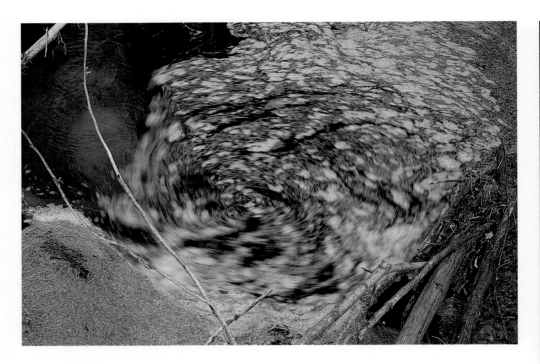

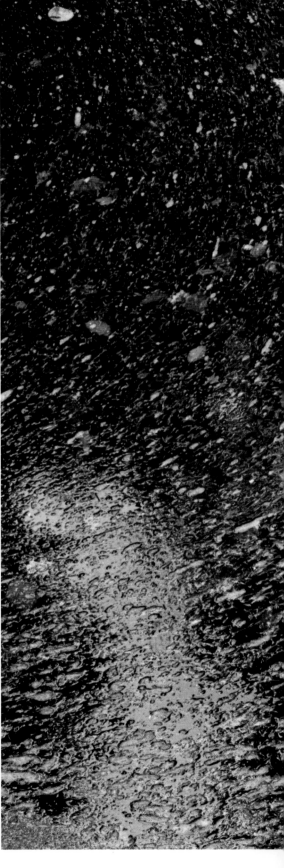

UNTITLED

swirl of spruce needles in a dammed stream

Samerberg, Chiemgau, Upper Bavaria, Germany, 1997

(above)

UNTITLED

spruce needles in a dammed stream

Samerberg, Chiemgau, Upper Bavaria, Germany, 1997

(right)

*At a loop in the stream
in the forest I came across a tree
that had fallen into the stream.
After I blocked the stemmed flow of
the water as carefully as I could with a
few twigs, large numbers of spruce
needles floating on the current
began to build up at the weir.*

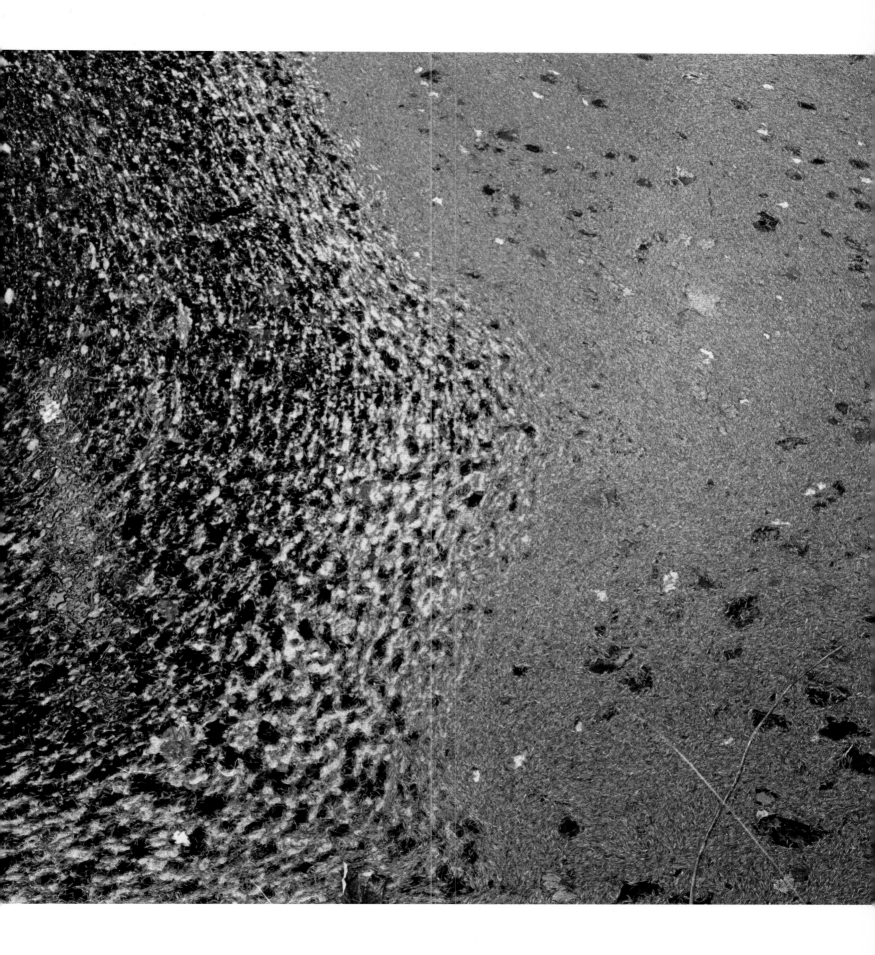

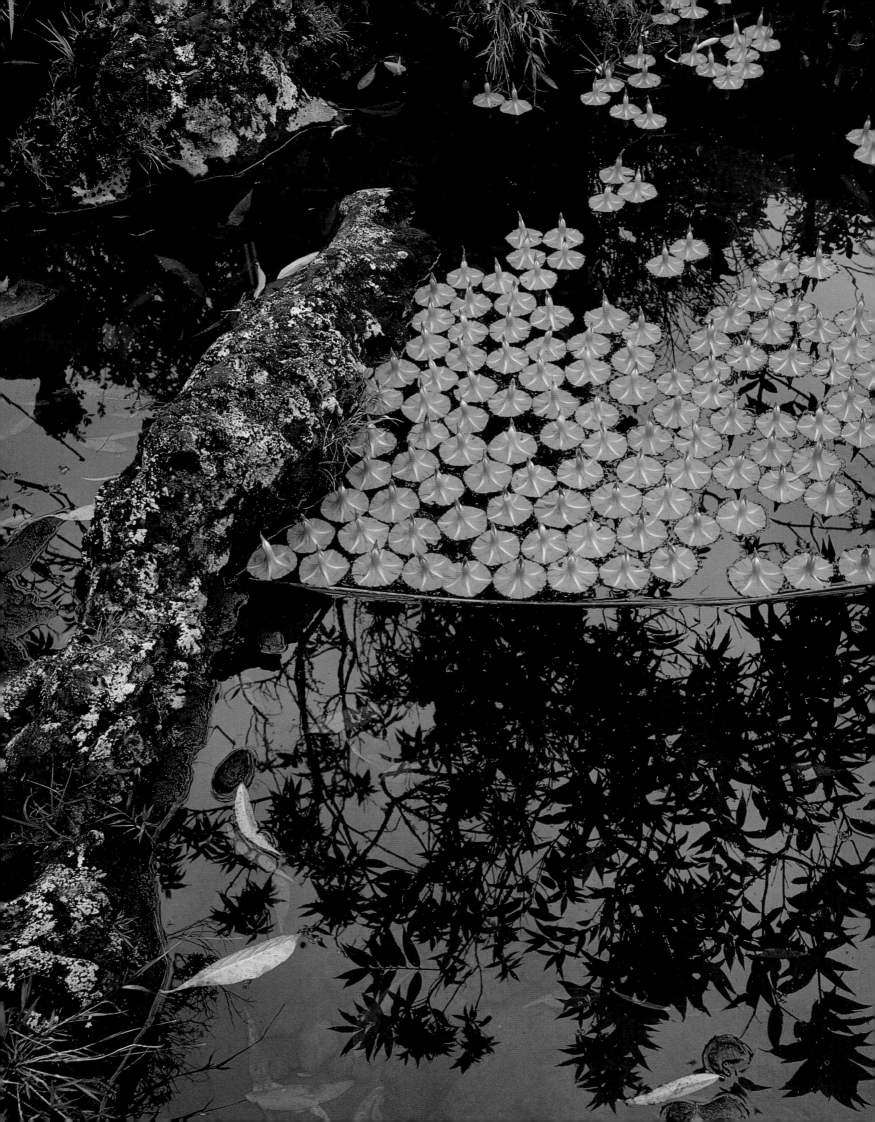

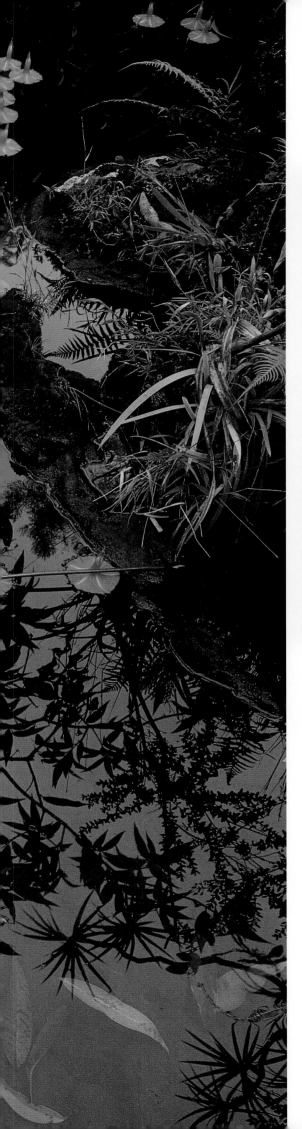

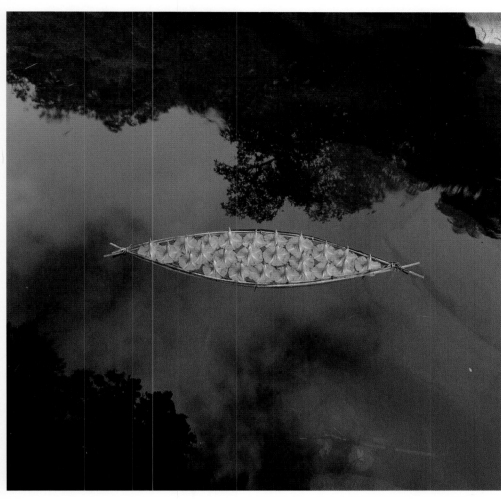

UNTITLED

branches bound with blades of grass,

bindweed flowers on a pond

Réunion, Indian Ocean, 1990

(above)

UNTITLED

bed of a stream, bindweed flowers

Réunion, Indian Ocean, 1990

(left)

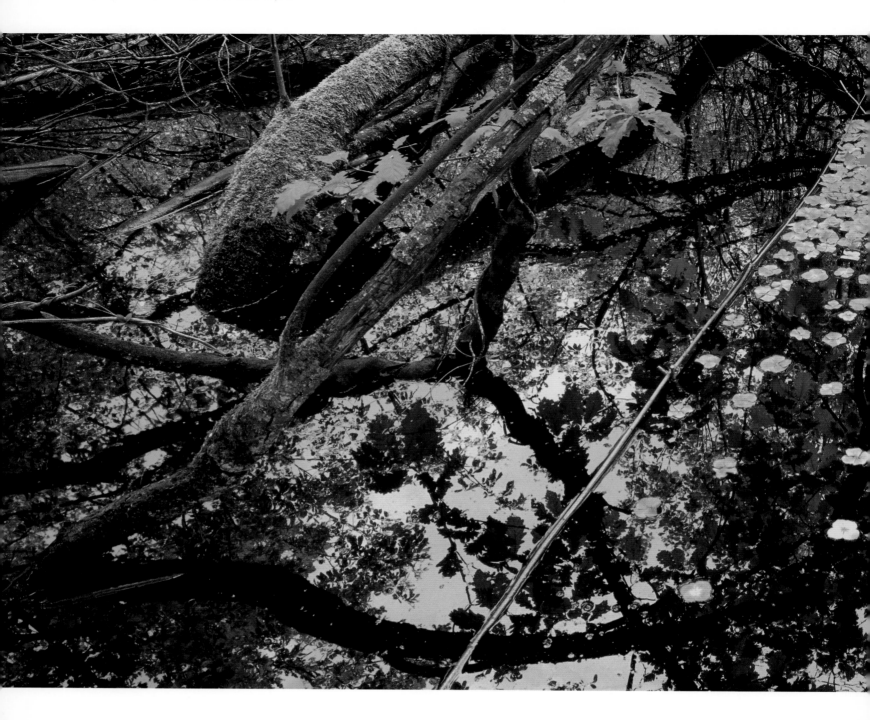

UNTITLED

hazel branches, hortensia flowers

Bois des Marcelots, France, 2000

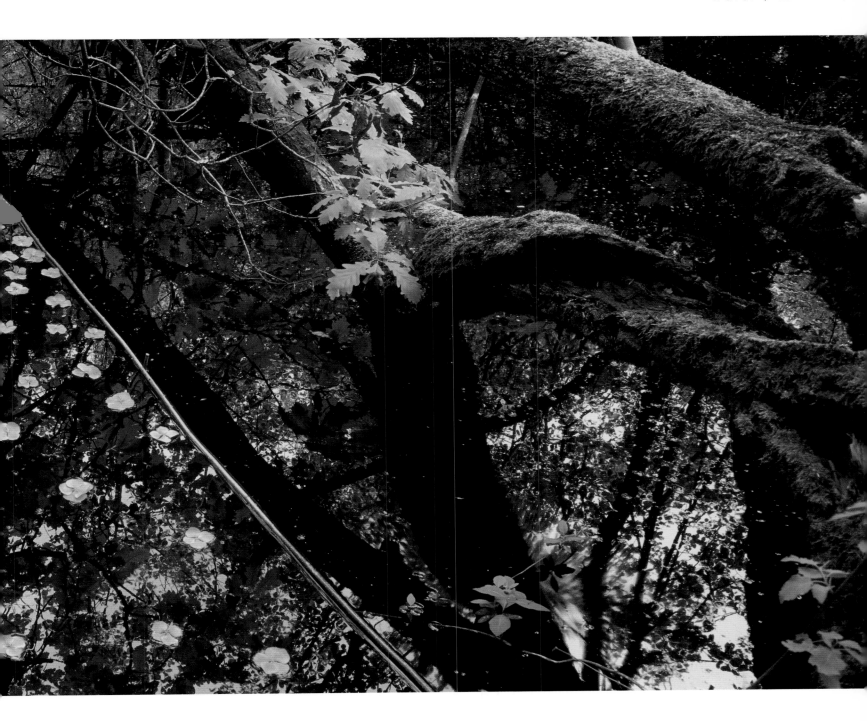

An example of my work on the theme of the "Blue Flower," in the countryside near the
village of Vallery, for the event Bleu 2000 held in the summer of that year.
On the surface of a pond, I carefully laid out two hazel switches and crossed them at both ends
using small forked branches that were in the pond. To finish, we delicately laid each
individual blossom on the water by means of a long stick.
In front of our eyes, microcosmos and macrocosmos, heaven and earth, melted and ran together
to form one indissoluble unity: the universe of the pond. Branches, twigs, and leaves hung over the water;
on its surface, tiny, miniscule particles, leaves, seeds, and insects danced. Plants and branches living in and under
the water broke the surface and reached upwards, drawing the eye towards the clouds and the sky,
the never-ending reflections revealing their own identical, real life.

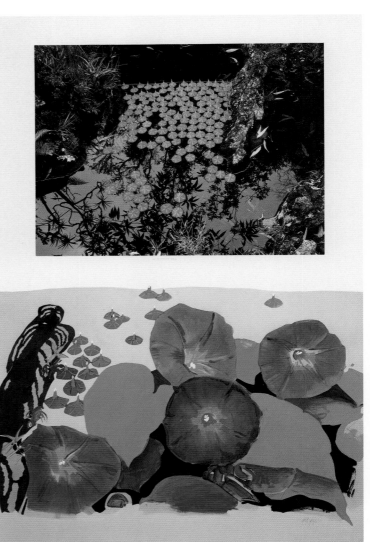

UNTITLED

riverbed, bindweed flowers

acrylic and ilfochrome on Rives paper, 120 x 80 cm

Réunion, Indian Ocean, 1990/2000

(above and facing page)

A volcanic stream bed in
the forest on the island of Réunion.
In the brush of the undergrowth glowed
the great blossoms of a species of bindweed.
Placed upside down on the water, the blossoms
floated away on the current, only to become
stranded against a stick pinned between two rocks.

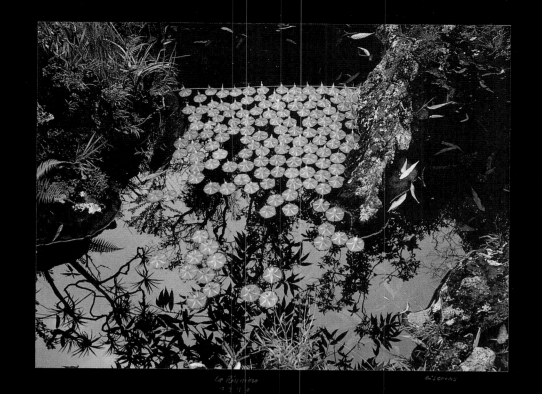

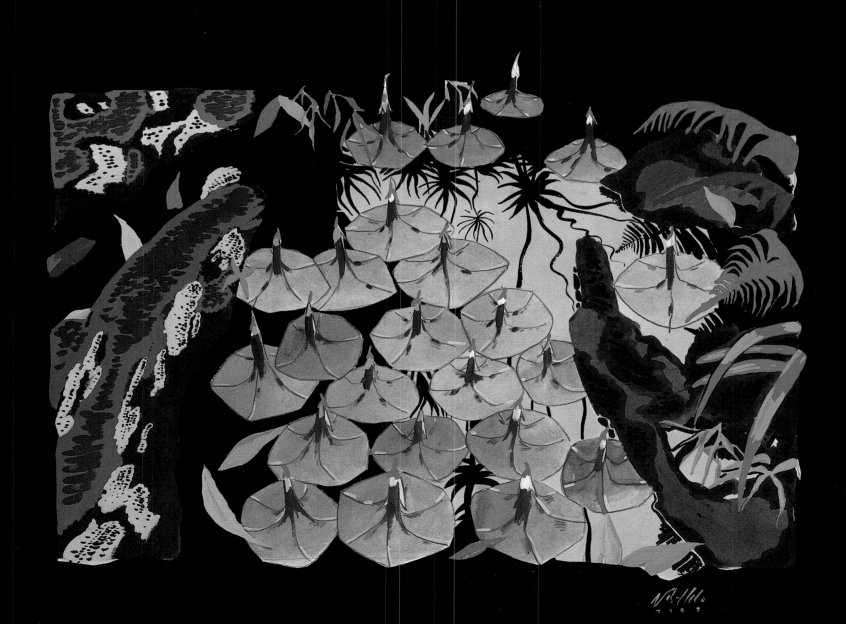

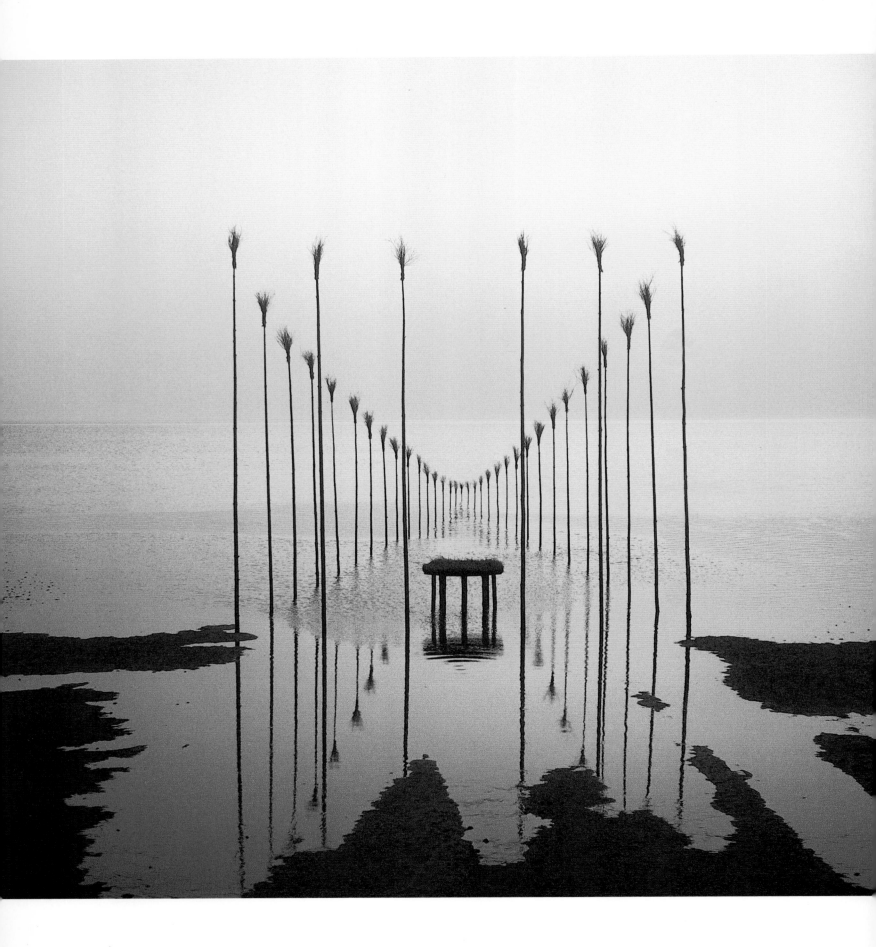

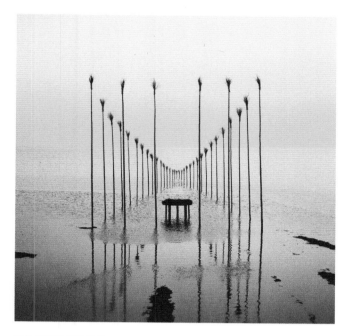

*The installation was far out on the mud-flats.
The surface of the flats, stretching
endlessly to the horizon, was covered
in billions of tiny mud-worm casts.
The tide came in at regular six-hour intervals.
At first, it was merely a thin line on the horizon.
Then, approaching ever faster, it filled the channels and
tideways, turning them into deep and treacherous inlets.
As the water drew near, one began to hear its delicate
splashing as it rose higher and higher, covering the
whole width of the mud-flats in broad, lazy courses.
Of course, we could only work at low tide. Once,
however, the rising tide caught us entirely
unawares. All of a sudden, it was threateningly
close to the installation, and only by stretching our
capacities to the limit did we manage to drag
the heavy equipment back to dry land.
Obviously, I had misread the tide tables.
To start, we piled up the excavated earth to form an
arrow-shaped pond, then we set up the spruce trunks
with their birch brushwood, before finally building
the island, which was planted with turf.
Spending time on the island, one could follow
the movement of the tides. The approaching water.
The waves washing under the island, while overhead,
low clouds enveloped the trunks. And finally,
the ebbing of the tide.*

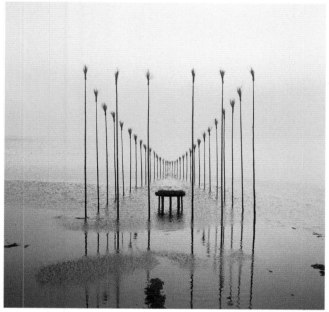

WATER HOUSE
spruce trunks, silver birch branches,
willow and turf plantation
Waddensee tidal mudflats,
Cuxhaven, Germany, 1982
(facing page and right)

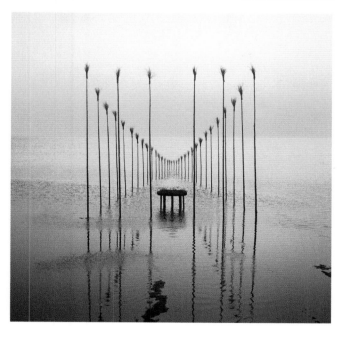

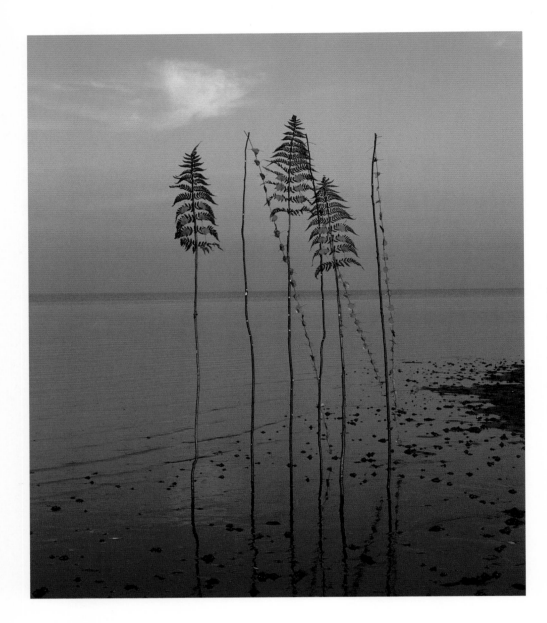

WATER HOUSE
spruce trunks, silver birch poles,
willow and turf plantation
Waddensee tidal mudflats,
Cuxhaven, Germany, 1982
(facing page)

UNTITLED (detail)
silver birch poles, stalks of fern
and ribwort, pine needles,
petals of the dog rose
Rosa Rugosa Thunberg
North Sea, 1986
(left)

*I had cut several slender birch rods
and stuck them into the slime of the mud-flats.
I then gathered in a basket wild rose petals, a few
beautiful fern leaves, strands of ribwort, and pine
needles. I bound the fern leaves to the birch rods
with blades of grass and pinned the rose petals
to the fern leaves with pine needles.
Then I made three flower-chains using the petals,
the strands of ribwort, and the pine needles,
and pinned them onto the tips of the birch rods.
Evening light, a gentle breeze.*

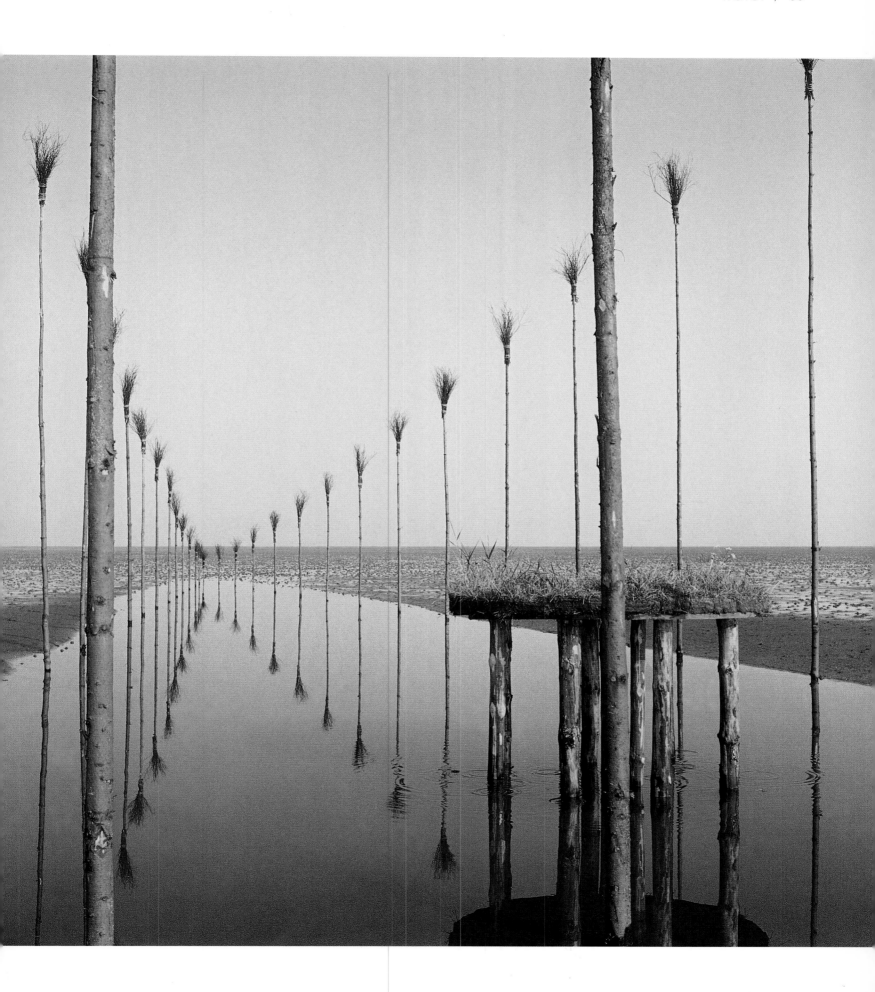

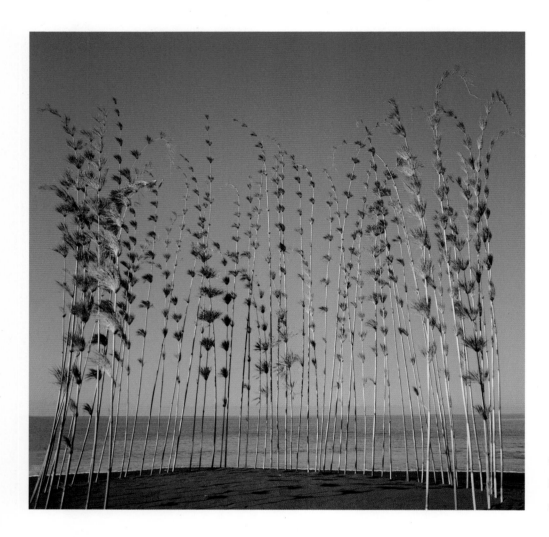

CIRCLE OF CALUMET BAMBOO

Réunion, Indian Ocean, 1990

(left and facing page)

bamboo

The first time I stayed for several weeks on the island of Réunion in the Indian Ocean, during an exploratory foray into the mountains, I discovered the Calumet bamboo, which is endemic to this island—it grows nowhere else in the world. Of course, I had to work with this plant, one of the loveliest I have ever been fortunate enough to see! The theme was self-evident. It could only be the plant itself. It would be enough simply to show its uniquely slender form.

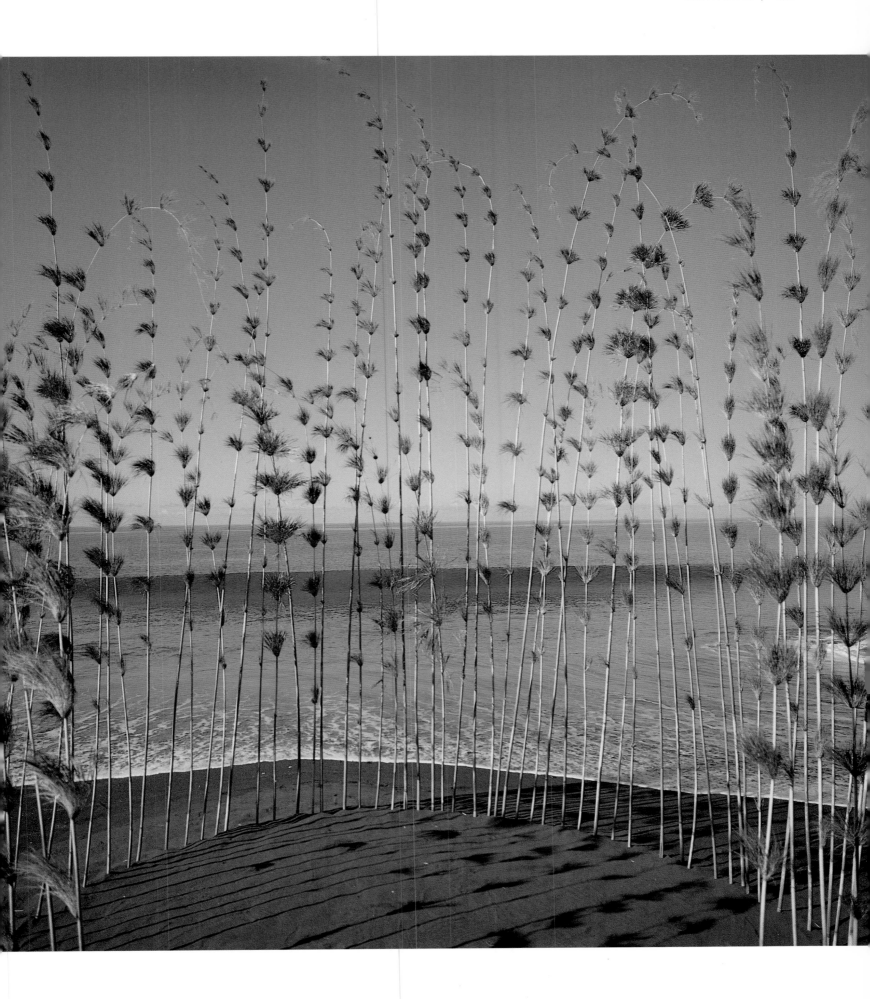

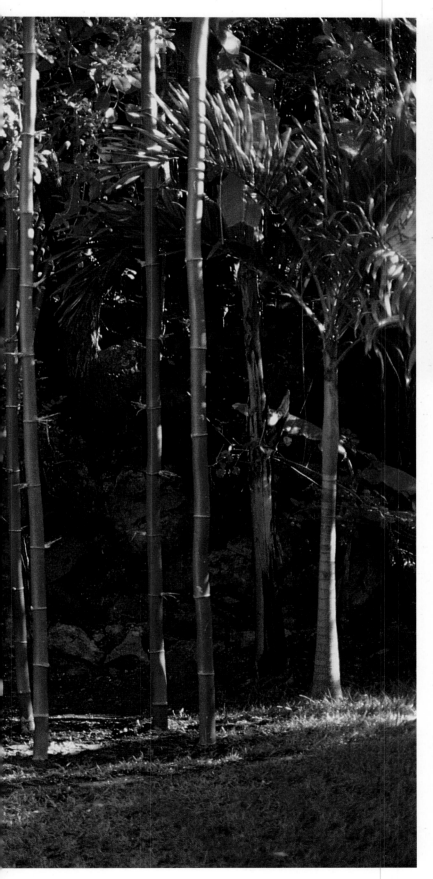

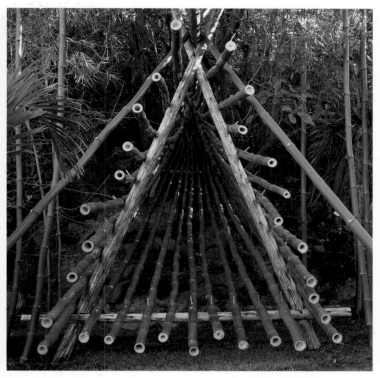

BAMBOO LINE

bamboo stalks, bamboo plantation, tree trunks

Réunion, Indian Ocean, 2001

(left and above)

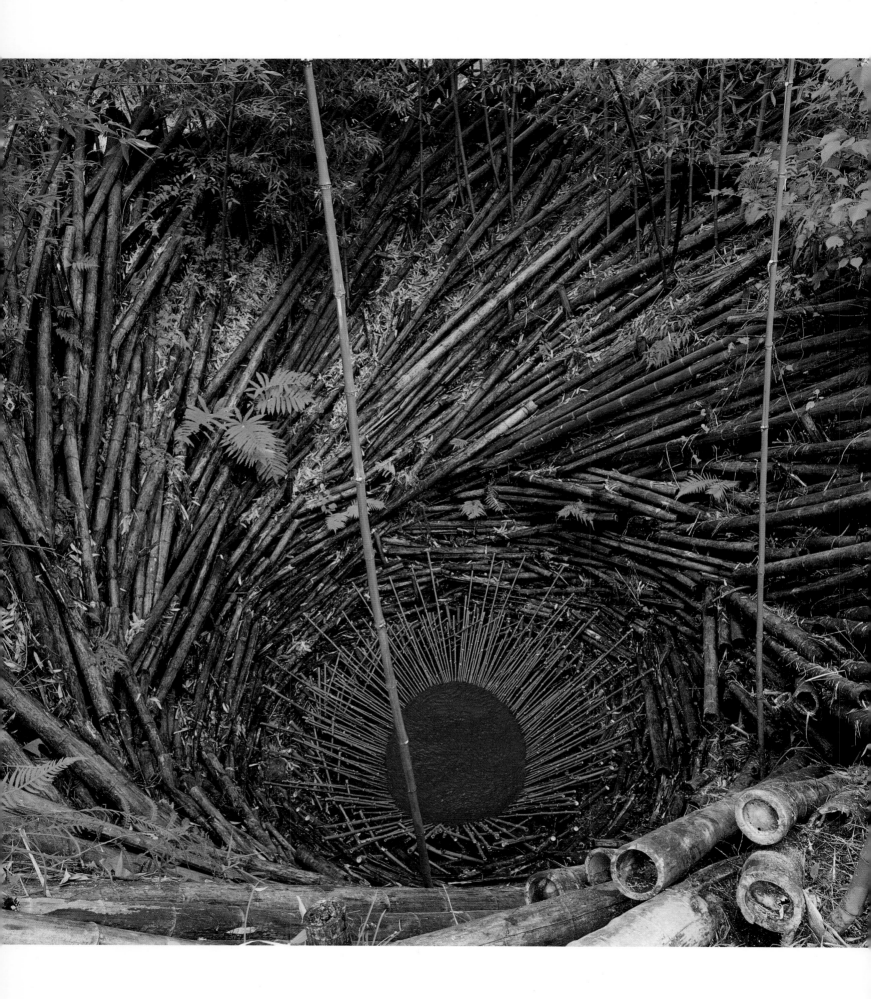

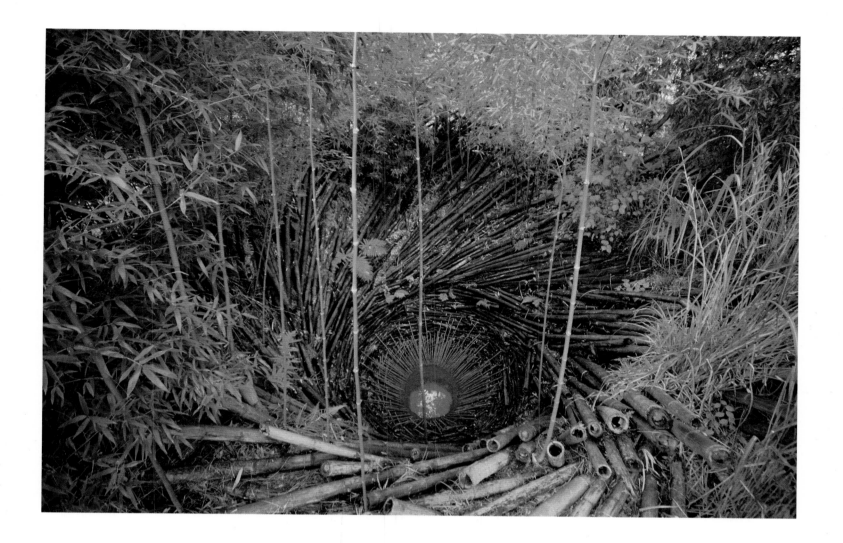

nests

BAMBOO NEST II

earth, bamboo canes,
and bamboo plantation
Fujino, Japan, 1988/1994
(facing page and above)

In 1988, I built my large bamboo nest. Because I did not want to cut down large numbers of living bamboo plants for use in the project, we asked the peasants living in the region to bring us all the dead stalks they found in their forests. They brought us hundreds, of all different lengths and diameters.
We dug the nest deep in the earth and surrounded it with a plantation of exceptionally long bamboo stalks. The plan was for the bamboo to spread and grow to become one with the nest. When I returned to the site six years later, the result surpassed my wildest expectations. The bamboo plants had spread to the point where the nest had entirely disappeared in the midst of what had become a bamboo forest (see page 153). It had grown in width, covering the walls of the nest. Over the nest, giant stalks of bamboo, with their dense foliage, formed a green dome that swayed in the wind.

1978, on Lüneburg Heath.
I smelled the earth, the stones, the freshly hewn
wood. I built the walls of the nest up high,
and wove its floor. From the height of the top edge
of the nest I looked down to the forest floor,
and up into the branches and the sky.
I heard the song of the birds and felt the breath
of the wind. In the twilight, I began to shiver.
The nest was not yet finished. As I squatted
on the edge of the nest, I thought: I am building
myself a house, it is sinking noiselessly through
the treetops down to the forest floor,
open to the cold night sky, and yet warm
and soft, buried deep in the dark earth.

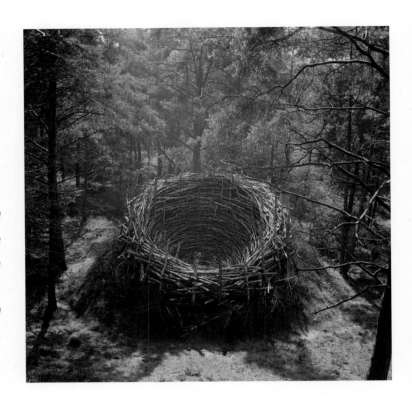

THE MIDDAY NEST

earth, stones, silver birch, grass

Luneburg Heath, Germany, 1978

(right top)

THE NEST

earth, stones, silver birch, grass

Nils-Udo is pictured in the nest

Luneburg Heath, Germany, 1978

(right bottom)

THE NEST

earth, stones, silver birch, grass

Luneburg Heath, Germany, 1978

(facing page)

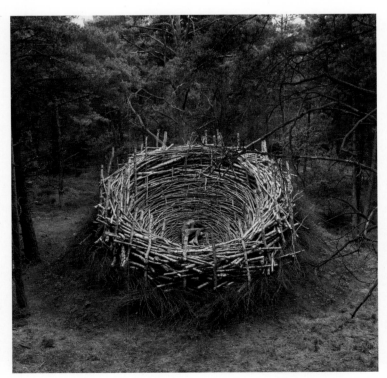

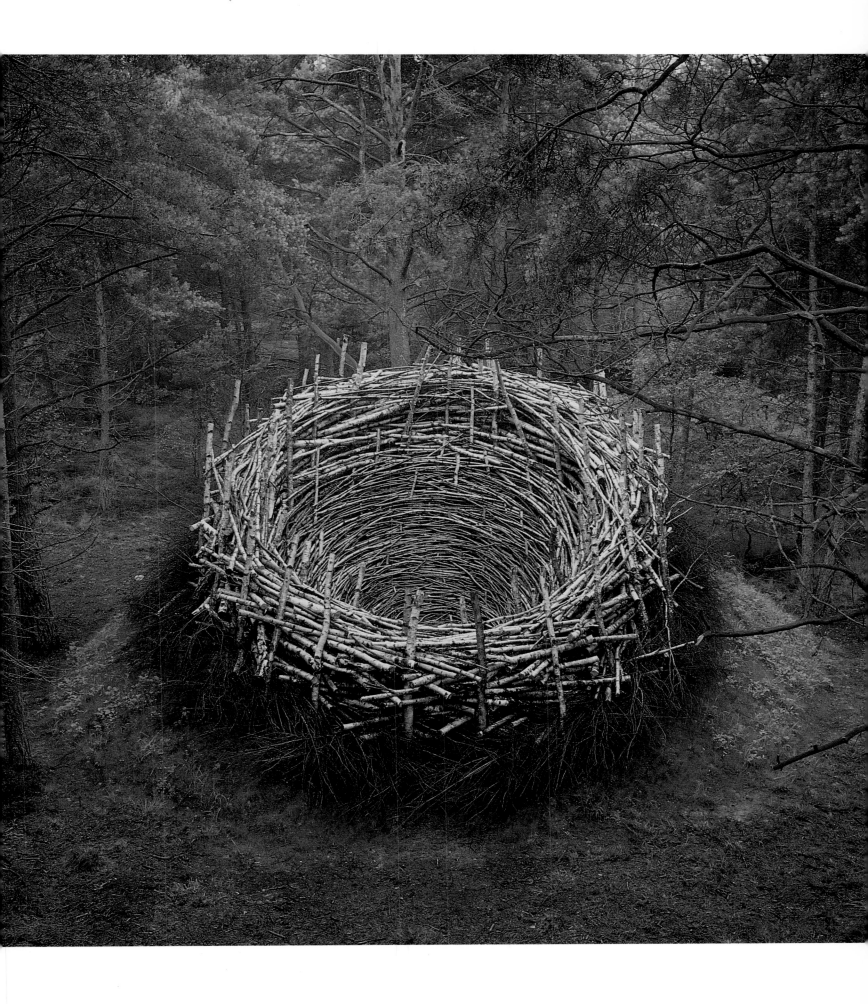

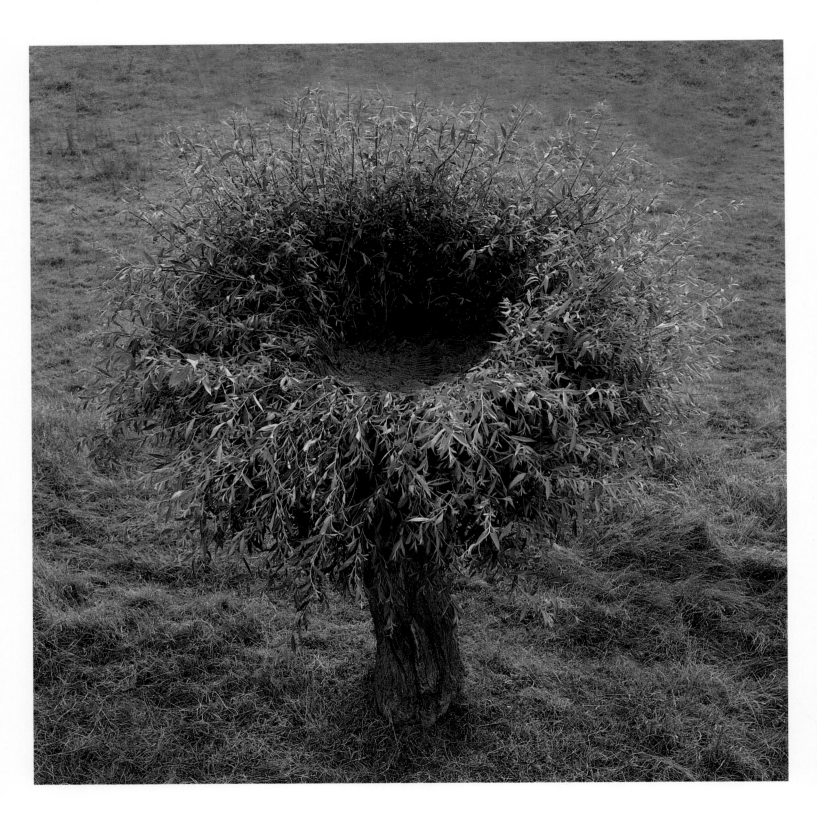

UNTITLED

pollard willow, hay,

stalks of fern

Marchiennes Forest, France, 1994

(above)

UNTITLED

pollard willow, hay,

stalks of fern, poppy petals

Marchiennes Forest, France, 1994

(facing page)

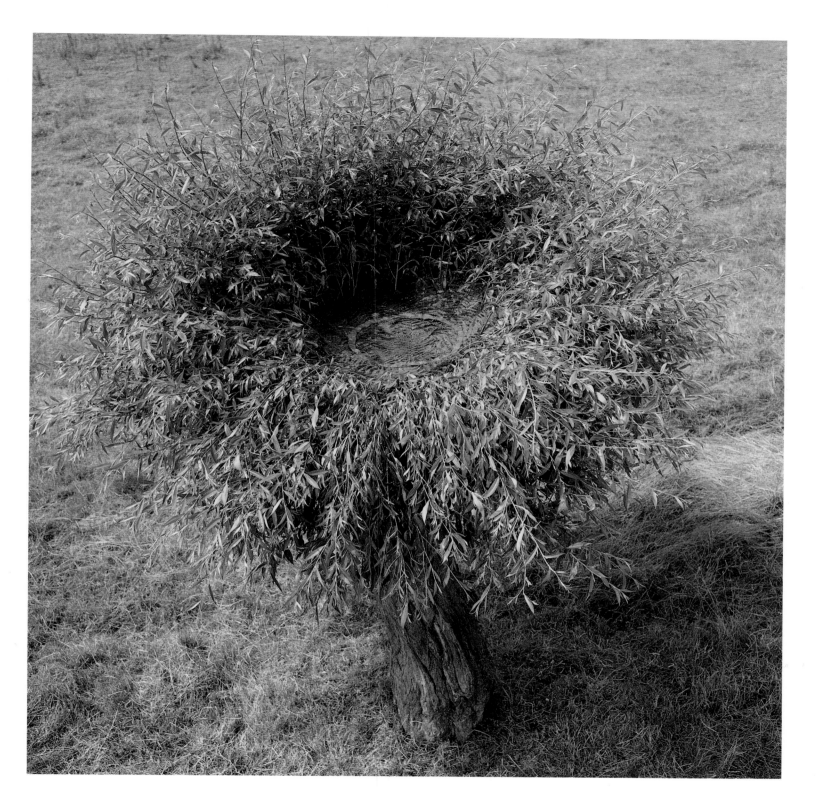

A pollard willow in a meadow.

I removed the middle branches and filled the hollow space with hay.

Then I covered the bottom of the nest with fresh fern leaves from the nearby wood.

The tree as nest—the nest in the tree.

Later I laid a ring of red poppy petals on the floor of the nest.

Another time, I placed a small child in the nest. A tiny, naked bird.

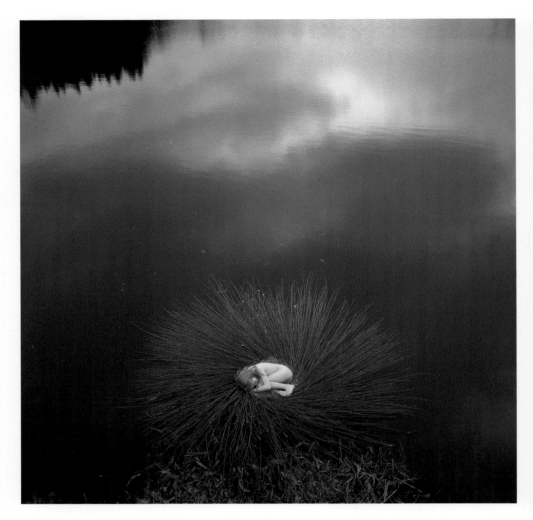

WATER NEST

Chiemgau, Upper Bavaria, Germany, 2001

(above)

UNTITLED

tree fern, child

Réunion, Indian Ocean, 1990

(right)

To begin with, I wanted to put the small Creole girl down in the crown of a thirty-foot- (10-m-) tall tree fern, which towered high over the jungle of ferns that reached to the very horizon. However, despite our careful preparations, the attempt was unsuccessful. The swaying, giant fern did bear the child's weight, but the situation ultimately appeared a little too precarious...

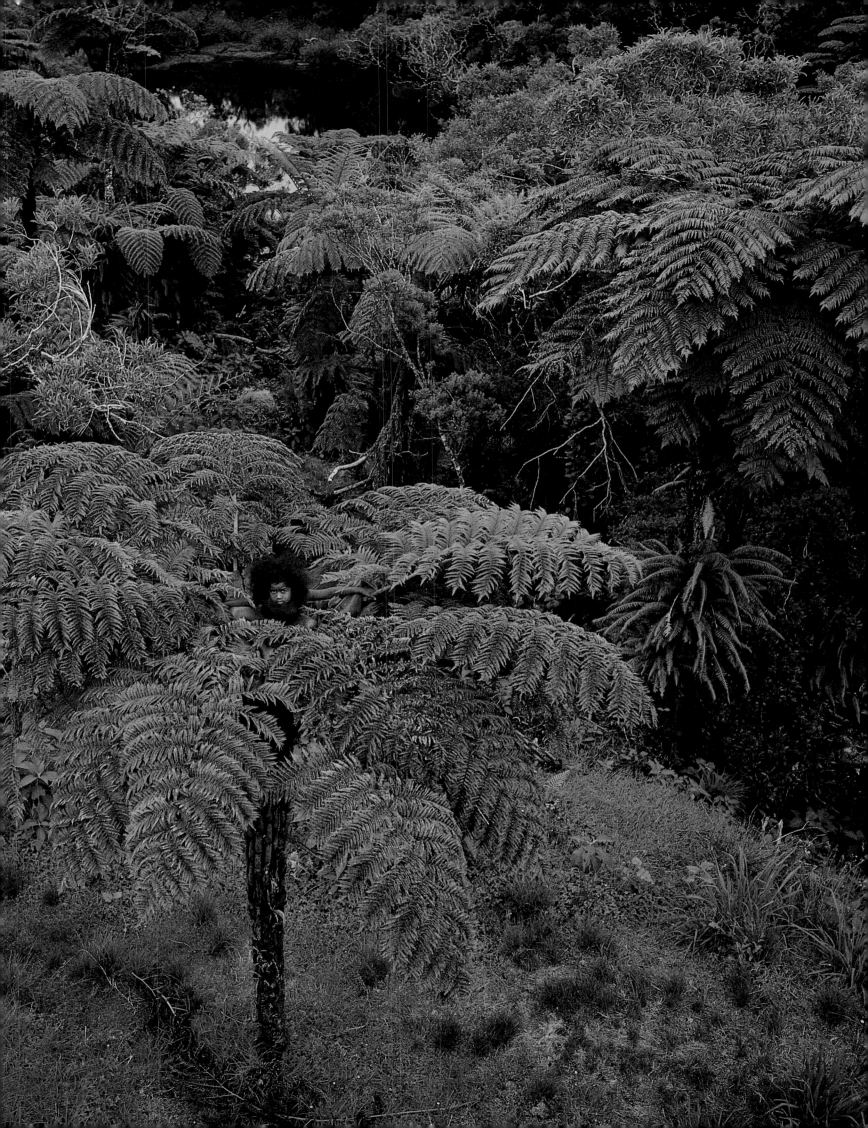

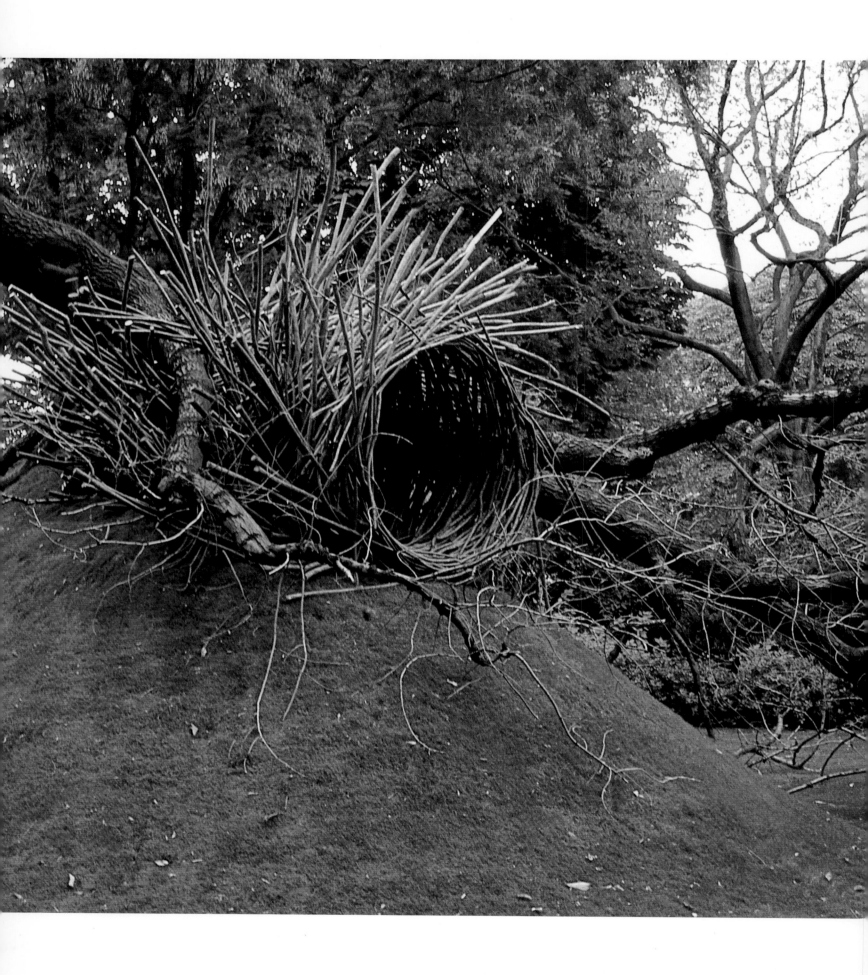

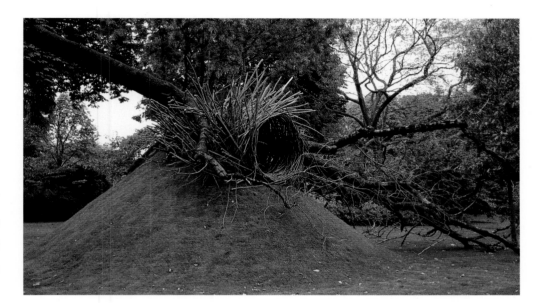

HABITAT

earth, turf plantation, maple, willow switches

Champs-Elysées gardens, Paris, France, 2000

(facing page and right)

ASH NEST

earth, turf plantation, ash, maple branches

Grounds of the Château de Bailleul,

Normandy, France, 1994

(right)

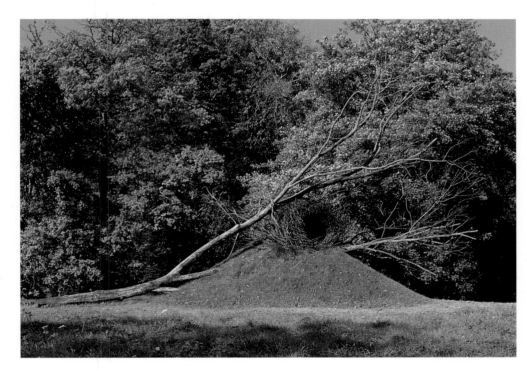

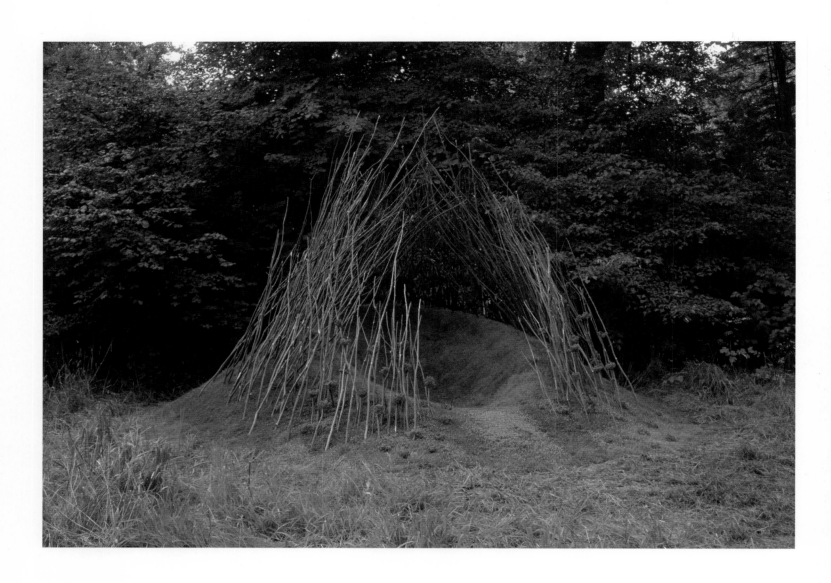

RED NEST
earth, turf plantation,
maple branches, sorb apples
Aachen, Germany, 1999
(above and facing page)

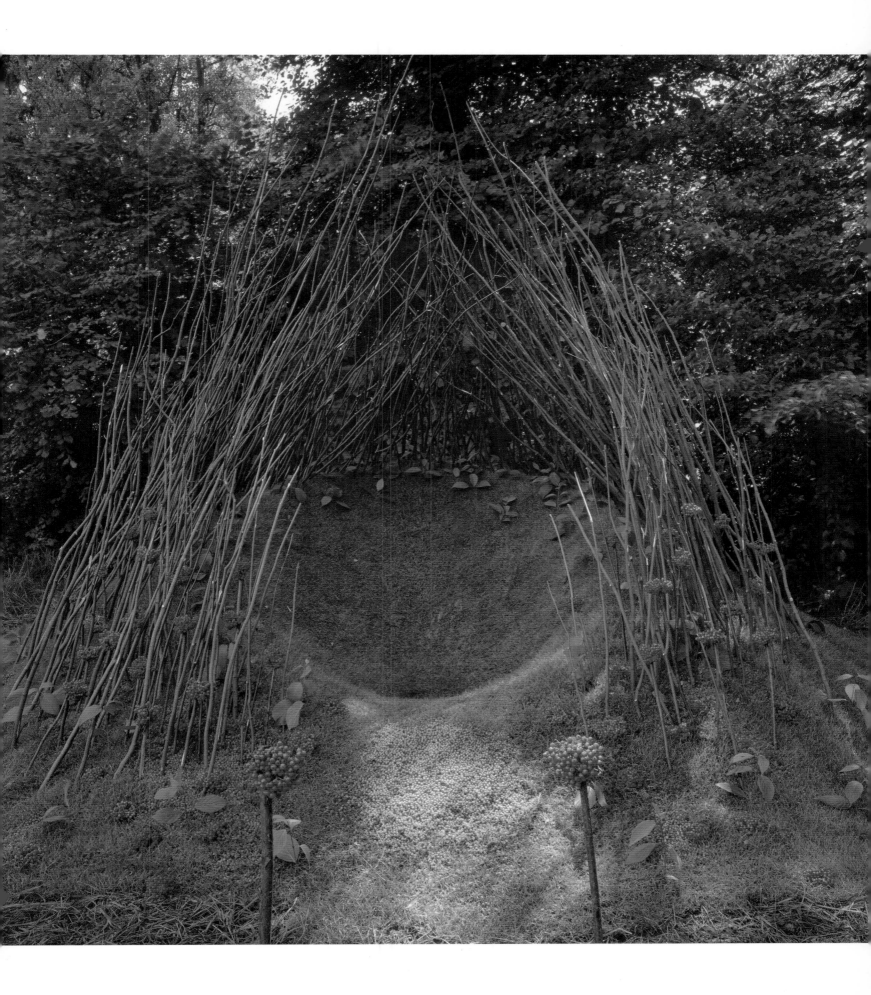

UNTITLED

juniper, sorb apples,

hazel branches, willow

Aachen, Germany, 1999

(facing page)

UNTITLED

limestone, sorb apples

Hintertal, Austria, 1984

(right)

berries

A magnificent juniper tree on the edge of the wood.
I had never worked with juniper before, and so I
simply had to do something with it.
To begin with, we collected heaps of glowing red berry
bunches from the nearby rowan trees. Then we cut a
number of hazel switches from the undergrowth, the
longest and straightest we could find, and tied a luxuriant
bunch of rowanberries to the end of each switch.
Stuck horizontally into the tree, the bunches of berries
outline the shape of the tree.

UNTITLED

forked oak branch, red elderberries

Dietenbronn, Bavaria, Germany, 1992

(above)

UNTITLED

fallen tree in a gorge, sorb apples

Chiemgau, Upper Bavaria, Germany, 1993

(left)

A stream channel in the Chiemgau region.
Magically overgrown with moss and young spruce,
the trunk lay over the gully like a bridge.
I marked its mid-point with a round
cross-section of trunk, scattered with rowanberries.

UNTITLED

ivy, sorb apples

Aachen, Germany, 1999

(above)

UNTITLED

linden, sorb apples, linden leaves

Aachen, Germany, 1999

(facing page)

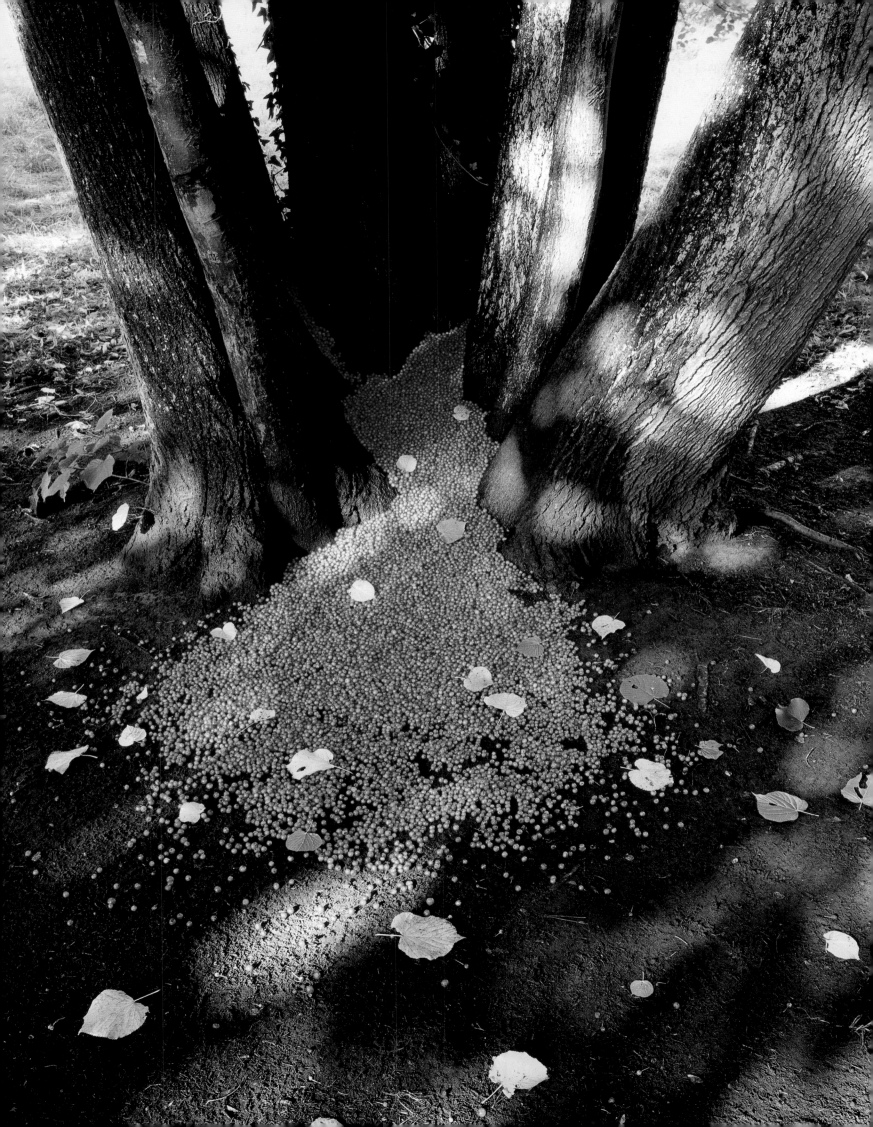

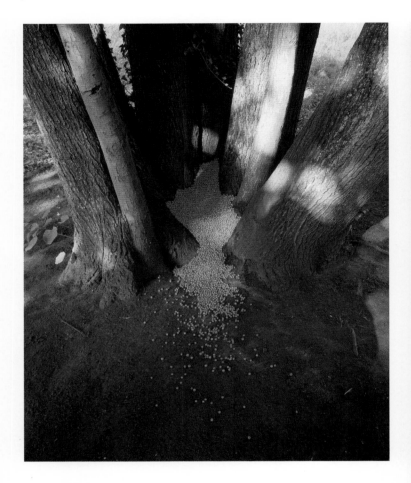

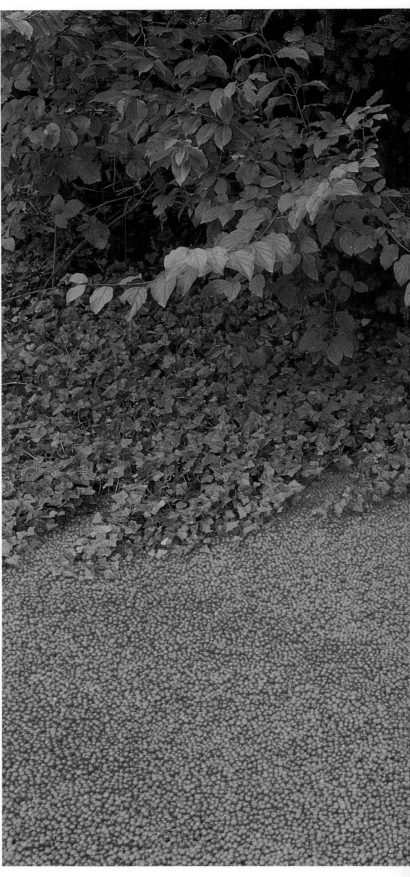

UNTITLED
linden, sorb apples
Aachen, Germany, 1999
(above)

UNTITLED
ivy, sorb apples
Aachen, Germany, 1999
(right)

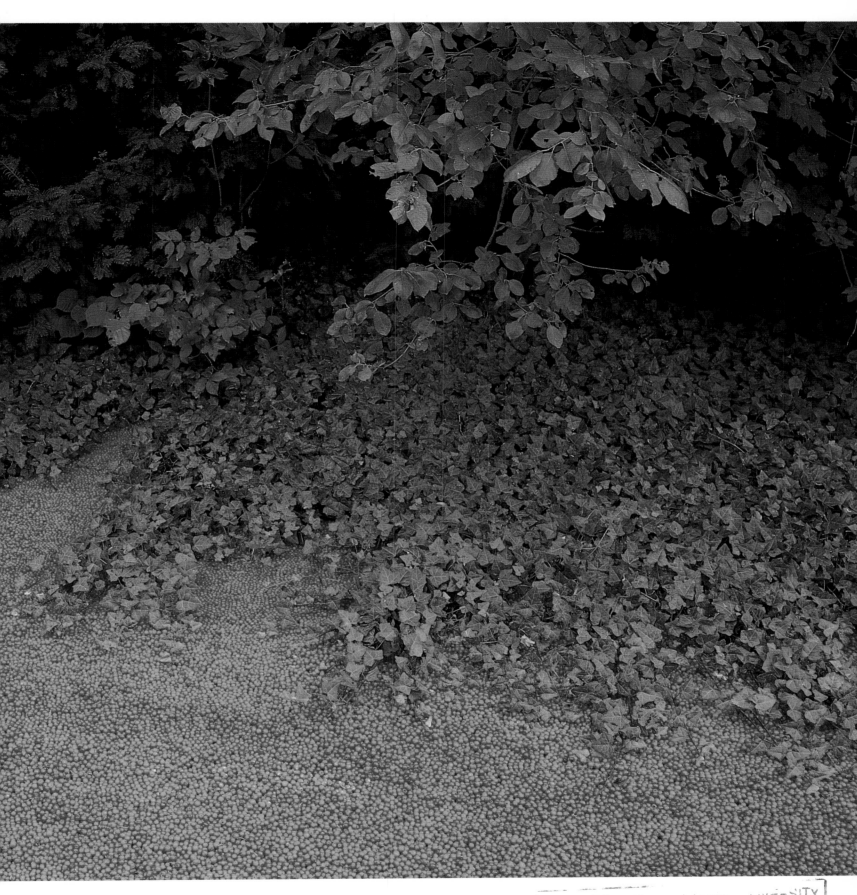

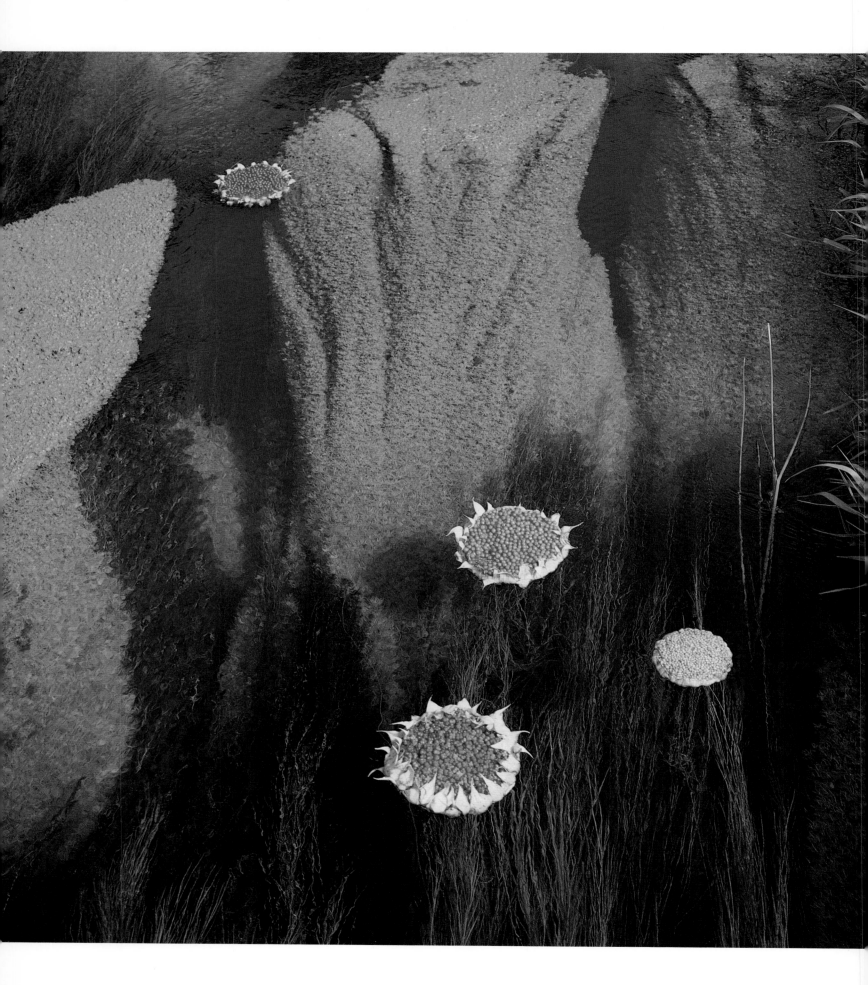

UNTITLED
sunflower heads with the seeds removed,
guelder rose berries, bishop's mitre,
seeds of bishop's mitre afloat on a stream
Danube marshlands, Bavaria, Germany, 1993
(facing page)

UNTITLED
sunflower head with the seeds removed,
guelder rose berries afloat on a stream
Danube marshlands, Bavaria, Germany, 1993
(right)

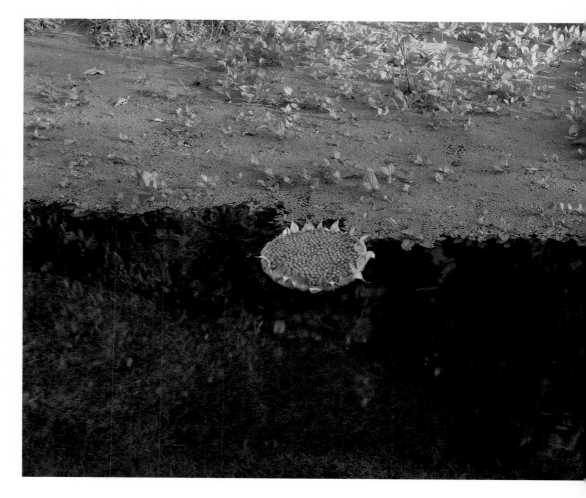

*A summer day. A small river, clear as crystal, flows
through a wooded pasture in the Danube marshlands.
A rampant, lush carpet of underwater plants. The mat of
translucent green undulates gently in the current.
Along the river I found guelder rose bushes, spindle trees,
rowanberries, and a few scattered sunflowers.
I stripped the seeds from the blowsy sunflowers, loaded
the heads of the flowers with the berries I had gathered,
and floated them on the water.
The freight headed downstream, towards the Danube...*

UNTITLED

sunflower head with the grains removed,

guelder rose berries afloat on a stream

Danube marshlands, Bavaria, Germany, 1993

(above)

*I just had to find somewhere to put
my collection of superb snowball-berries
(guelder rose berries), shiny as glass!
I looked around and found a sunflower
growing near the pond. I stripped away
its leaves and seeds, and then covered it
in berries and laid it on the water.*

UNTITLED

earth, water, willow, blades of grass,

sorb apples, privet berries

Aachen, Germany, 1999

(right)

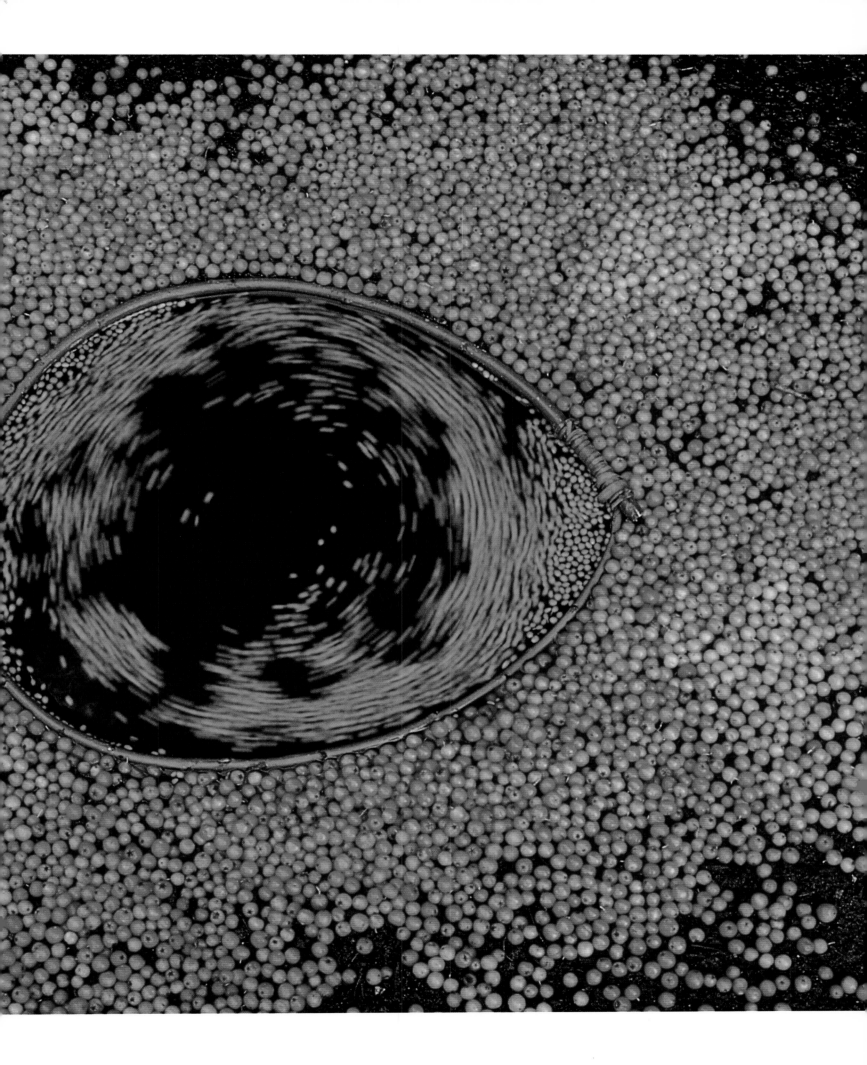

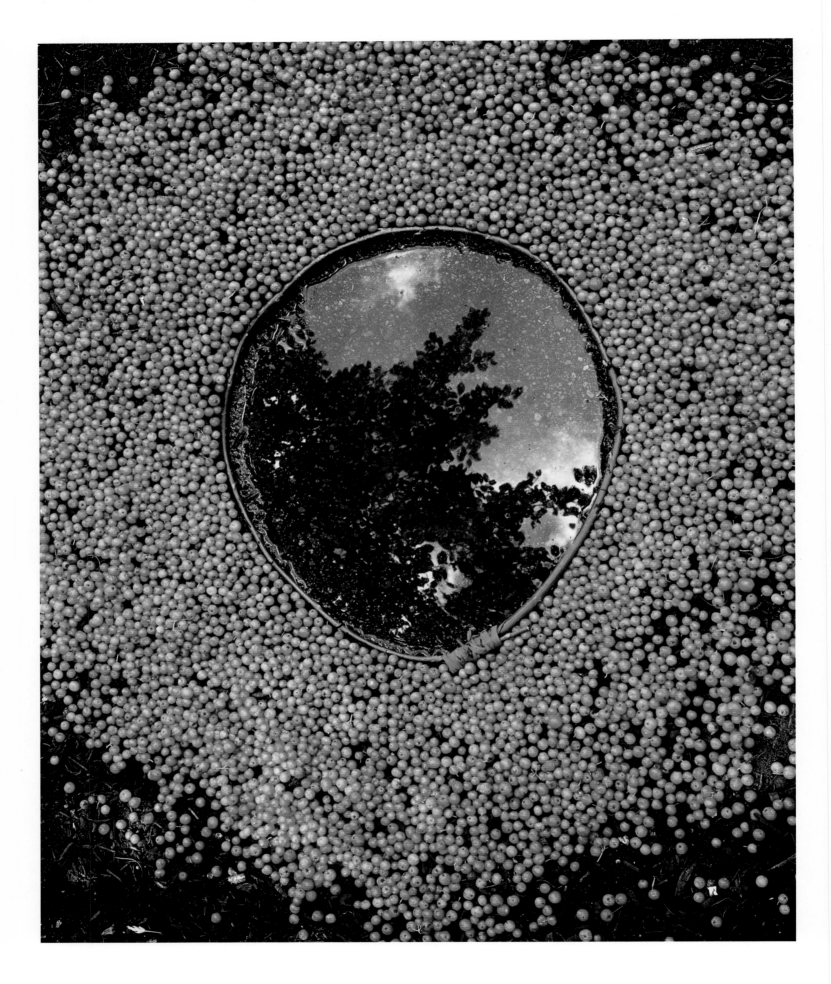

MIRROR
earth, water, sorb apples,
willow, blades of grass
Aachen, Germany, 1999
(facing page)

UNTITLED
earth, water, willow, blades of grass,
sorb apples, privet berries
Aachen, Germany, 1999
(right)

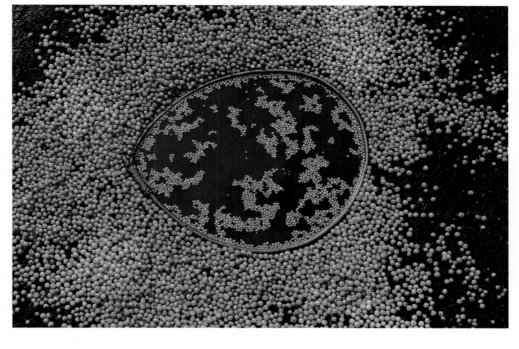

UNTITLED
earth, water, charcoal, hazel switch,
willow, plane tree fruits
Auvergne, France, 2000
(right)

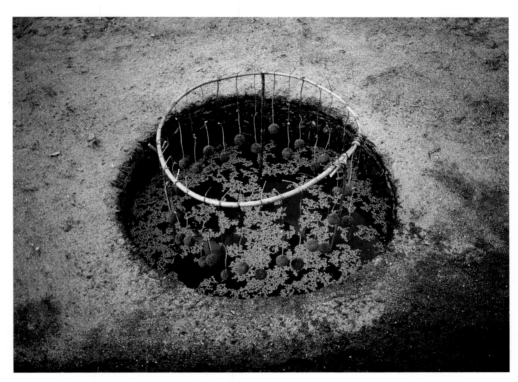

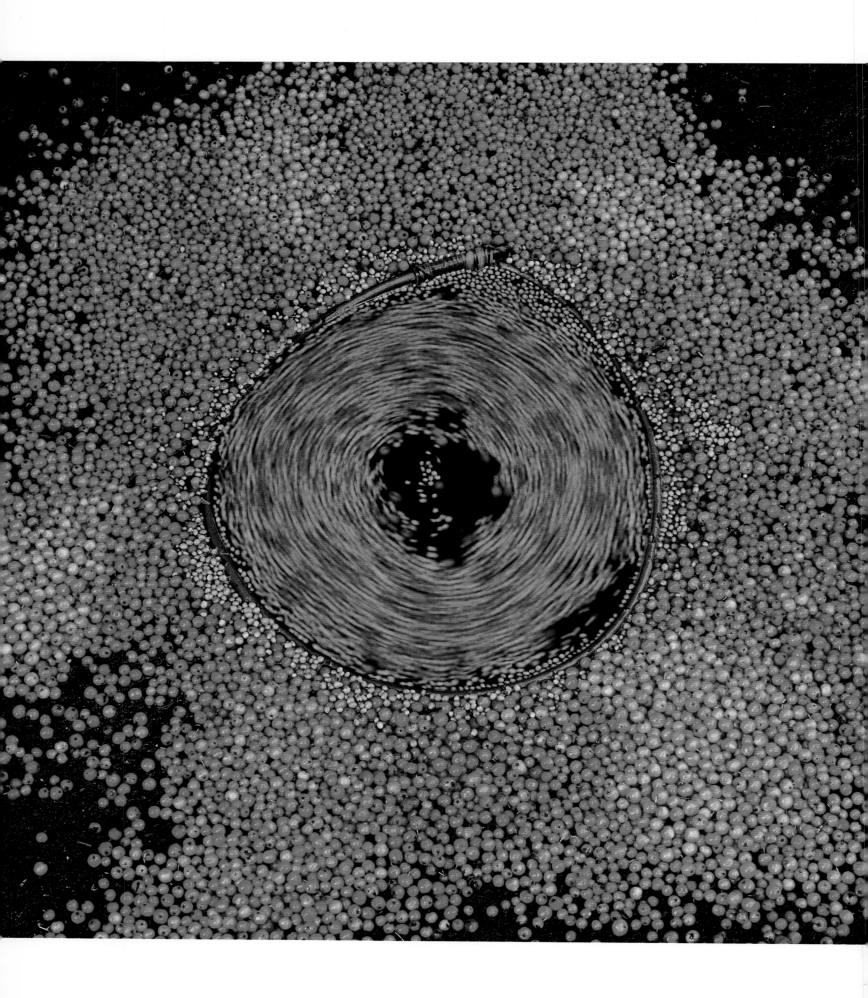

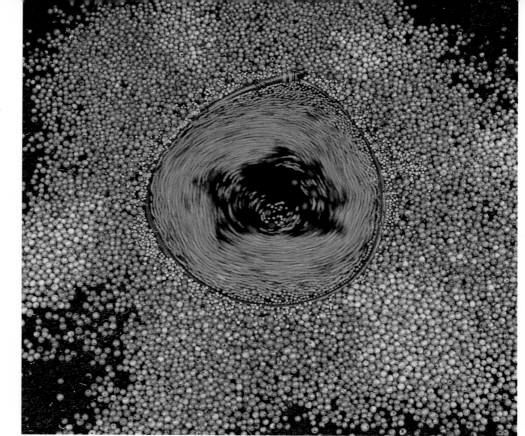

UNTITLED

earth, water, willow, blades of grass,
sorb apples, privet berries
Aachen, Germany, 1999
(facing page)

UNTITLED

earth, water, willow, blades of grass,
sorb apples, privet berries
Aachen, Germany, 1999
(right, top and bottom)

Summer in the park.
A puddle of water.
I tied a green switch of willow with
blades of grass to make a circle,
and laid it on the puddle.
Then I covered the surface of the
puddle with unripe green privet
berries and red rowanberries,
and the surrounding area with
red and orange rowanberries.
Red and green.
The complementary colors chase
each other around in a circle.

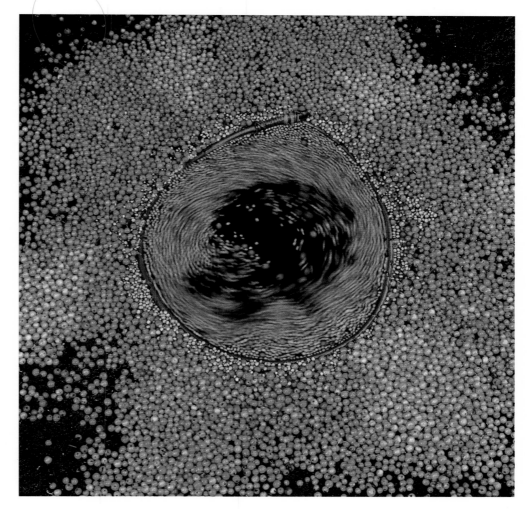

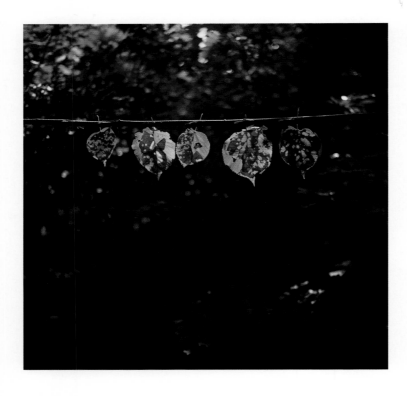

leaves

Evening sun in the woods.
I found some large linden leaves,
eaten through by insects. I stuck wet poppy
petals on the back of the leaf to show
through the holes, and attached the leaves
by their stalks into a notched stick,
which I held up to the evening sun.

LANTERNS

linden leaves eaten through by insects,

dampened poppy petals

Haarlem, The Netherlands, 1984

(left)

UNTITLED

cherry tree leaves,

willow switches

Ecquevilley, France, 1985

(facing page)

A sunny, windy autumn day.
On the opposite side of the valley, the flaming red
autumn foliage of a cherry tree lit up the hill.
I gathered its leaves, in all different shades. Then I
sorted them into small heaps and laid them on the
slope of a meadow.
Soon, I had to weigh them down with willow switches
against the rising wind.
When I passed by again later, after the first photographs,
a herd of sheep had walked over the leaves.

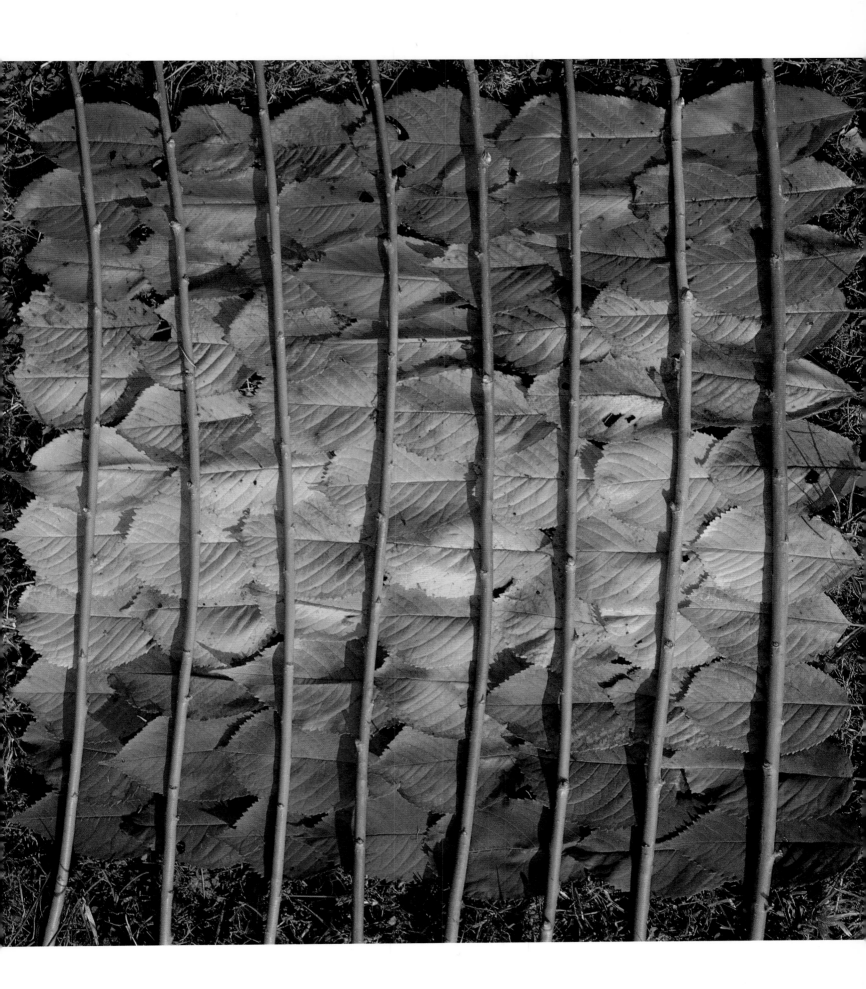

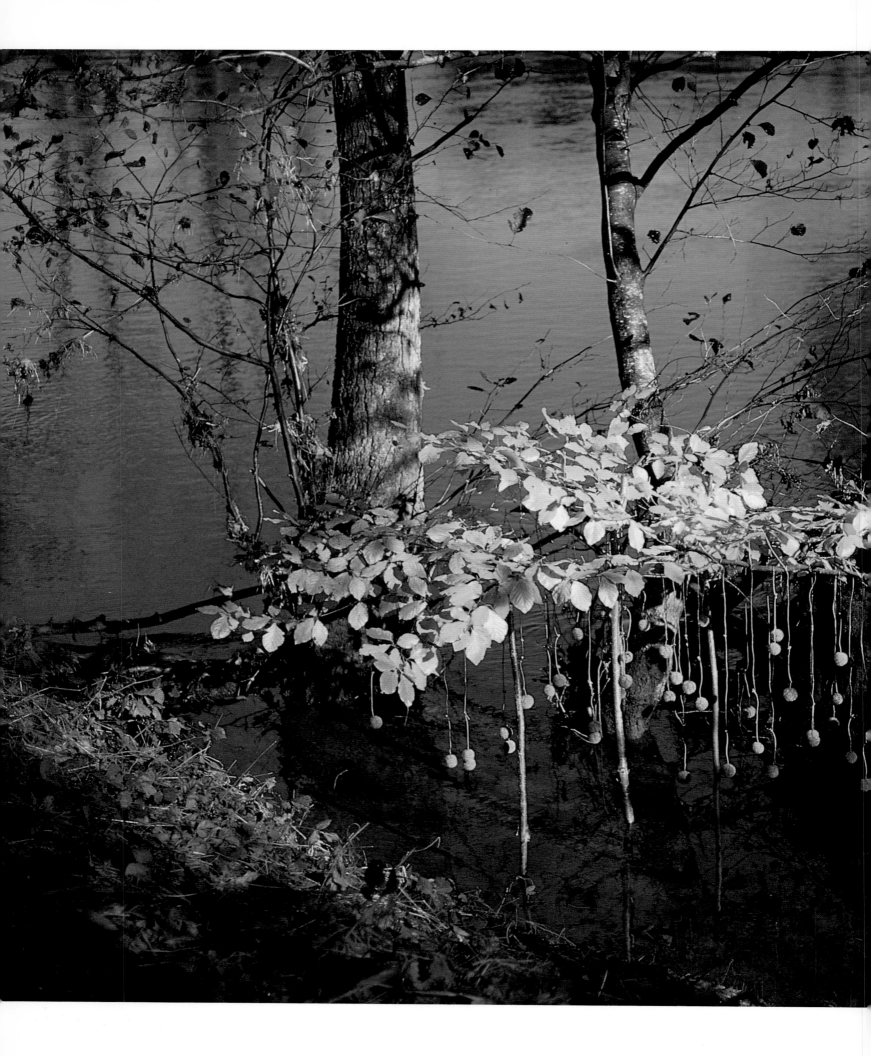

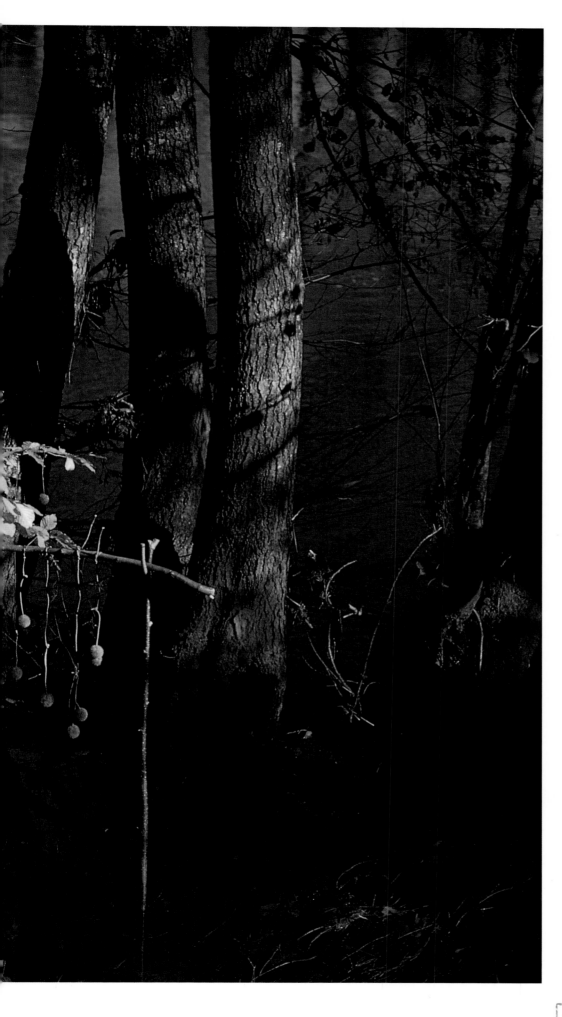

A little autumnal apotheosis.
A group of alders, standing
in the river, formed a small,
sheltered bay by the bank.
A flaming yellow beech twig,
hung with plane tree fruit
and set in the blue river.

UNTITLED

beech branch, plane tree fruit

Auvergne, France, 2000

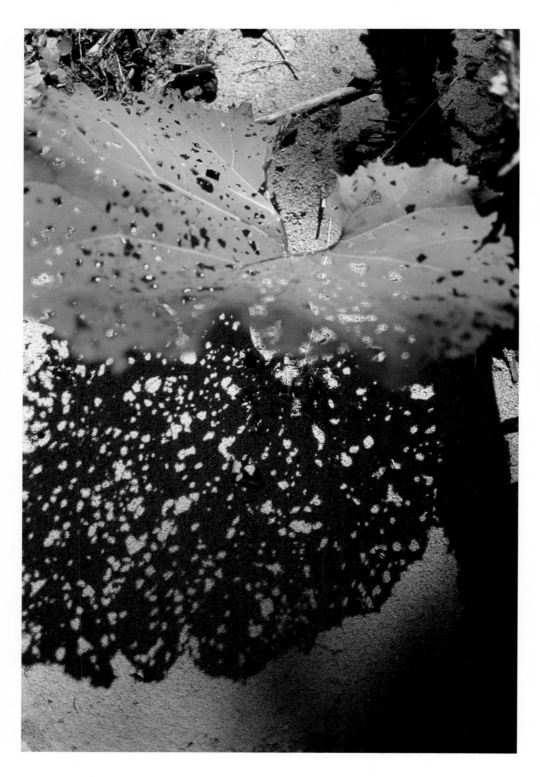

Along the riverbanks in Chiemgau,
you often come across large fields
where sturdy butterbur leaves
proliferate like in some primeval forest.
Later in the summer, delicate
patterns appear on many of
the leaves, formed by countless
holes where insects have eaten
through the leaf.
I cut a few chosen leaves
and stuck them in the pale
sand of the riverbank.

UNTITLED

butterbur leaf, shadow

Hintertal, Austria, 2000

(left and facing page)

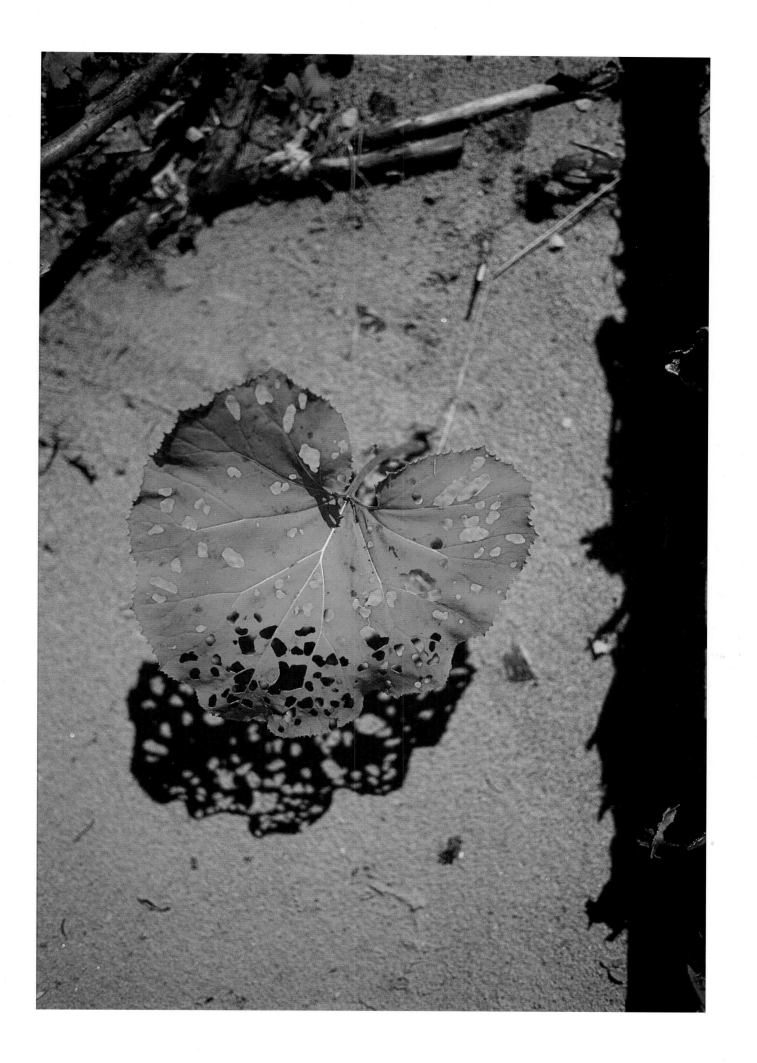

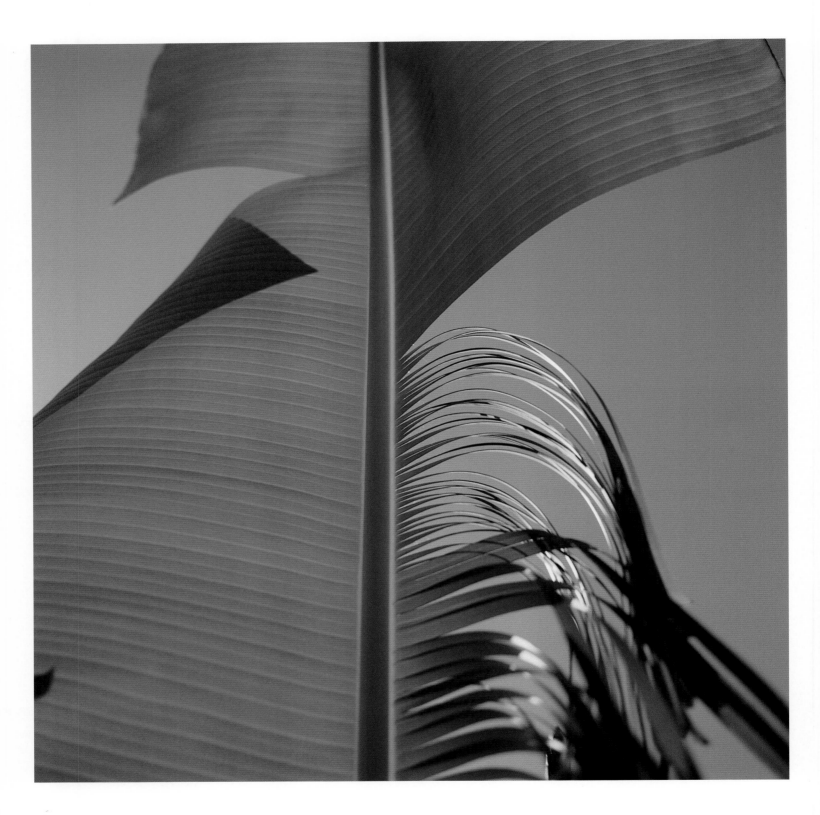

UNTITLED

torn banana leaf

Réunion, Indian Ocean, 1990

(above and facing page)

The huge, bright green fields of still young and shiny banana leaves.

The spotless purity of the grown leaves lasts for only a short while. The leaves begin to tear

as soon as they are exposed to the first strong buffets of wind.

I selected a few leaves and then carefully tore half of each into strips along the veins.

CHRYSALIS

child, autumn leaves

Marchiennes Forest, France, 1995

(above)

ENTRANCE

fallen tree, hazel leaves, hazel switches, pine needles

Dietenbronn, Bavaria, Germany, 1993

(facing page)

The first snowfall, on an autumn day.

In the forest I came across a fallen pine tree.

Its roots were exposed, leaving a hole

in the earth like the entrance to a cave.

The path led through a curtain of hazel leaves.

FERNS

Vassivière, Limousin, France, 1986

(above)

UNTITLED

silver poplar leaves

face up and face down

Berck-sur-Mer, France, 1997

(facing page)

HORSE CHESTNUT LEAVES

Equevilley, France, 1985

(following double page)

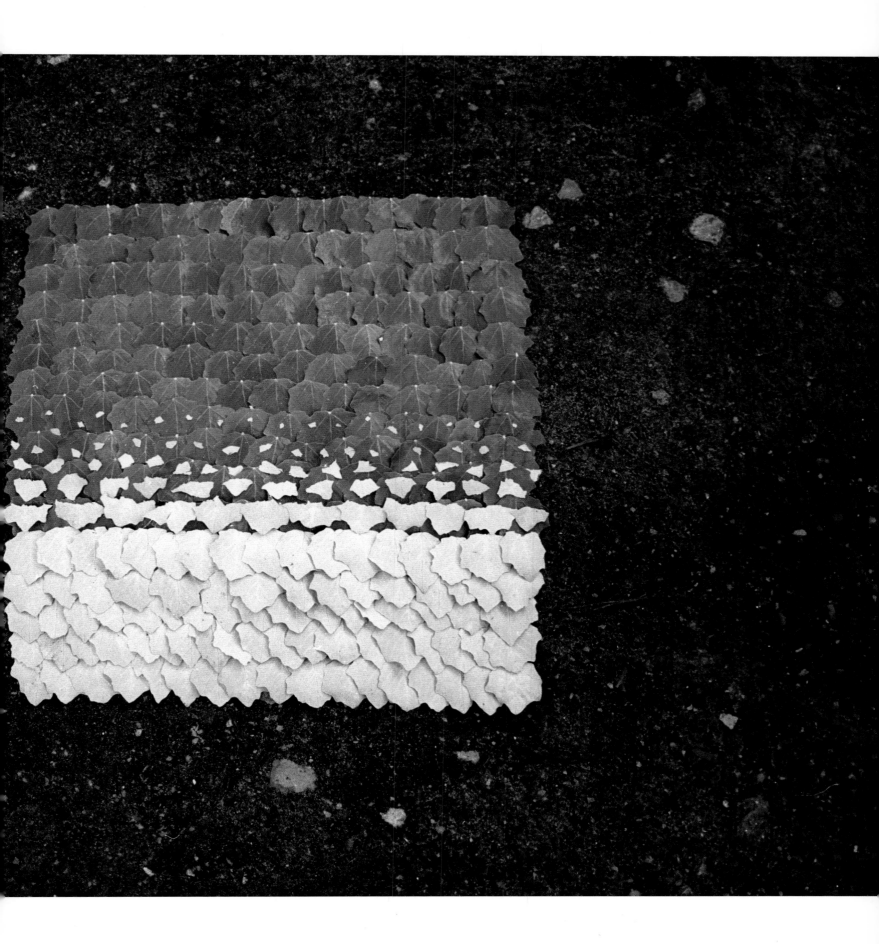

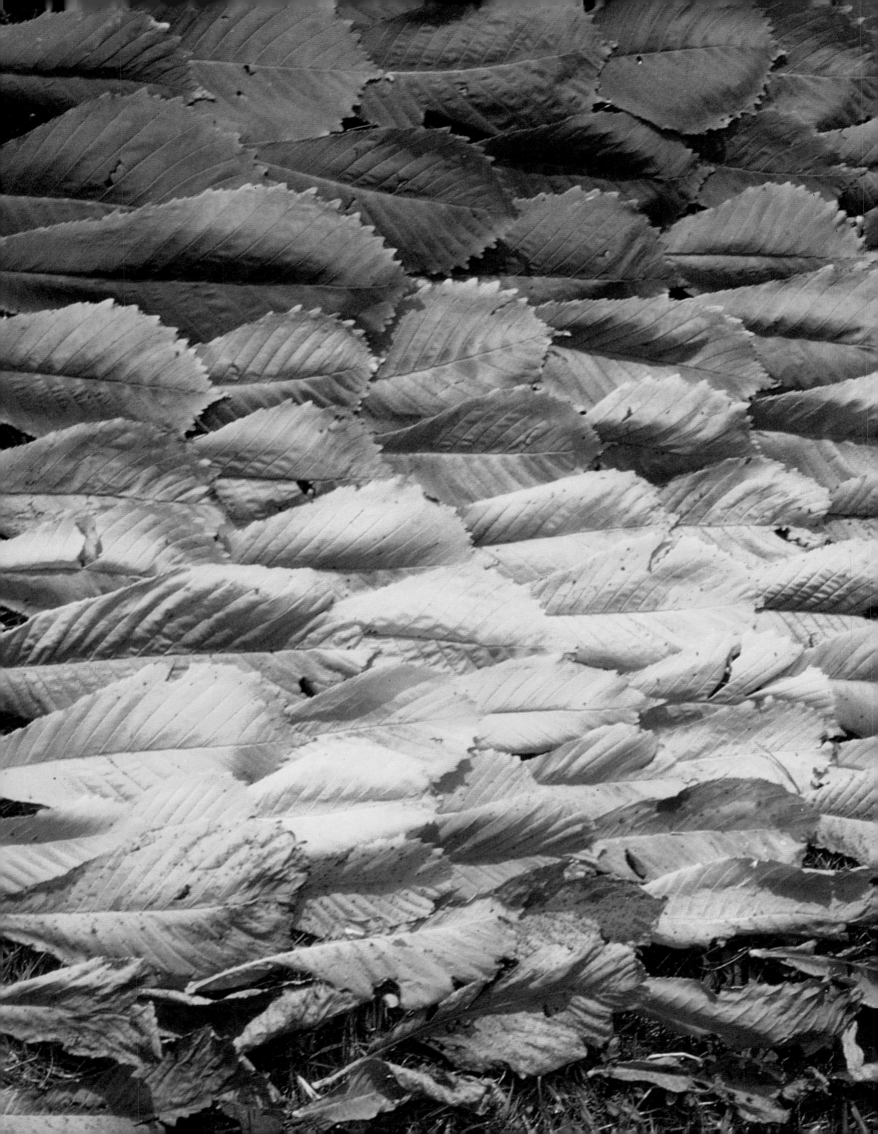

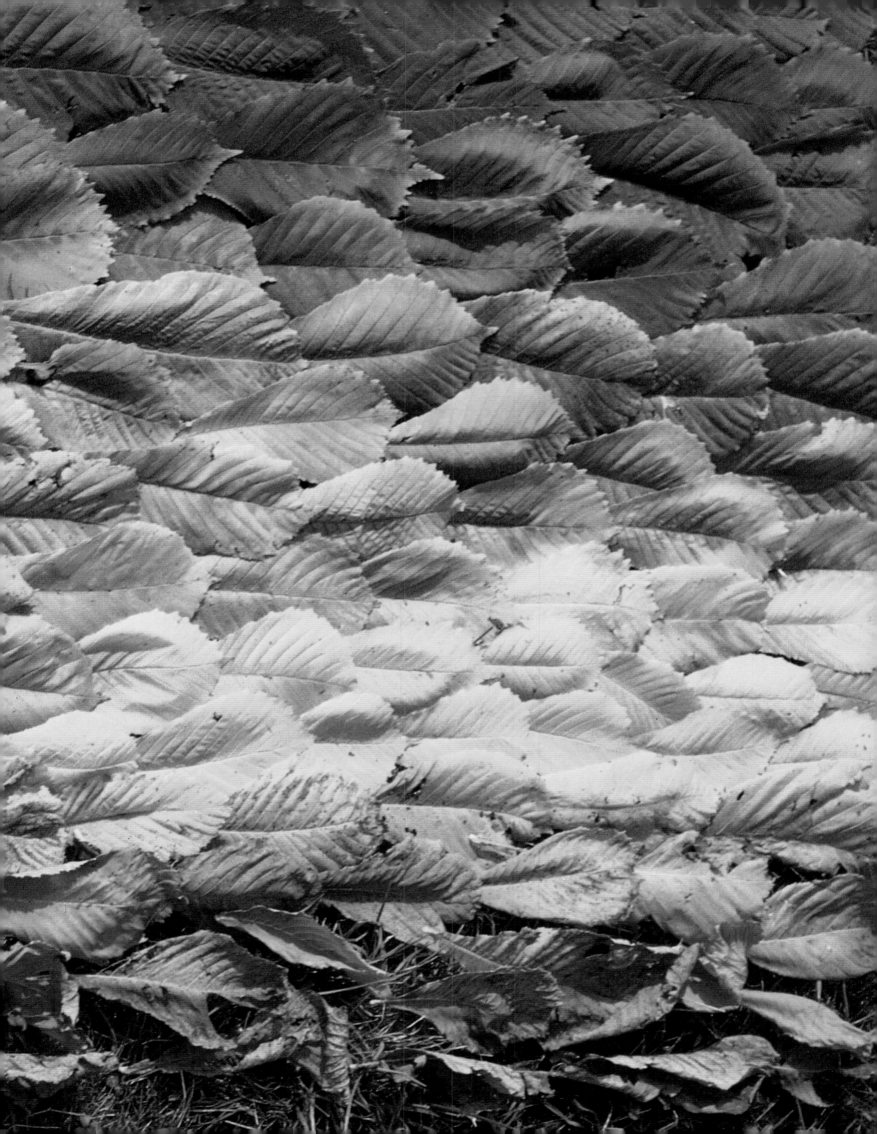

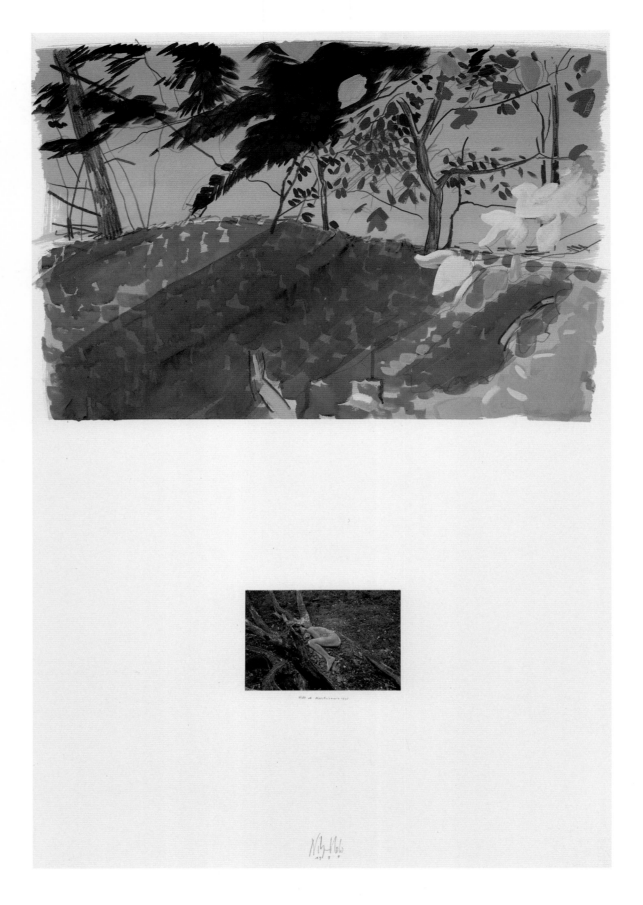

CHILD, WOOD FLOUR

acrylic and ilfochrome on Rives paper, 120 x 80 cm, 2000

Marchiennes Forest, France, 1995

(above and facing page)

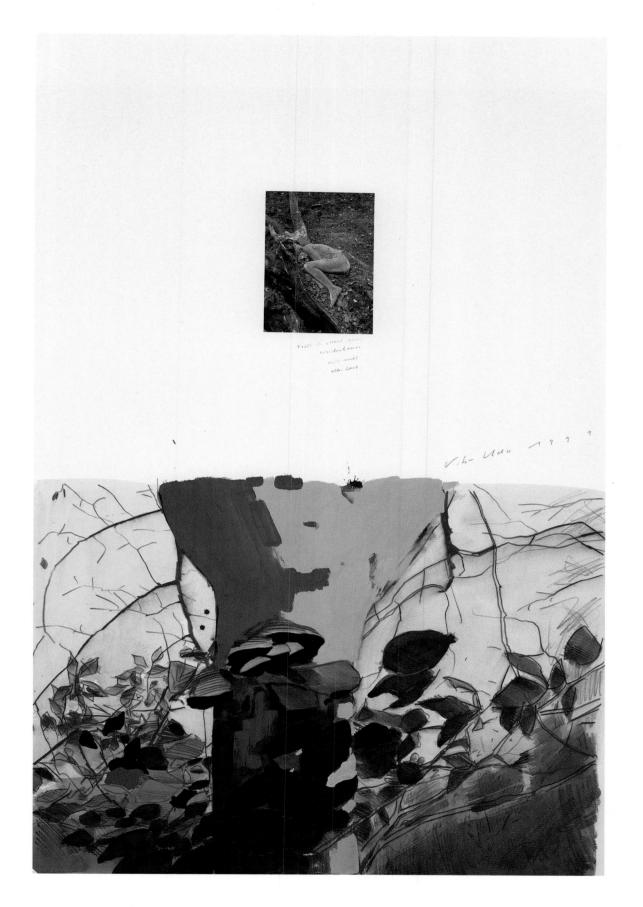

Autumn wind, autumn light, autumn picture.
An ancient, rotting willow on the edge of a pond in the forest.
At some point I made a decision not to exclude man from my works any more.
From then on, I began to integrate man—and even to dissolve him—
as much as possible into nature.

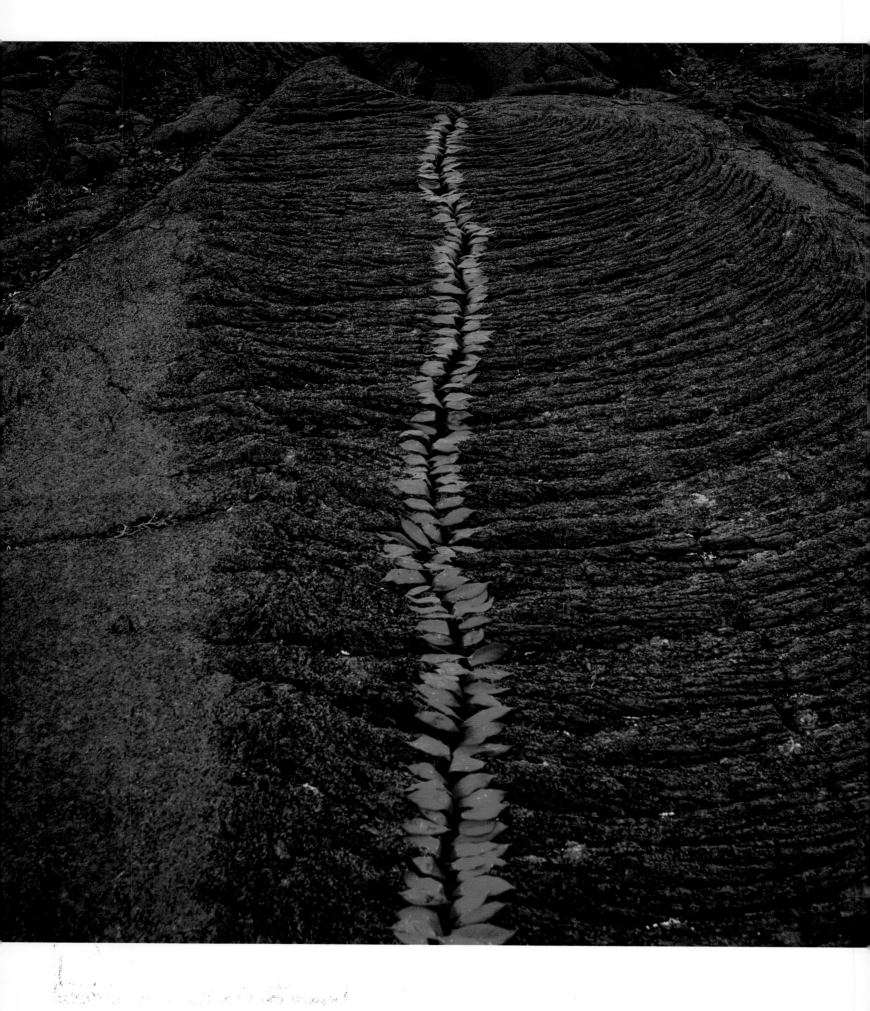

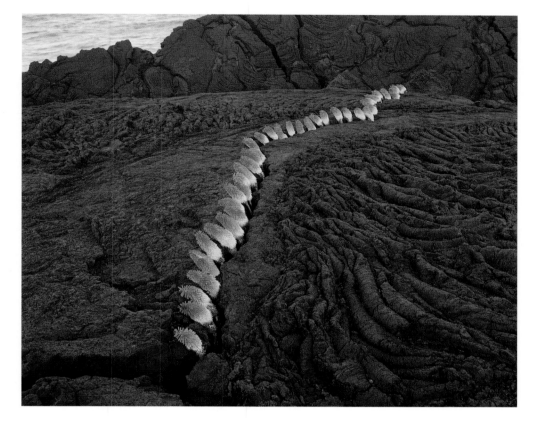

UNTITLED
fissure in a lava flow, petals of
the flowers called "tongues of fire"
Réunion, Indian Ocean, 1990
(facing page)

UNTITLED
fissure in a lava flow,
"lantern" flowers
Réunion, Indian Ocean, 1998
(right)

flowers and petals

During my stay on Réunion in the Indian Ocean,
I definitely wanted to produce a work on
the theme of volcanoes.
I climbed the Piton de la Fournaise very early
one morning, so as to avoid the cloudbanks
that rise up around the volcano every day.
As I walked along the cone of the volcano,
I came across one particularly impressive rift
in the lava. A vision flashed upon me: the red
petals known to the islanders as "tongues of fire"
(poinsettia) flickering out of the crack in the lava.

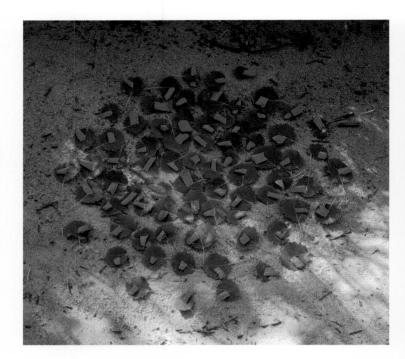

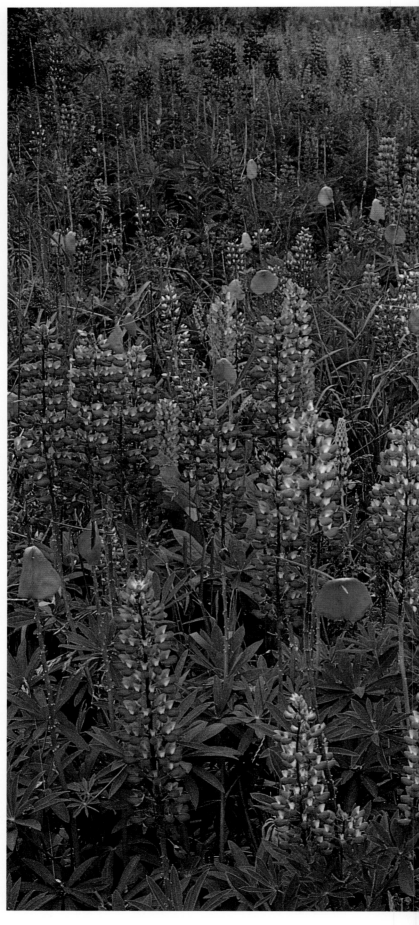

UNTITLED

aspen leaves, petals of the dog rose

Rosa Rugosa Thunberg

Sylt Island, Germany, 1986

(above)

UNTITLED

lupins, petals of the dog rose

Rosa Rugosa Thunberg

Sylt Island, Germany, 1986

(right)

UNTITLED

palm leaves, poinsettia petals,

beefwood needles

Réunion, Indian Ocean, 1998

(following double spread)

Is anyone interested in five red lines
against the deep blue of the sky
over the Indian Ocean?
Will anyone guess that they are my five
long red fingers? They are touching
the palm leaf, and swaying in the wind.

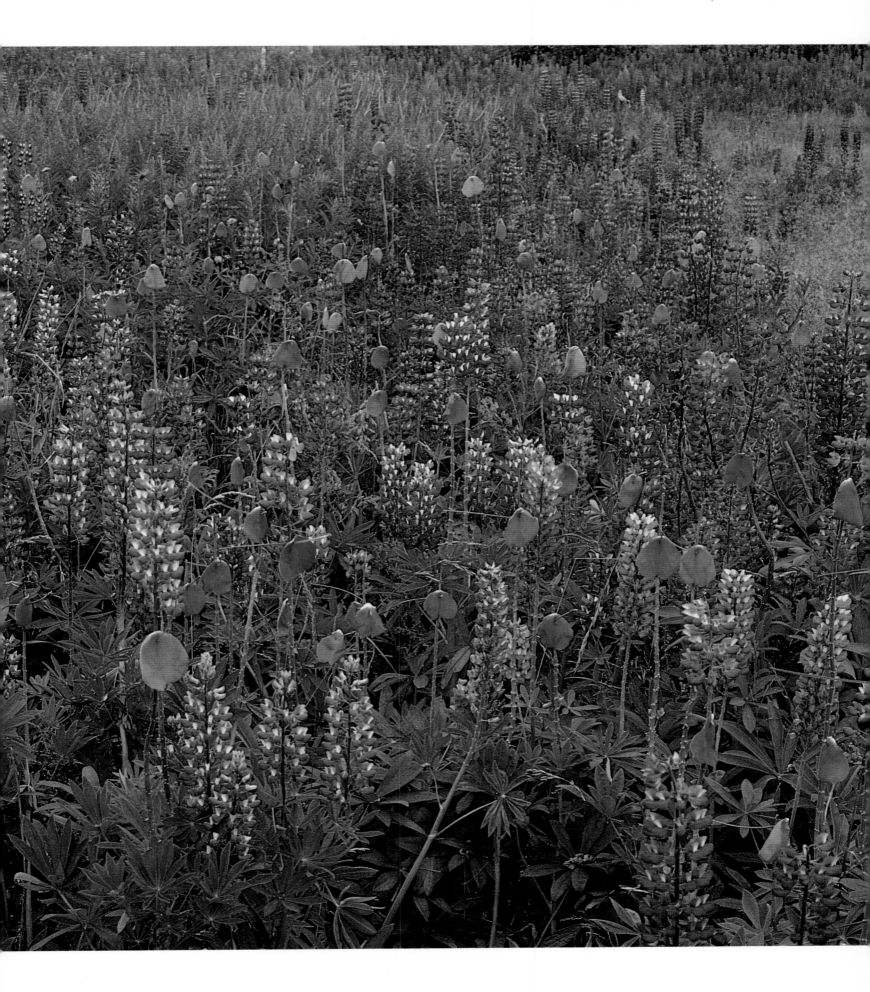

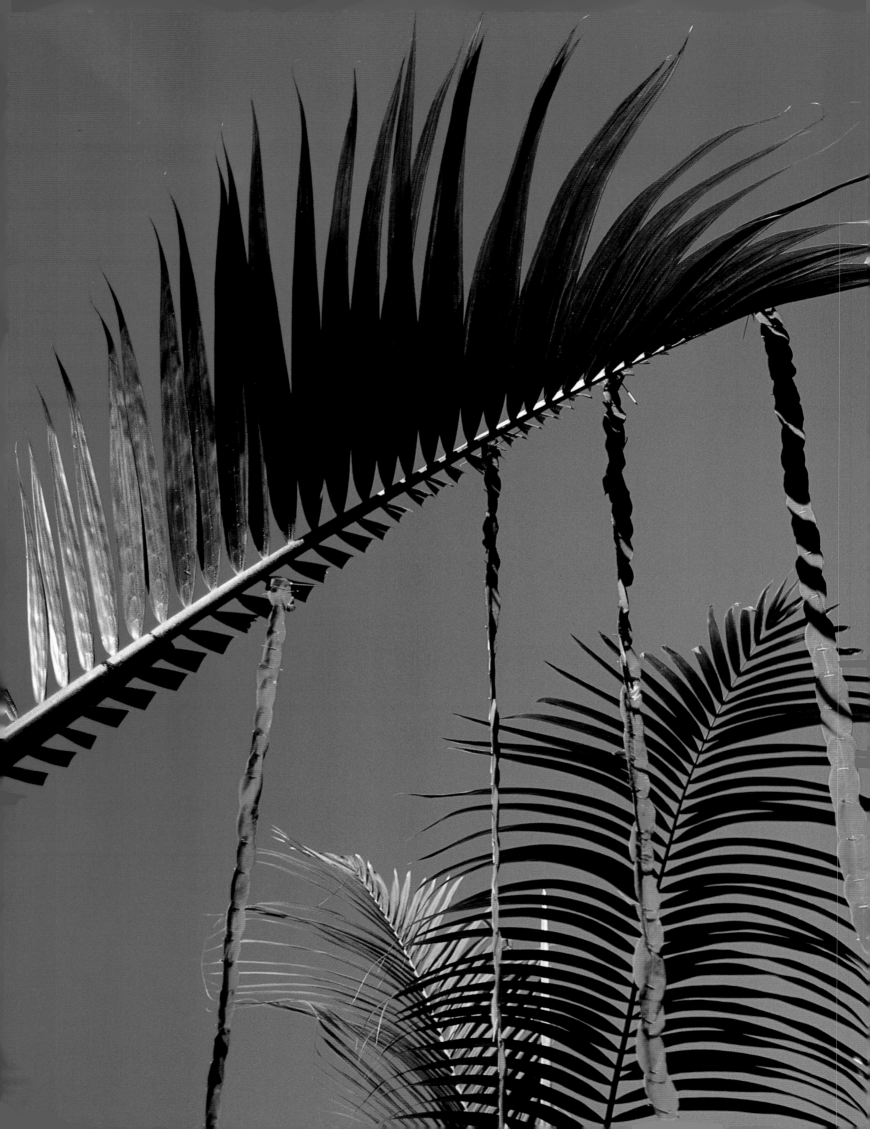

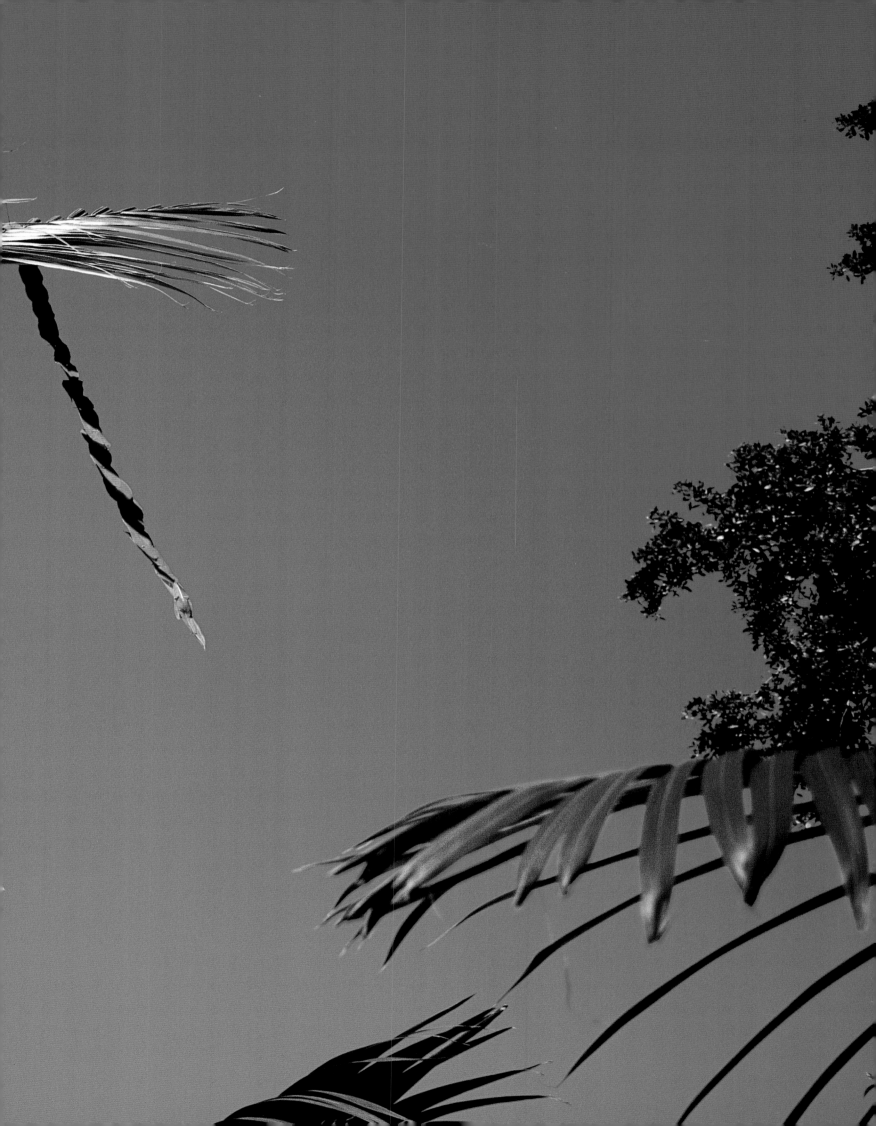

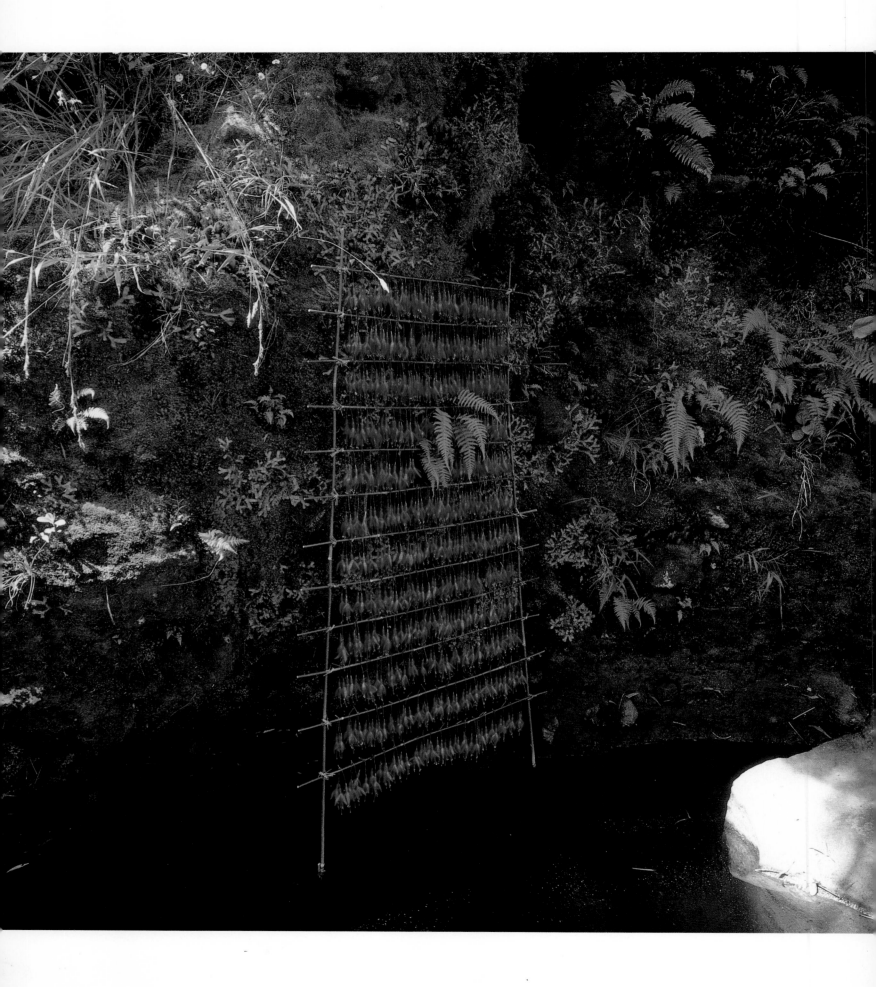

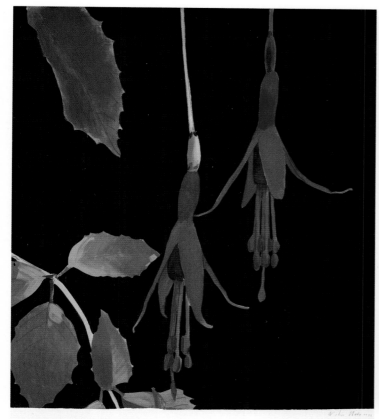

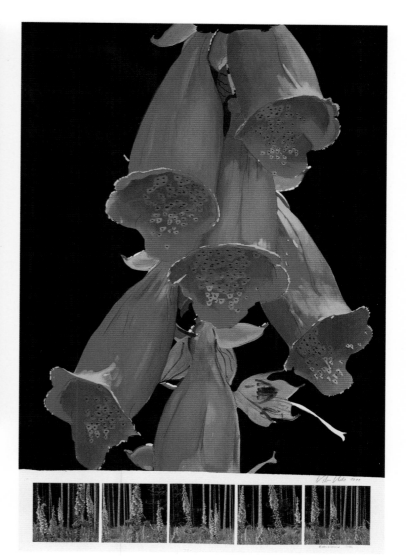

BAMBOO, FUCHSIA BUDS, BLADES OF GRASS

Réunion, Indian Ocean, 1990

acrylic and ilfochrome on Rives paper, 120 x 80 cm, 2000

(above)

CLEARING WITH FOXGLOVES

Dietenbronn, Bavaria, Germany, 1992

acrylic and ilfochrome on Rives paper, 120 x 80 cm, 2000

(above)

BAMBOO, FUCHSIA BUDS, BLADES OF GRASS

Réunion, Indian Ocean, 1990

(facing page)

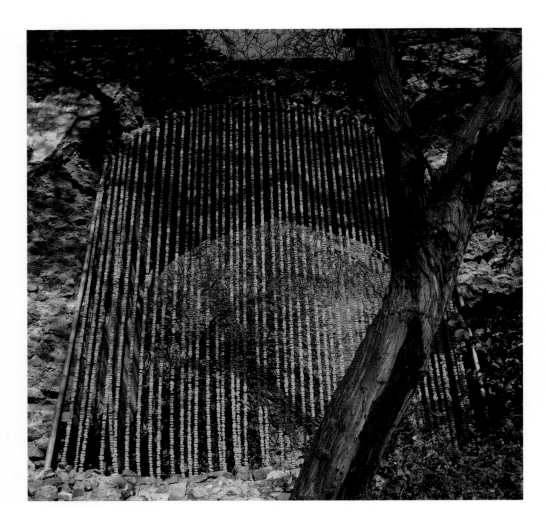

India Gate was created by retracing the characteristically delicate bow-form of the architecture of a gateway that is sinking back into nature. The situation of an entrance on a hill: a flower-covered arch in the spellbound world of a fairy-tale that seems to be both foreign and familiar. A pastel-colored kind of temple/palace structure.

INDIA GATE

bamboo canes and chains of marigolds

Government Sunder Nursery, New Delhi, India, 1994

(above and right)

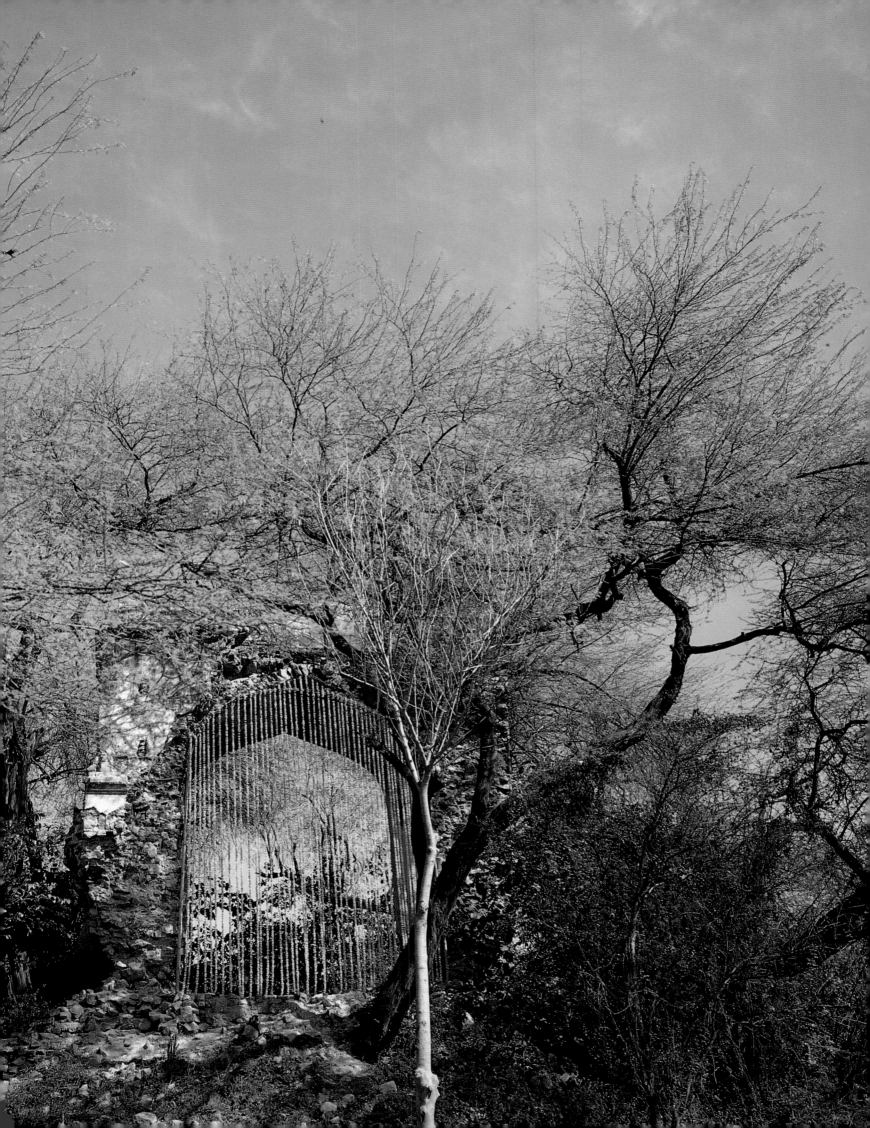

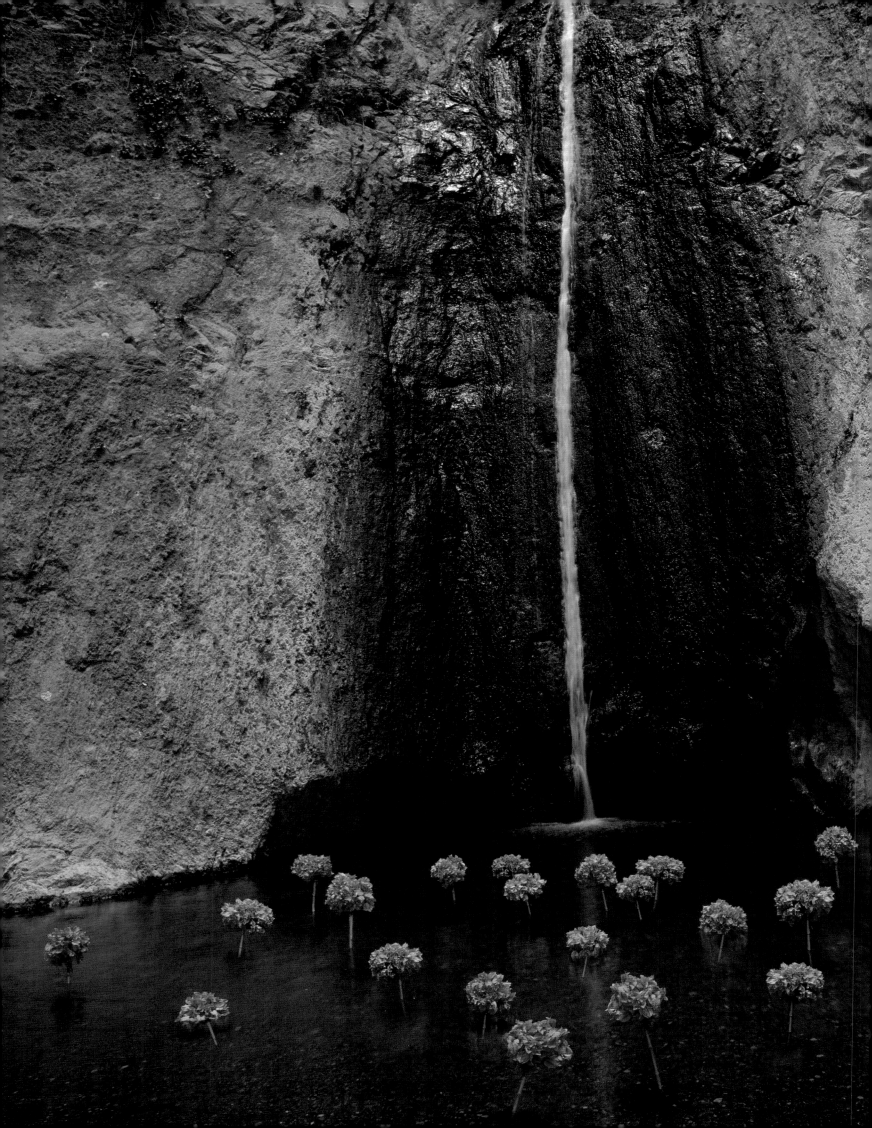

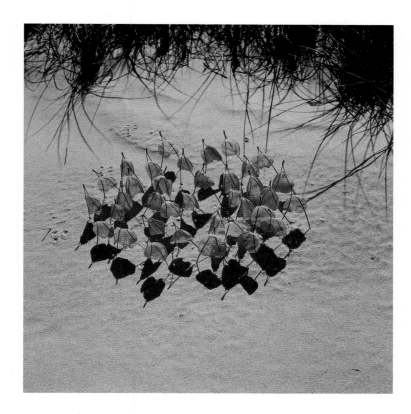

UNTITLED
petals of the dog rose *Rosa*
Rugosa Thunberg, pine needles
Sylt Island, North Sea, 1986
(above)

UNTITLED
barranco del infierno
Teneriffa, Spain, 1999
(left)

At the end of a long walk on the red-hot flanks of an
arid, rocky, sun-scorched barranco, where enormous
cacti were growing, the valley became narrower.
In the shadow of the sheer rocky walls, willows formed
thick undergrowth along the stream. The steep walls drew
ever closer together, and the ravine ended in a narrow
basin at the foot of the vertical drop of the waterfall.

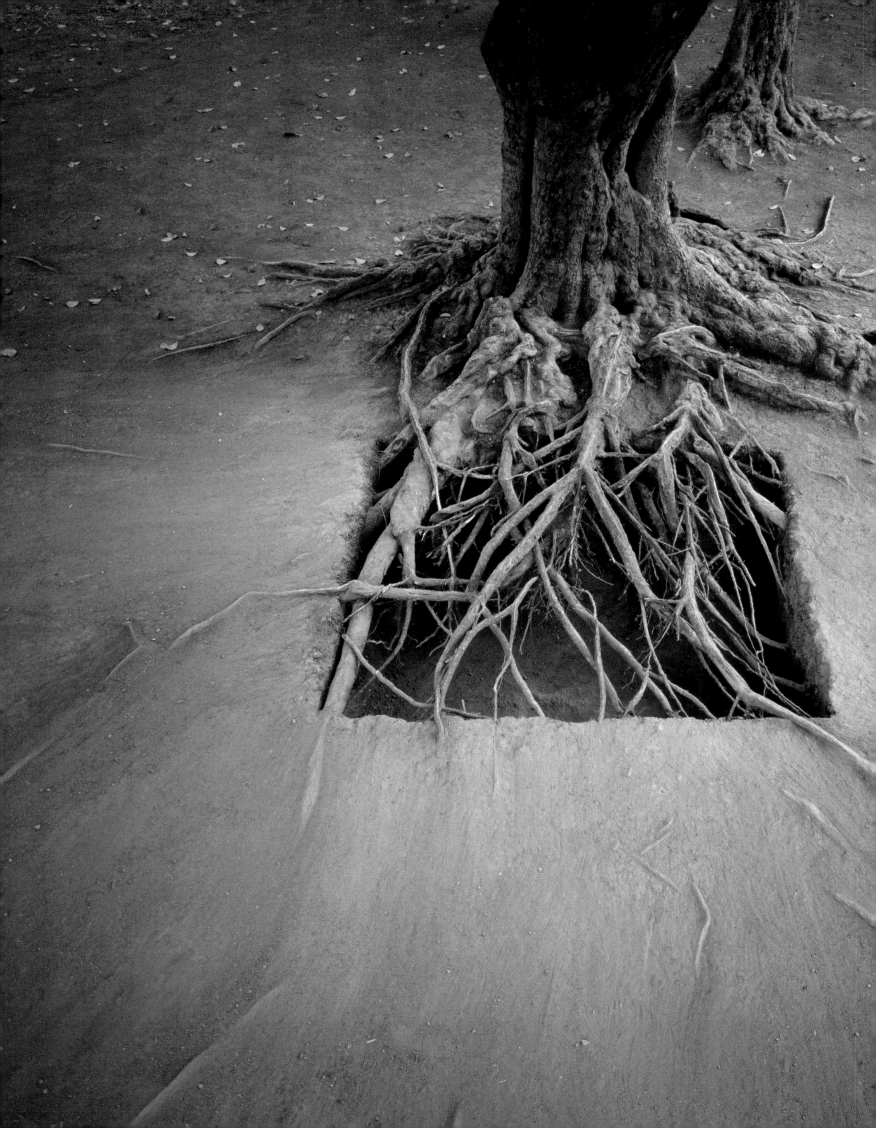

roots

It was towards the end of the dry season. It had hardly rained for months. The earth was nearly as hard as concrete. We had to proceed very carefully so as not to damage the more delicate roots. Seven people dug, scraped, and shoveled the earth for a week. After the photograph was taken the hole was, of course, filled in again.

ROOT–SCULPTURE

Parque Chapultepec,

Mexico City, Mexico, 1995

PINE STUMP, MORNING

Auvergne, France, 2000

(below)

FRAMED PINE STUMP, MORNING

Auvergne, France, 2000

(below)

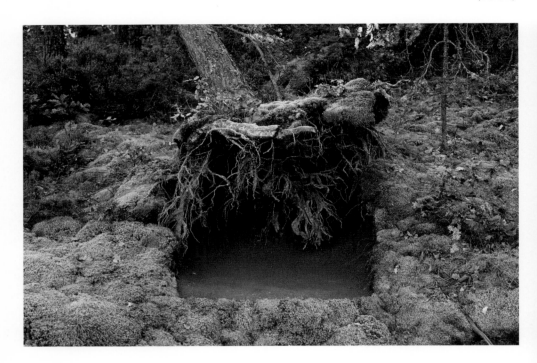

A walk through the wood.
I looked everywhere. Wherever I glanced, I saw a potential project.
Often, I begin by looking upwards. I follow the tree trunks upwards,
into the branches, into the sky. If only it weren't so complicated
from a technical point of view, I would love to work up there, in the trees…
Further on, I found a pine tree that had been nearly blown over during
a storm. Although the roots had mostly been torn out of the ground,
thickly carpeted with moss, the tree seemed somehow to have survived.
We removed the clods of earth and tatters of moss that were
hanging in the roots. Then we smoothed the earth beneath
and straightened out the mossy edges of the hole.
Later, we hung a frame made of peeled hazel sticks and
twigs, bound together with willow switches, around the roots.
In the dazzling morning sun, the dark, smoothed-down earth
contrasted with the weave of the roots and the fabulously
manifold forms of life on the forest floor. Is anyone today interested
in twenty square feet (2 m^2) of forest floor in the morning sun?
Its roots are ours, its fate is ours.
Its life and death are our life and death.

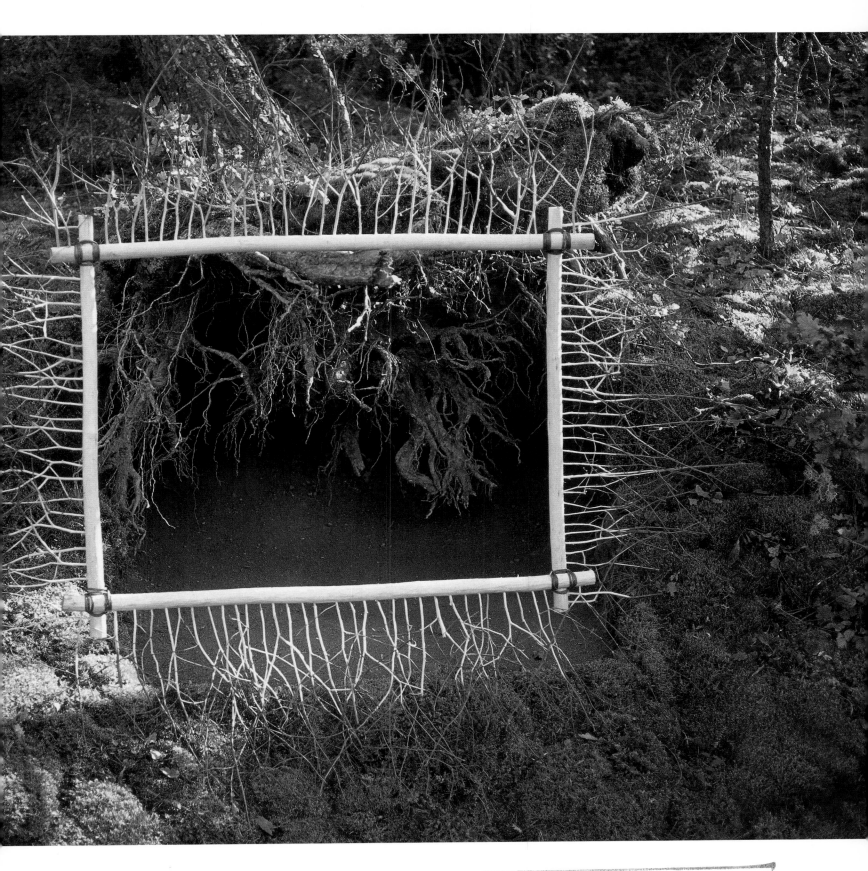

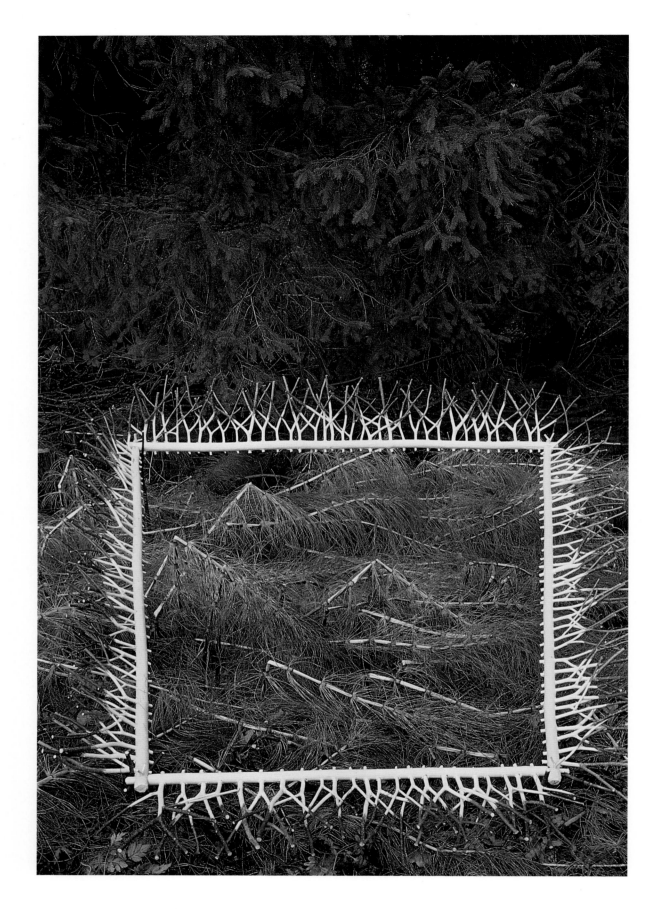

HORSETAIL PICTURE I

frame of hazel branches with part of the bark removed

Samerberg, Chiemgau, Upper Bavaria, Germany, 1996

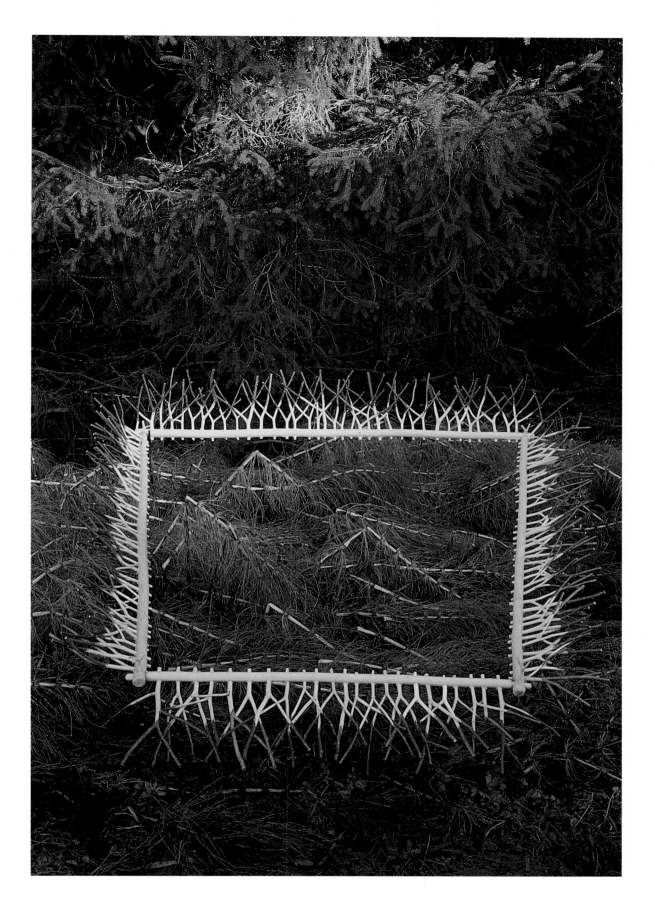

HORSETAIL PICTURE II

frame of hazel branches with part of the bark removed

Samerberg, Chiemgau, Upper Bavaria, Germany, 1996

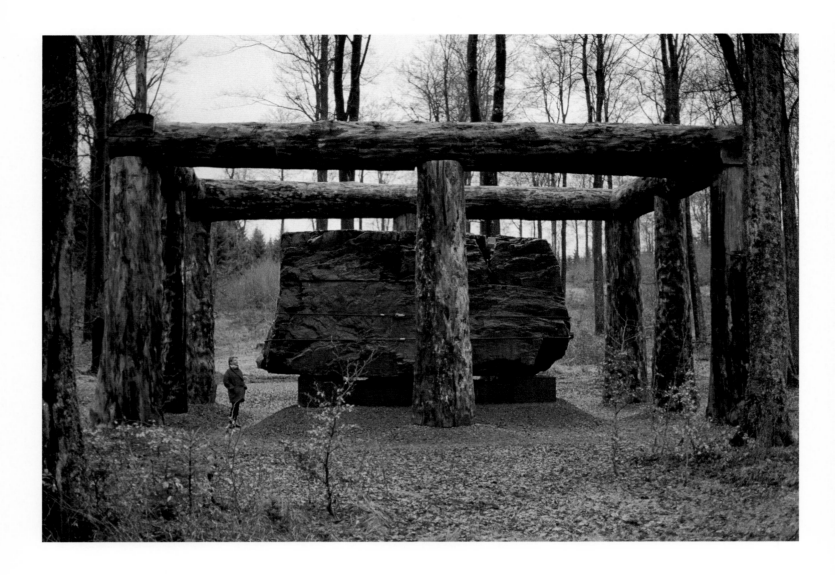

stones

STONE–TIME–MAN

quartzite monolith weighing around 150 tons,

fir trunks blown over in a storm

Forest Sculpture Trail, Wittgenstein-Sauerland,

Bad Berleburg, Germany, 2001

Fragility and temporality of human existence.
I discovered the stone in a quarry, where it had been
broken from the cliff face long ago, and now awaited
its charge of dynamite. On seeing such a monumental
block of stone, I was faced by unavoidable thoughts
and sensations; I wanted to become as unobtrusive
as possible. The stone remained unworked. I created
a space for it in the bright beech woods, where it would
be both protected and on display. Here it rests, propped up,
surrounded by columns of mighty tree trunks whose huge
dimensions echo the monumental nature of the stone.
I fetched the mighty fir trunks one by one from the
foresters' stockpiles of storm-damaged
wood in the Black Forest.

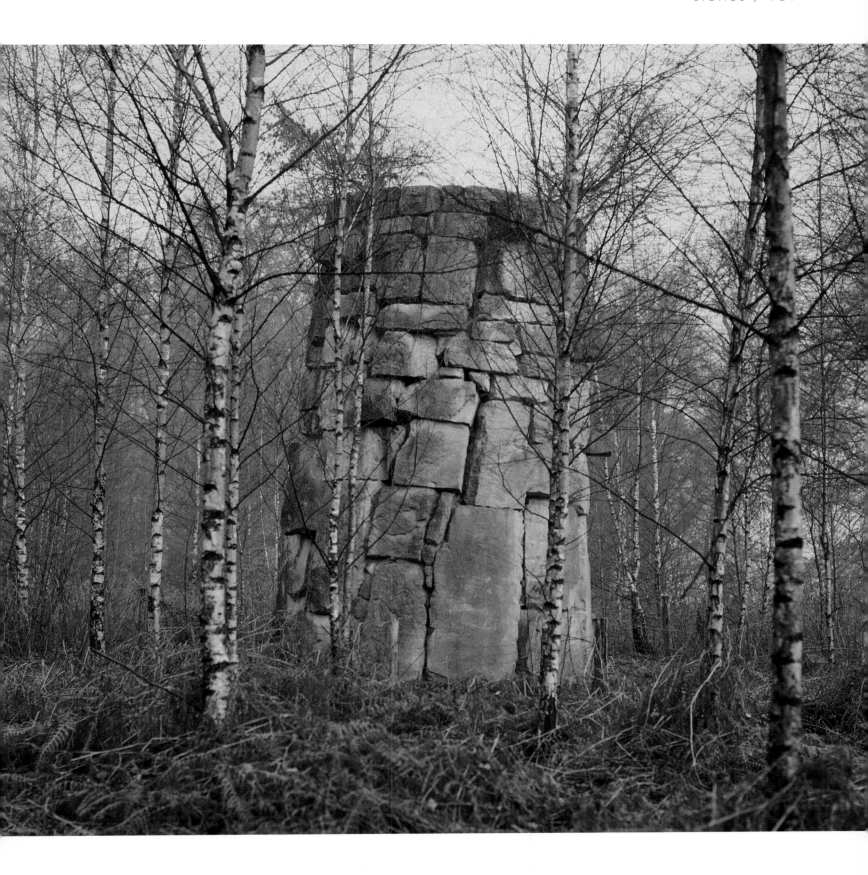

TOWER

Bentheim sandstone

Nordhorn, Germany, 1982

On the Island of Cres in Yugoslavia.
We spent a night on the coast in tents,
lying on scant mattresses of foliage and grass
that barely padded us against the rock-filled soil.
After a sleepless night, very early the next morning,
I discovered some strangely shaped cliffs.
I rubbed the leaves of a nearby tree on part
of the cliff face.

UNTITLED

cliff face on the beach

rubbed with green leaves

Island of Cres, Yugoslavia, 1988

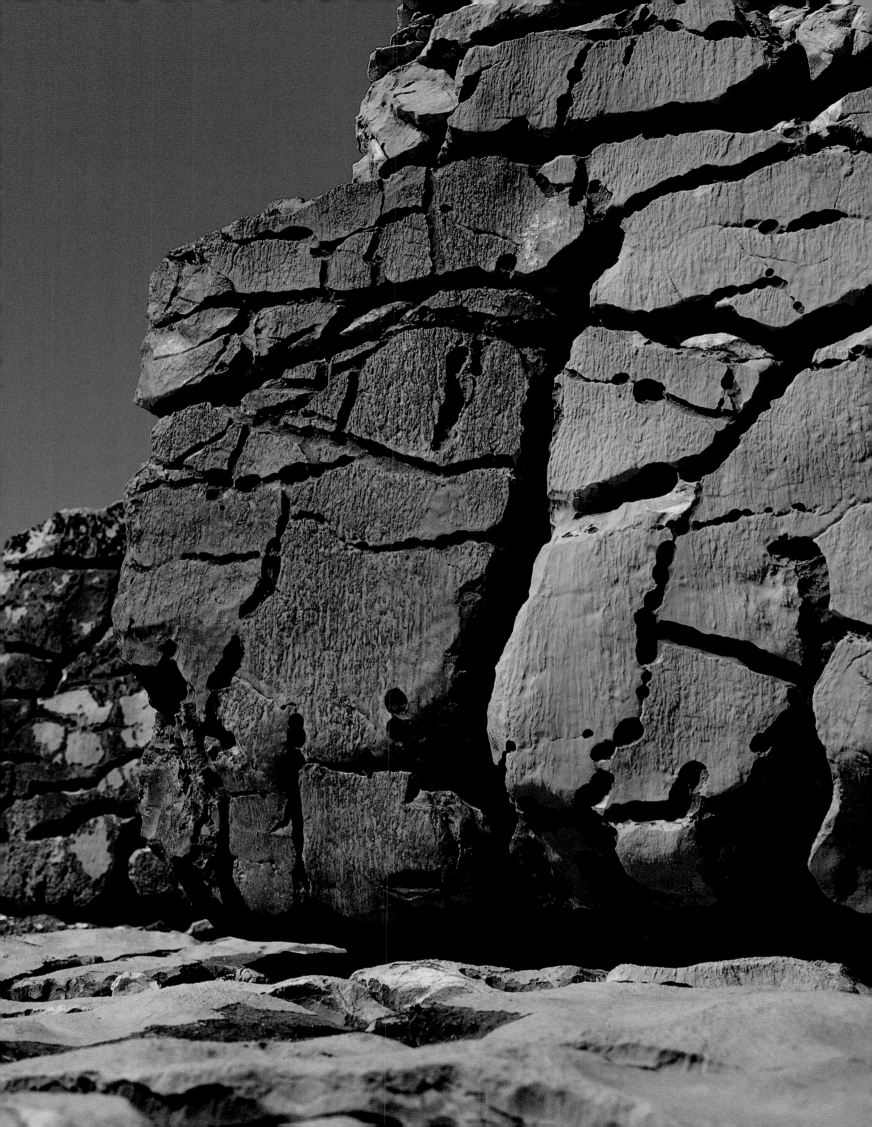

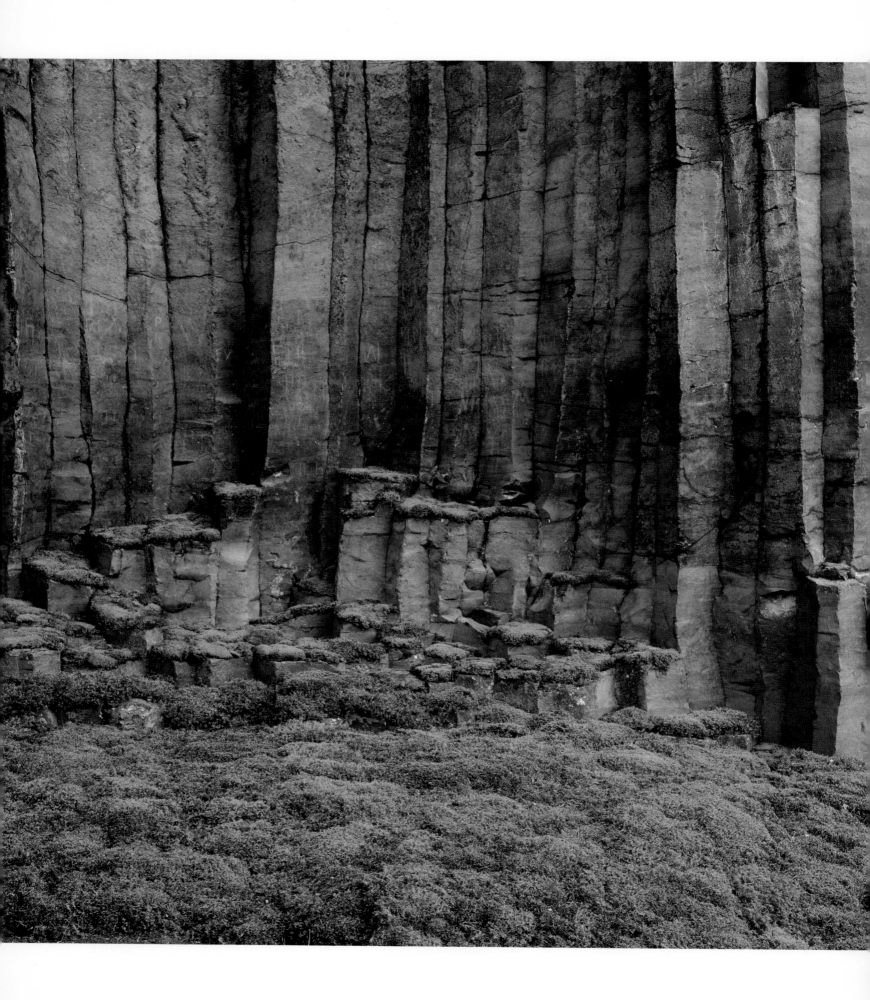

UNTITLED
basalt columns, moss
Auvergne, France, 2000
(facing page)

UNTITLED
aggregation of stones
rubbed with green leaves
Tel Hai, Israel, 1987
(right)

Forests of gigantic basalt columns that tower up to the sky,
breaking through the impenetrable green canopy of leaves
in the ancient, primeval moss-forests...

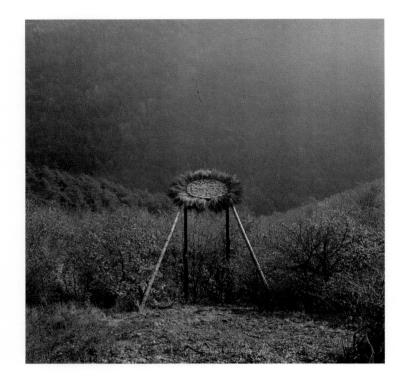

IN THE PARADISE GARDEN

spruce trunks, stones, and broom branches

Bad Münster a Stein-Ebernburg,

Germany, 1979

(above)

IN THE PARADISE GARDEN

spruce trunks, stones, beech branches, sunrise

Bad Münster a Stein-Ebernburg,

Germany, 1979

(facing page)

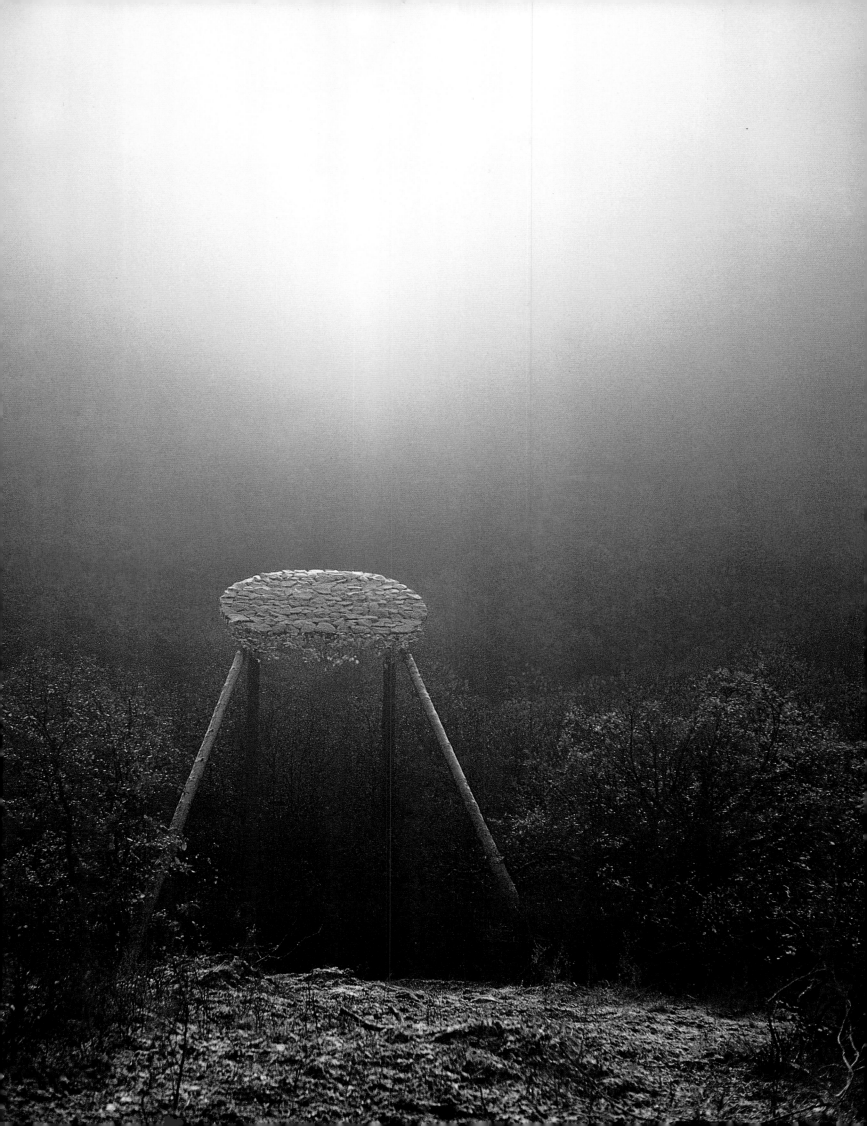

snow

Winter in Chiemgau.
On the edge of the forest I found a bush
with red guelder rose berries. I gathered the berries
in a container, and pressed the juice out of them.
Later, in the forest, I came across a small hollow
in the snow. I made a few snowballs dyed with
the berry juice, and laid the red-stained orbs
in the hollow. Then I made a garland from
some nearby brambles that were still green,
and laid it round the nest.
When I had taken the photograph, I watched
as the red slowly sank into the snow.

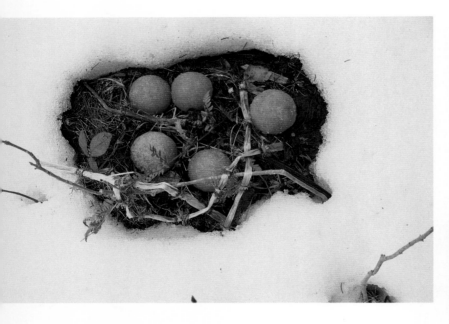

WINTER NEST

snowballs dyed with guelder rose berry juice

Upper Bavaria, Germany, 1996

(above)

WINTER NEST

snowballs dyed with guelder rose berry juice

Upper Bavaria, Germany, 1996

(right)

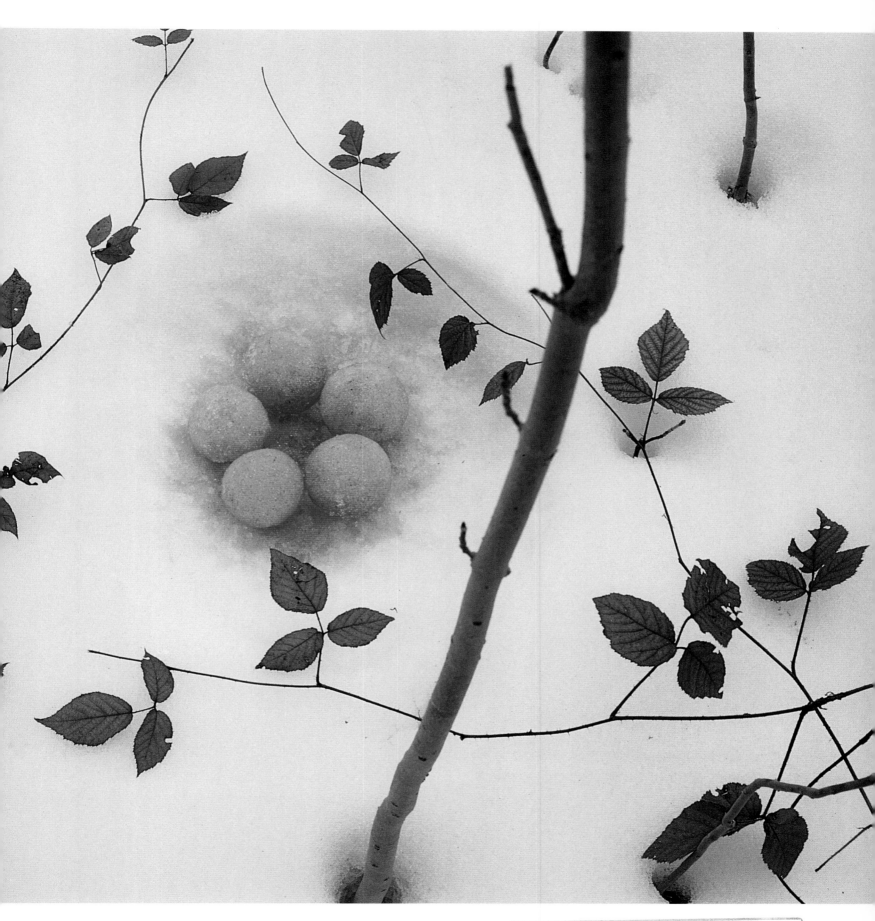

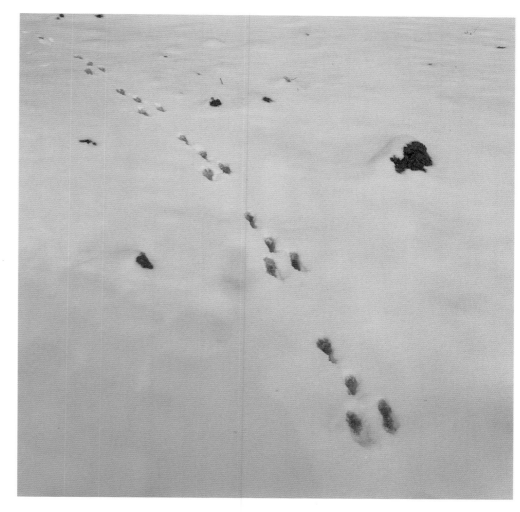

UNTITLED

hare tracks in the snow,
guelder rose berry juice
Upper Bavaria, Germany, 1983
(right)

UNTITLED

wild garlic leaves, snow dyed with
the juice of crushed wild garlic leaves
Upper Bavaria, Germany, 1984
(facing page)

Green snow.
Spring in Chiemgau. The broad green leaves
of the wild garlic were already growing in thick
clumps in the fields by the streams.
Once again there was a very late, heavy snowfall.
White snow on green leaves.
I dyed the white snow with the green juice
of the shredded and pressed wild garlic leaves.

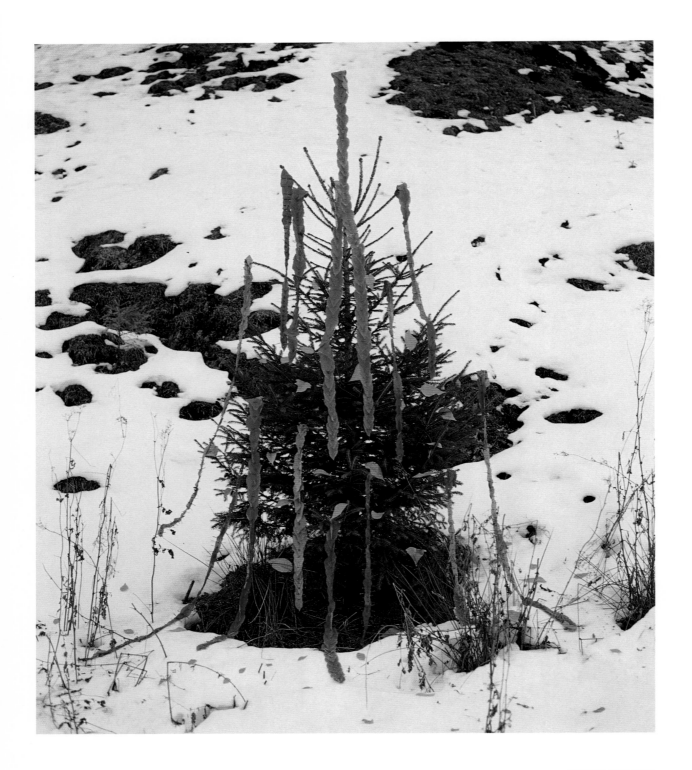

WINTER SPRUCE I

Chiemgau, Upper Bavaria, Germany, 2000

(above)

WINTER SPRUCE II

Chiemgau, Upper Bavaria, Germany, 2000

(facing page)

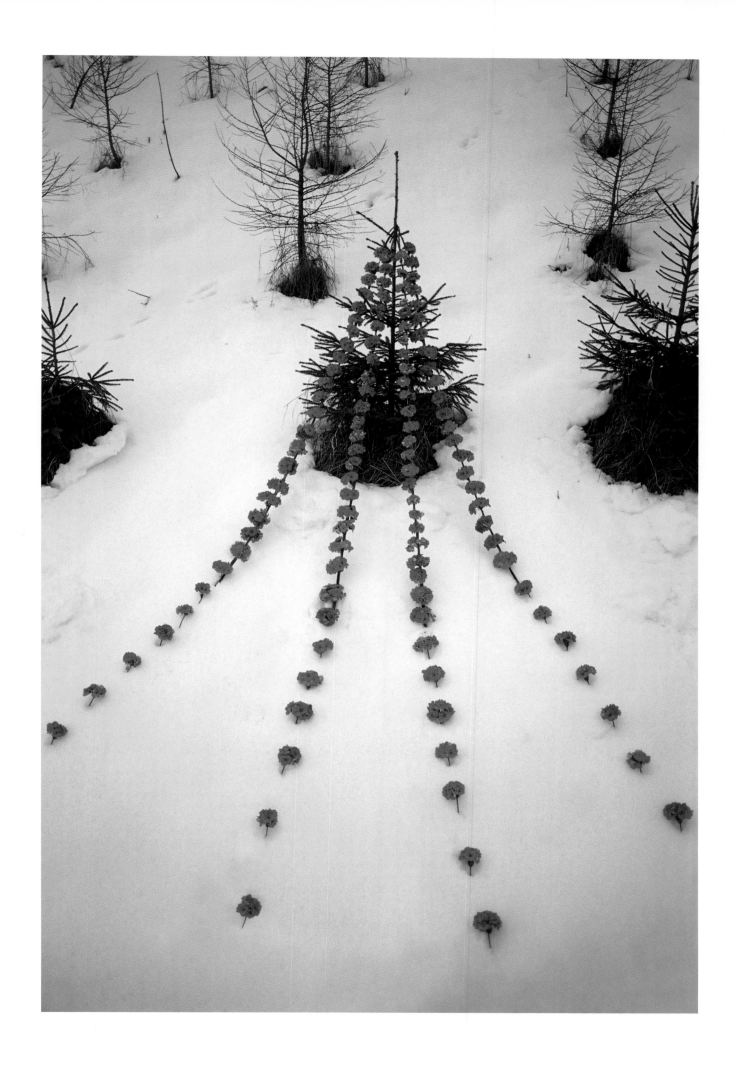

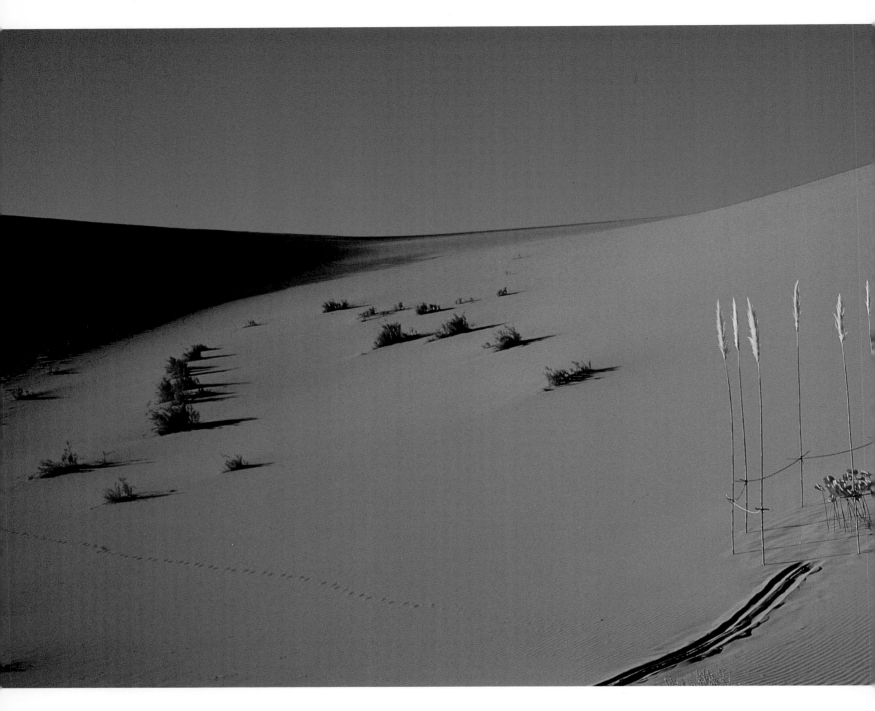

desert

*At the ends of the earth, lost in the immensity
of the mountainous red sand dunes of Namibia.
Not a breath of wind, not a sound.
The tracks of a solitary gazelle crisscross the huge,
immaculate hollow at the foot of one gigantic sand
dune. The shadow of the late afternoon sun draws
closer, ever more rapidly. One of the works created
in the Namib desert for a film, shot for the launch
of the perfume Mahora by Guerlain.*

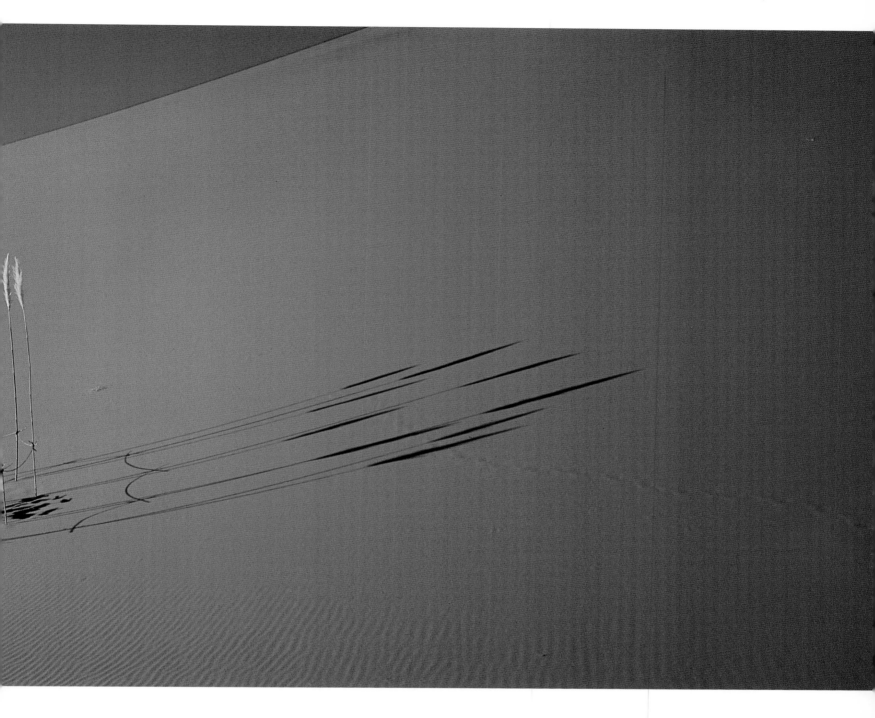

UNTITLED

pampas grass, bamboo stalks, anthurium

work created for a film to mark the launch

of the perfume Mahora by Guerlain

Namibia, 2000

Namibia. In one of the oldest deserts in the world.
By walking first on the right, then the left-hand side
of the ridge, my son August managed to plant
a row of pampas grass along the perfect line
of the top of the dunes, to the horizon,
without leaving a single trace of his presence.
This was one of a series of works produced for
a television advertisement for the perfume Mahora
by Guerlain.

UNTITLED

sand dune, pampas grass

work created for a film to mark the launch

of the perfume Mahora by Guerlain

Namibia, 2000

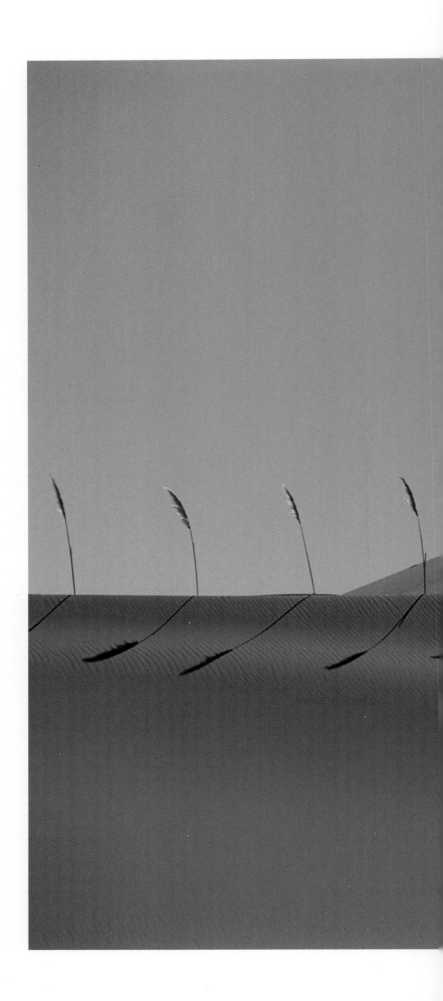

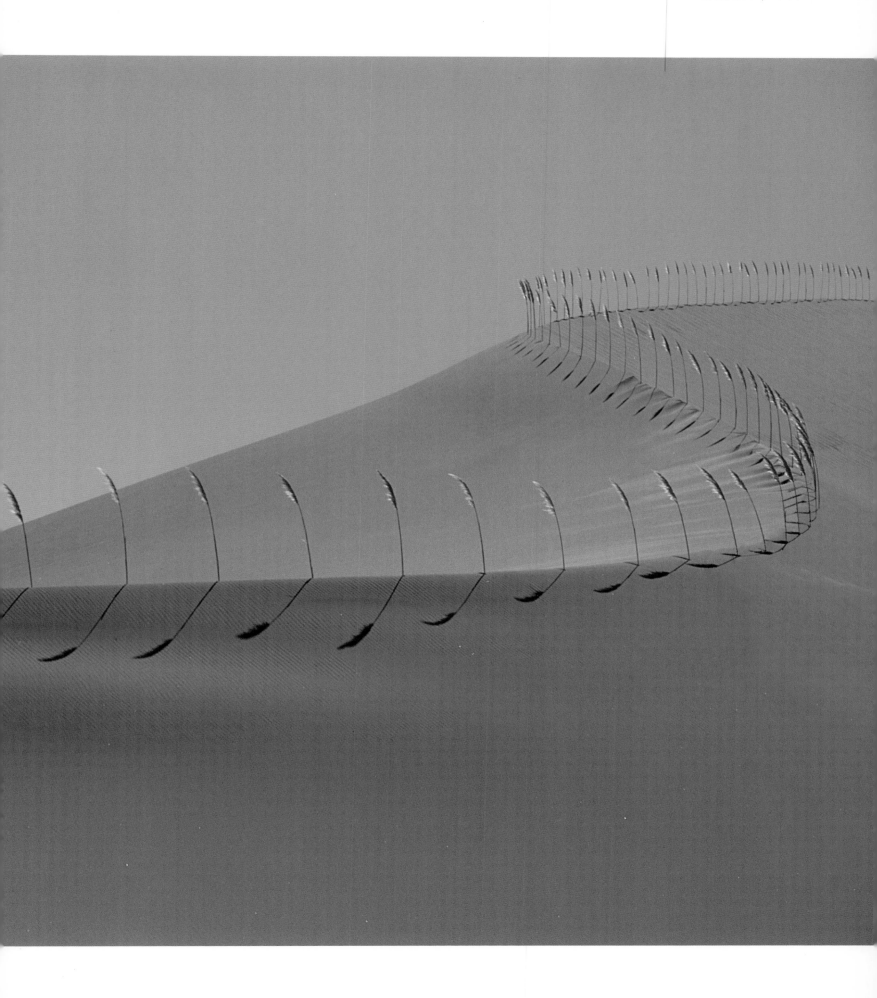

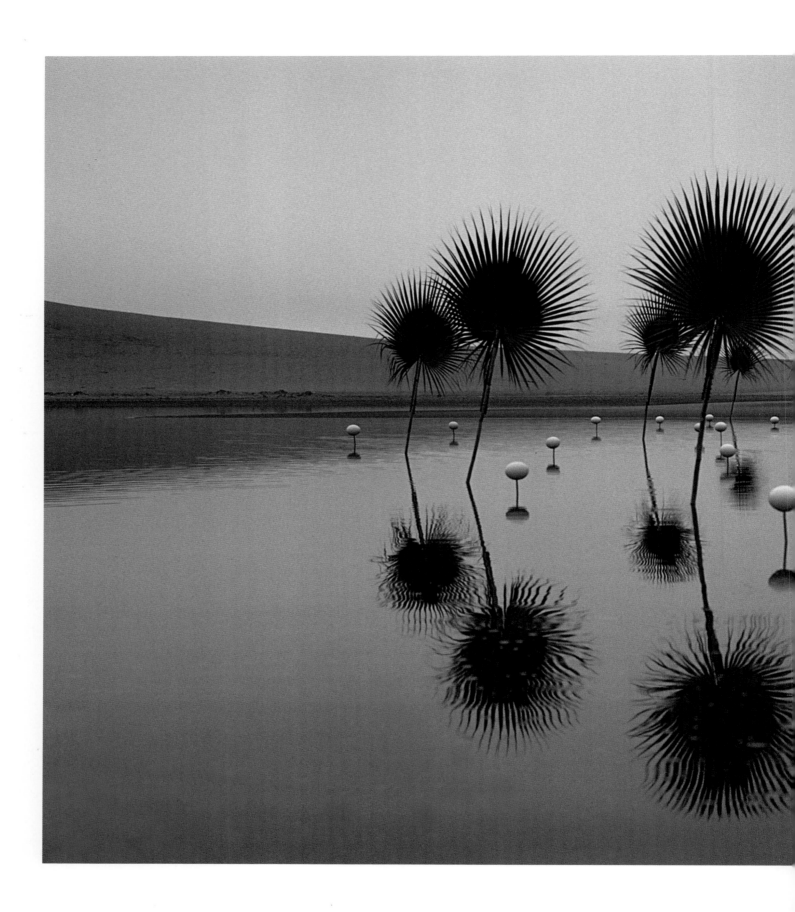

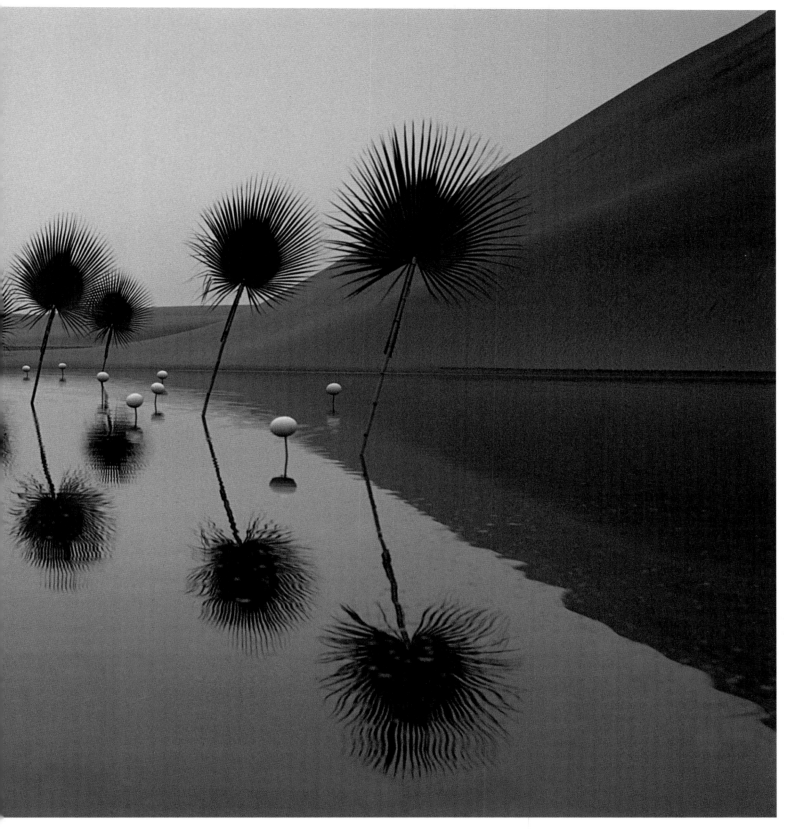

UNTITLED

palm leaves, bamboo stalks, ostrich eggs

work created for a film to mark the launch of the perfume Mahora by Guerlain

Namibia, 2000

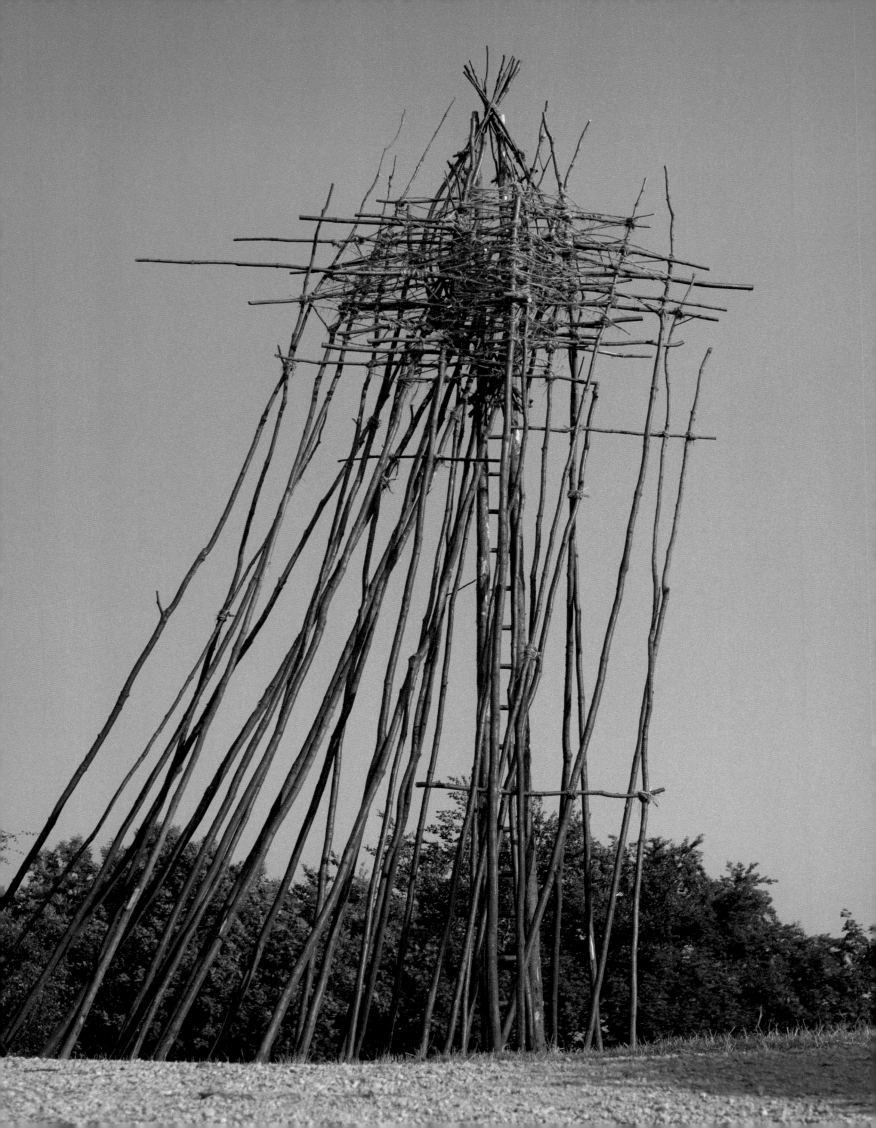

Hubert Besacier / the artist within nature

RAIN TOWER
red oak poles, spruce trunks,
hazel sticks, traveler's joy
Schlossberg, Freiburg, Germany, 1983
(facing page and right)

From the dawn of mankind, our destiny has been dependent on nature. Yet in art, the notion of the landscape is relatively recent. The idea rapidly evolved beyond principles of straightforward representational art, and was taken up by mid-twentieth century sensibilities. Nils-Udo's work is characteristic of this development. Over three decades, his creations have become emblematic, their significance transcending notions of artistic categories and geographical boundaries.

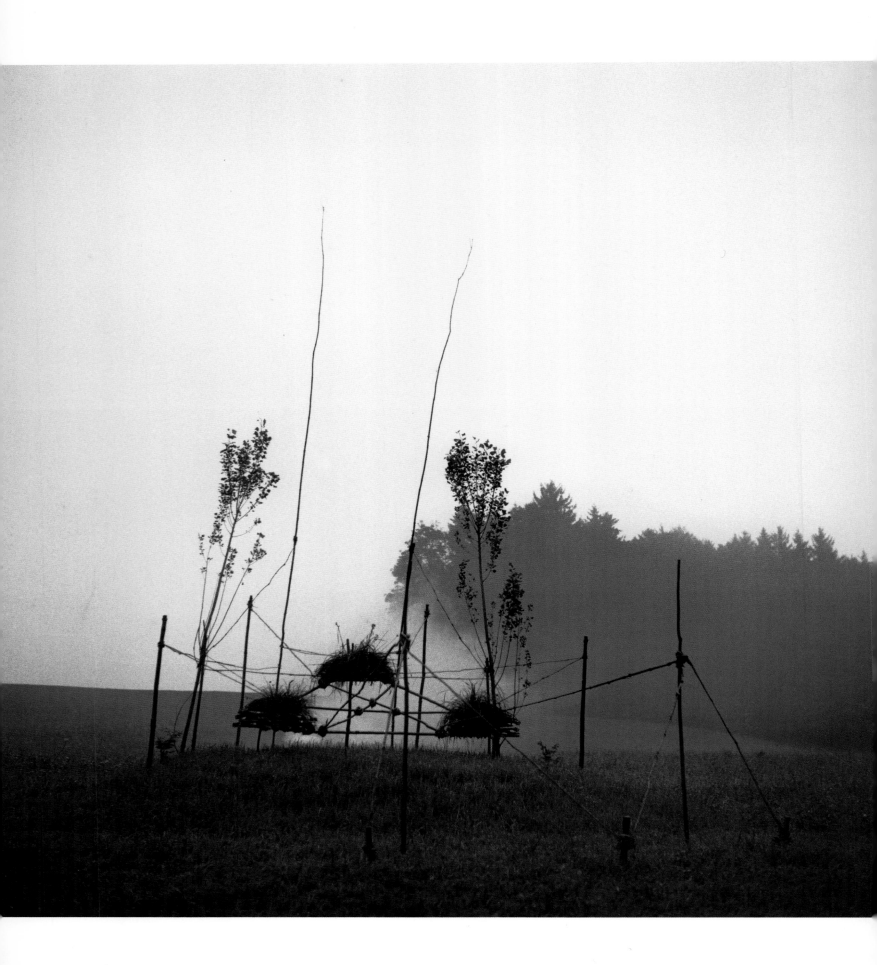

the art of landscape

It was in the season when trees bloom,
Bushes put forth leaves, meadows turn green,
Birds sing sweetly in their language at dawn...

Chrétien de Troyes, *Perceval* (1180)[1]

From the early 1970s, Nils-Udo summed up his artistic activity with the phrase *Natur–Kunst–Natur* (Nature–Art–Nature). Generally, in our Western civilisation, the juxtaposition of the two words "art" and "nature" automatically brings to mind the imitation of nature through art. From this angle, nature is first and foremost a cultural phenomenon, most often identified with the concept of the landscape. The landscape is always viewed through the prism of art, to the point where what we seek in nature is, above all, a correspondence with the image art has implanted in our minds and senses of perception. For the artist's vision is primarily aesthetic, and thus implies a process of selection. He frames the image, and thus orders it as he sees fit; he attempts to decipher it, to establish a certain coherence, and in so doing, he creates a composition. The work is the reflection of a desire to construct an image—in terms of how it is centred, if nothing else—which would translate the artist's vision, which could then therefore be shared. Often, on country walks, immersed in culture as we are, we react to the sight of Nature by a comparison to Art: thus we might say that a fragment of Nature is as lovely as a Poussin, a Turner, or a Corot. This prompted Oscar Wilde to write in his *The Decay of Lying* (1889), not without a deliberate touch of provocation, that "Nature imitates art." Without going quite so far as to accept the categorical conclusions of this piece of wit, in the end we are forced to concede that our vision of the landscape is highly dependent on our cultural environment. The fact that during the nineteenth century, land-scape painters tried to work directly from nature—with experiments such as painting in the open air, the work of the artists' colonies at Barbizon and Skagen, and so on—does not change this fundamental truth. When the first colonial artists set up their easels in the Australian outback, they produced

1 From: Roger Sherman Loomis and Laura Hibbard Loomis, trans. and ed., *Medieval Romances* (New York: The Modern Library/Random House, 1957), p. 123

HOMMAGE À GUSTAV MAHLER
hillock, poplar and grass plantings,
ash poles, hazel sticks, traveler's joy, fire
Chiemgau, Upper Bavaria, Germany, 1973
(facing page)

From my very first projects in and with nature in 1972, plantations were the central part of my work.
First of all, I began by leasing land from farmers in my home region, Chiemgau in Upper Bavaria. On these patches of land, I carried out a series of projects in the early 1970s, involving earth modeling and plantations with trees, bushes, lawns, and flowers, sometimes over a wide area.
The idea of planting my work literally into nature—of making it a part of nature, of submitting it to nature, its cycles and rhythms—filled me on the one hand with a deep inner peace, and on the other with the thought of seemingly inexhaustible new possibilities and fields of action, putting me into an almost euphoric state of readiness for new departures.
I lived and worked as part of nature, living day to day to her rhythms and under the conditions she imposed. My life and work were united. I was at peace with myself. The decade-long, comparably abstract struggle in front of the canvas with the subject of my life, nature, was now past. Nature's room itself was to become my art space.
I did not know any artist whose subject was living nature in such a comprehensive, fundamental sense and that included all the natural phenomena that humans are receptive to: not the minimalist work of Richard Long, and even less so, the works of American Land Artists, who were often fairly indifferent to the vitality inherent to nature.

historical landscapes in the style of Constable or Turner, or else Italianate scenes influenced by Claude Lorrain. (And in fact, are not Turner's works a transposition of Lorrain's Italian landscapes to the English countryside?). Since the nineteenth century, amateur artists have sought in nature the model of a style of landscape already inscribed in the Western artistic tradition. Thus, although landscape painting as a phenomenon is limited in terms of art history to the period stretching from the fifteenth century to the end of the nineteenth century, from Patinir to Cézanne, it has become a screen between nature and the onlooker, altering his perception. (Of course, this interaction of art and nature implies that conversely, many landscapes have been altered to resemble the works of famous artists). But if we wish to take a step back from the notion of art as imitation and dissociate the concepts of nature and the cultural notion of the landscape, the question takes on a new dimension.

man's attitude to nature

In the broadest sense, the concept of nature implies the existence of living cycles, geological and vegetal, each with its own temporality but dependent on the other. The time scales of these two cycles are also very different from the cycles of animal life and human existence. The rhythms of evolution and change of these geological and vegetal cycles are an inevitable reminder of the finite nature of our existence and the brevity of our life pulse. This is probably why we have such a powerful fascination for the plant kingdom. Because its cycle includes our own demise.

For many thousands of years, natural phenomena terrified mankind, but can we doubt that they were also a rich source of aesthetic pleasure? Mankind's attitudes toward nature have been contradictory from one era to another. Everything beyond our control is unsettling, "wild." Oceans, mountains, forests: untamed nature is a source of fear. It was not until the pre-Romantic period that the first attempts were made to live in communion with nature in all its guises, including the most untamed. It was this relationship with an imperious Nature that demanded fear and respect—thus reminding men of their brief and hazardous passage on earth—that gave rise to the notion of the sublime.

Above all, we must avoid the belief that aesthetic experiences can only be transmitted through the prism of art or culture, or simply (as one sometimes reads) that aesthetic experiences are only available to people

WORK IN PROGRESS IN A GORGE
Alps, Chiemgau,
Germany, 1972

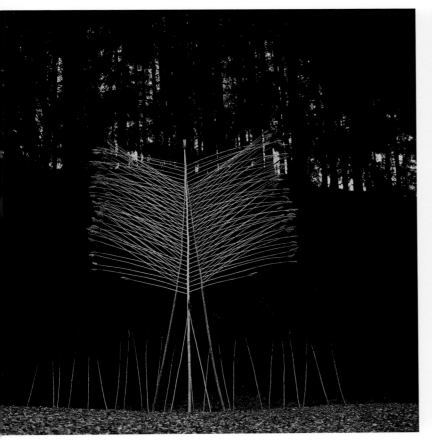

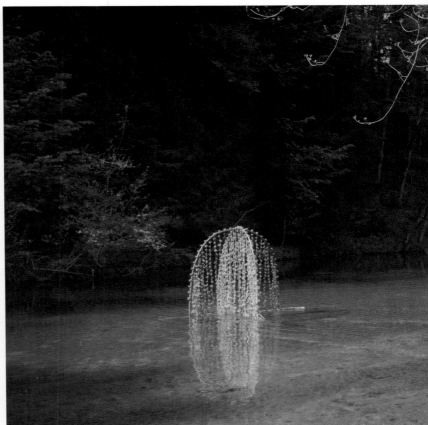

who have attained a sufficient degree of cultural awareness. Because landscapes are a human invention, aesthetic experiences are often a part of human existence that must be separated from the narrower domain of art. They can be experienced and felt through contact with natural phenomena.

Unless we adopt the viewpoint of the creation myths of Genesis, where nature as a creation presupposes a supreme artist-creator, nature and natural phenomena—if not organized, modified, started, or controlled by man—cannot be considered as works of art. Independent of man's gaze, nature is neither beautiful nor ugly. If we consider the concept of beauty from this perspective, nature, independent of man's aesthetic judgement, is indifferent, an-aesthetic. Nils-Udo interprets this concept as follows: "Nature is neither beautiful nor hideous. Nature is so self-evident that it makes our impotent little categories obsolete."

Beyond the idea of art in the traditional, mimetic sense of the term, there is every reason to believe that man has always taken an aesthetic approach to nature. It is an aesthetic attitude or process, passive or dynamic, which can be limited to straightforward contemplation, or which can push us to dare to reach out to nature, to immerse ourselves in it, to attempt to create a kind of pantheistic communion, to seek out a place conducive to meditation or in which we can confide our doubts and our secrets. This is the hidden meaning of the walk.

MARCH ALTAR
ash poles, reeds, traveler's joy
Priental, Upper Bavaria,
Germany, 1981
(above left)

RIVER ALTAR
ash, hazel sticks,
traveler's joy, dandelions
Priental, Upper Bavaria,
Germany, 1980
(above right)

May in Chiemgau.
The meadows are covered in bright yellow dandelions.
Preparation: To build a raft in the shape of a cross, bind two branches of ash together with traveler's joy. Attach two bent hazel switches to the ash cross. Bind the hazel sticks with more traveler's joy to the point where the ash sticks cross. Cut holes in the hazel. Bring the raft to the riverbank.
Collect dandelions and thread the heads through the stalks to make a chain. Carefully hang the chains in the hazel struts, and set the raft adrift in the middle of the small river.
The moment was well chosen. In the late afternoon sun, the altar shone bright as it floated downstream.

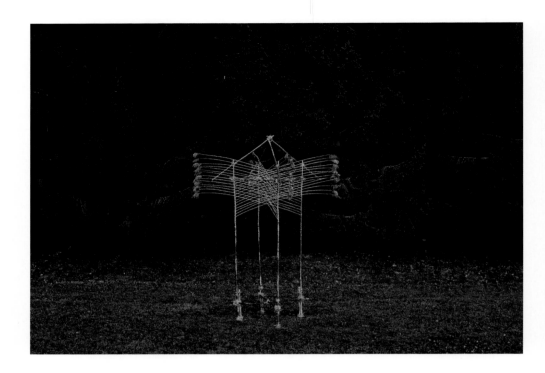

MARCH TOWER
ash poles, reeds, traveler's joy
Chiemgau, Upper Bavaria,
Germany, 1981

the walk

Of course, anyone can go for a walk, but it can also be a starting point for
all the domains of creative activity: poetry, literature, art, music. From
Petrarch's bucolic poetry composed as the poet meditated at the source
of the river Sorgue, to Wordsworth's *Lyrical Ballads*, Jean-Jacques Rousseau's
Reveries of the Solitary Walker, Turner's watercolor notebooks full of Alpine
scenes or the banks of the Loire, Franz Schubert's *Winter Journey*, and
Wilhelm Müller's poems, the walk has inspired diverse creative works.

Man seeks himself in nature, and in nature he comes face to face with
himself. The feeling of otherness he experiences comes from the confrontation
with a living force. And yet contemplation and meditation are not the only ways
to experience an aesthetic emotion in nature. Natural elements can be used
as a base for, or even as materials of, the creation of an aesthetic phenome-
non. Sometimes, during a walk, it is tempting to leave a record of one's pres-
ence. This can be anything on from a simple trace inscribed in the landscape
to the structured organization of a park or garden.

Leaving behind the inspired exaltation of the Romantic movement—
without wishing to repudiate its heritage—and forging a modern, pragmatic
vision under the positive angle of man's relationship with nature, we could
say that today, nature's enigmatic character and illusory familiarity in the
end always bring us back to humanity. Nature speaks of man because it
bears his trace, but also because of man's desire to work with nature. An
understanding driven by realism rather than feelings induces man to
become involved in a different way in the natural cycles discussed above.
Nature allows him to "find himself," to qualify his worldly existence. When this is
the work of an artist, he allows us not only to partake of this very private

experience, but also to break through the indifference we feel when we attempt a dialogue with nature by ourselves.

Today, art stands at the crossroads of these historical, cultural, existential, and concrete elements. The works of Nils-Udo awaken strong echoes in our modern sensibility, because they are based both on a solid cultural foundation and a clear-eyed appreciation of their situation in today's world.

contemporary creation and nature: walking the landscape

In the early 1960s, artistic trends underwent a decisive shift. The new generation of artists questioned themselves about the nature of reality. They expunged the temptation of pretense from their works, and tried to return to simpler actions and forms. It was the decade of minimalism, of Arte Povera. Some artists used their own bodies as an instrument, seeking direct contact with the audience during artistic events and performances. It was also the heyday of the call to return to the bosom of nature. Given this historical context, it seemed obvious that just as traditional artistic practices—and painting in particular—were being called into question, several young artists were attempting to return to primitive forms of the aesthetic experience, where the walker is in direct bodily contact with natural spaces. This was a general phenomenon, found on both sides of the Atlantic. Robert Smithson, Nancy Holt, and Carl André walked through the wide open spaces of North America. There was also an English school, led by Hamish Fulton and Richard Long, for whom the walk itself was the key element. But other artists, like Peter Hutchinson or David Nash, also worked with nature.

TABERNACLE
ash poles, willow sticks,
traveler's joy, snow
Chiemgau, Upper Bavaria,
Germany, 1980

Winter. Last few patches of snow in the shadowy corners of the wood.
An apple tree in the sloping meadow leaned over the lake, still partly frozen.
From the bushes on the edge of the wood, I cut long hooked twigs from suitable branches. Then I made a number of snow-balls and carefully pressed one onto each hook. I carried the freight down the slope, and hung the hooks in the branches of the tree.
The last dazzling rays of the sun before sunset.
The next morning.
Overnight, the snowballs froze to form balls of ice on the hooked twigs. I gathered them by their long stalks, and laid them out on the meadow.

In the 1980s, a new school came into being, spearheaded by Andy Goldsworthy, who followed in the footsteps of David Nash and Nils-Udo.

In the United States, during the 1960s and 1970s, these artistic practices gave rise to the Earth Art or Land Art movement, which implied a reshaping of the lay of the land, and the frequent placing of sculptures or installations in the landscape. The most famous examples are *Spiral Jetty* by Robert Smithson, *Sun Tunnels* by Nancy Holt, *The Lightning Field* by Walter de Maria, and *Double Negative* by Michael Heizer. The British artists were more interested in producing works that bore a trace of the path followed on the walk. The artist as rambler might leave signs of his presence, but these would be slight. They would leave traces of the body and its physical action, such as displaced rocks, traces of footsteps in the grass, bundles of branches, piles of stones—but would not use earth-moving machines as was the case in the American deserts.

Fulton and Long also produced photographic records of their work. Their large black-and-white shots are accompanied by captions and texts, and are framed, like more traditional art. They display the most characteristic elements of the landscape: the artist's interaction with it, the small, ordinary objects the artists would find daily on site, or the animals and birds they encountered.

Nils-Udo's living, evolving creations

It was in this very particular context at the beginning of the 1960s that Nils-Udo began his artistic career. Born in Bavaria, he spent his childhood in Franconia and the Tyrol, where he still enjoys taking long walks whenever he can. During his formative years, he was immersed in the two modes of aesthetic experience: the emotions and feelings of walks in nature along with the acquisition of a musical, poetic, and philosophical culture in the German tradition. At first, his artistic endeavors were entirely expressed through painting. The decision to work in paint led him to complete his training with a period of total immersion in French culture: his apprenticeship ended with a stay of nearly ten years in Paris.

Nils-Udo's knowledge of the two complementary cultures—French and German—was further enriched by the essential dimension of finding himself in unfamiliar surroundings. In all of his biographical chronologies, Nils-Udo has insisted on the important role played by his travels in his artistic development. He spent many years travelling through Europe, the Soviet Union, Morocco, and the Middle East. The year he spent in Iran at the end of the 1950s proved decisive. It was the key to his discovery of the glorious vastness of the desert landscapes and his willingness to explore non-European cultures.

With his painting, the first phase of Nils-Udo's artistic activity was typically representative, although as early as 1960, he turned away from figurative painting, adopting a more abstract style more in tune with his desire to get inside things rather than simply to "represent" them. Towards the end of his stay in Paris, he found himself in step with the current art theory. When he returned to Bavaria in 1970, he quickly adopted a literal interpretation of direct contact with nature. From 1972, he began to leave painting behind, preferring instead to work directly in and with nature. His work passed from representation to presentation. The credo of *Natur–Kunst–Natur* perfectly formulates his artistic engagement. Art comes from nature and eventually must return to it. Art is a mere transition between two natural phases.

By opting for direct interaction in and with nature, Nils-Udo fulfilled the requirement for honesty demanded by the latest thinking on art. Nature was just an instrument like any other: it was no longer a model, a subject to be imitated in another medium, but rather became itself the object of aesthetic activity.

UNTITLED
apple tree, snowballs on twig hooks
Vassivière, Limousin, France, 1987

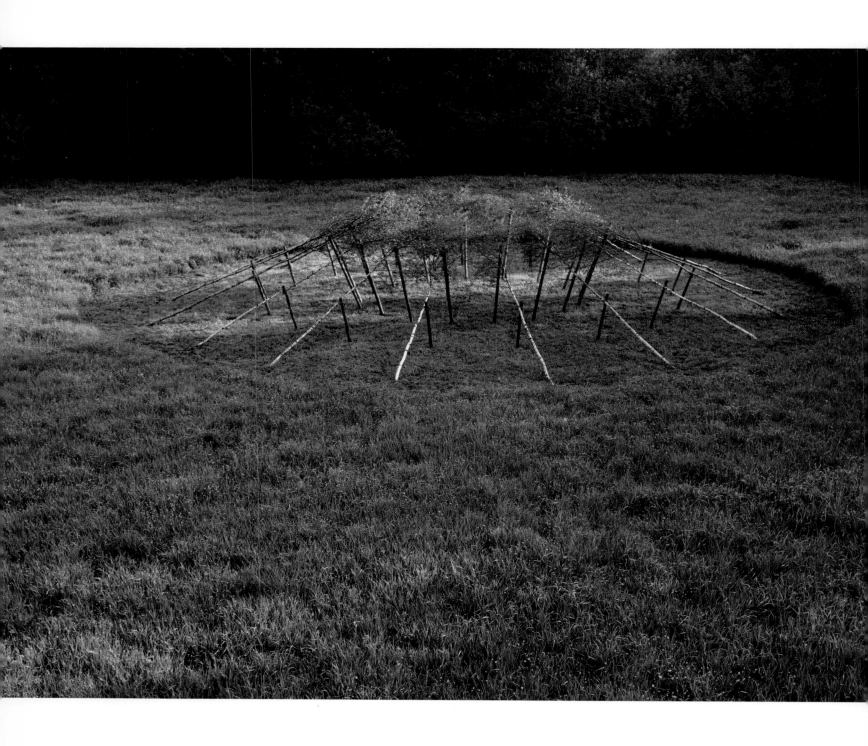

Planting birches.
In a lonely, hidden water meadow in Chiemgau, capture and fuse the endless beauty of all the tones of green of a May morning. The black-green of the shady forest. The blue-green of the meadows wet with dew. The gold-yellow of the first rays of the morning sun on the freshly mown circle in the meadow. The delicate yellow-green of the new birch foliage. The May-green call of the cuckoo.

I can't think of anyone who could render these precise tones of green today. Admittedly, such timidity is nothing new. Painters have always shied away from the color green, like the devil from holy water.

Even today, they avoid honest, bright tones of green like the ones produced by nature. Nature is neither beautiful nor ugly. Its evidence makes our impotent little categories obsolete.

A few months later, my plantation was poisoned by persons unknown.

from sculpture to image

During this first phase, Nils-Udo worked primarily in sculpture, but used the tools of the gardener or landscape designer. If we compare his work to that of the aforementioned Land Artists, his originality was to use the living vitality of nature itself as part of his production. His role as an artist was to use space. He planted and implanted, carried out grafts, and tried to use his natural surroundings to bring about a form which would then carry on as a living organism.

plantations in the 1970s and 1980s

In the countryside of the Chiemgau region of southern Germany, Nils-Udo leased land and meadows where he reshaped the land, planting trees and other plants, which, as they grew, altered the work's appearance. These sculptures did not just involve the life of the plants. They were carefully planned *in situ* to share in the geological and climatic existence of the location. This brings into play one of the meanings of the word "ephemeral": the material that the artist works on and with is alive. It takes place within a developmental context; it is itself destined to evolve, to develop, to undergo a transformation, and to end up fusing once more with the milieu where it began. These works require not only the artist, but also the spectator to get out into nature to be able to visit them. The visitor must put on a stout pair of shoes fit for a country walk, and in his turn tour meadows and forests to explore the sites. The art lover might be fortunate enough to come across a herd of deer that have sought refuge in the ring of silver birch trees that form the work *Hunger Meadow* (Hungerwiese, 1975), catch the last rays of the setting sun as they shine at the equinoxes through the collection of wood of the *Sun Sculpture* (oak, ash, spruce, and willow, 1979), or watch the shreds of mist—caught on a triangular trestle crowned with spruces—melt away.

The works that the walker comes across are in perfect symbiosis with the environment, and yet they do not exclude the human aspect. The title *Hunger Meadow*, borrowed from the name of a hamlet on the edge of a stretch of woodland, implies that the artist is perfectly aware of the relationship that has always existed between the local inhabitants and the nature they depend on for their livelihood.

The sculptures change according to the rhythm of the seasons and the weather conditions. They flower, grow foliage, and change color. When their cycle of greenery is over, the site is taken over by snow, and the water it contains is turned into ice, like in the work *Water Nest* (Wasser–Nest, earth,

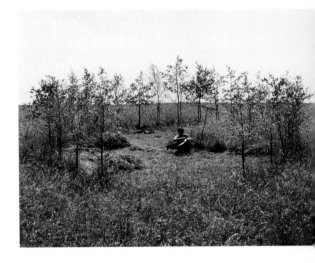

WORK IN PROGRESS FOR THE BIRCH PLANTATION HUNGER MEADOW
Chiemgau, Upper Bavaria, Germany, 1975
(above)

PARADISE GARDEN, THE MORNING
birch plantation, spruce posts
Upper Bavaria, Germany, 1979
(facing page)

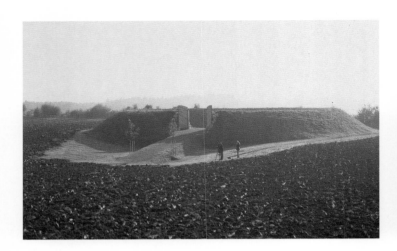 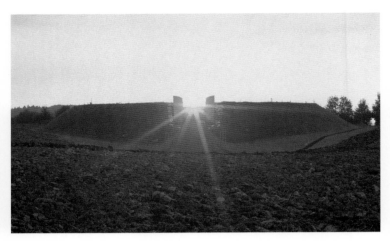

THE BLUE FLOWER
landscape for Heinrich von Ofterdingen
with threshing ramp and bavarian
sun sculpture for the equinox
Hermannsdorfer Landwerkstätten,
Glonn, near Munich,
Germany, 1995–1996
(above left)

THE BLUE FLOWER
landscape for Heinrich
von Ofterdingen, sunrise
Hermannsdorfer Landwerkstätten,
Glonn, near Munich,
Germany, 1995–1996
(above right)

grass, reeds, water, Chiemgau, 1976). Nils-Udo was also invited to produce works in other regions, where he made compositions using the materials he discovered there, imbuing his creations with the character and spirit of the site. He created installations designed to detect the movement of the tides as the level of the water rose and fell (*Water House*, Cuxhaven, 1982), or to follow the sun, or to play with rain and fog. He built sculptures for the wind, for streams, to underline the lay of the land against a backdrop of mountains, in forest clearings (*In the Paradise Garden*, (Im Paradiesgarten), Bad Münster am Stein-Ebernburg, 1979). Art was a game, where the aim was to combine in one configuration the life of nature and the mental forms of artifice—to make the alliance of the vegetal and the ideal seem self-evident.

rites and celebrations

Nils-Udo's vision of nature is based both on an aesthetic of contemplation and a total immersion in culture. Although his works play largely with the specificity of their environment, consisting exclusively of the natural materials found on site—rocks, wood, and plant matter—their actual physical layout generally adheres to the formal aesthetic canon which modern art has inculcated in us: simple, uncluttered forms, often geometrical (circles, triangles), linear structures that conform to the codes of graphic works or sculpture (*Sun Sculpture*, mountain peak in the Black Forest, 1979; *Wind Raft*, Chiemgau, Upper Bavaria, 1979; *Water House*, Maschteich, Hannover, 1980; *Rain Tower*, Schlossberg, Freiburg, 1983, among others). The deep-rooted cultural awareness indicated in the character of these works is also made explicit in their titles, which refer to the paintings of Caspar David Friedrich or Hiroshige, the poetry of Hölderlin, the writings of Goethe, Novalis, the Brothers Grimm, Heinrich Heine, or the music of

Schubert or Gustav Mahler. A sizeable proportion of Nils-Udo's works have titles that pay homage to these creative geniuses, or that contain explicit references to a specific a text, poem, or lied. His artistic life provides evidence of a number of recurrent sources of inspiration whose influence is unaffected by differences of period or evolutions in style. Examples are to be found in works such as *Hommage à Gustav Mahler* (Chiemgau, Upper Bavaria, 1973); *For Gustav Mahler* (Chiemgau, Upper Bavaria, 1976); *The Erl King* (Erlkönig, Sallenelles, estuary of the Orne river, France, 1990); or the *Valley of the Blue Flower* (Cahors, France), a direct allusion to Novalis's unfinished novel, *Heinrich von Offerdingen*. This Romantic masterpiece also inspired works such as *In the Paradise Garden* (Bad Münster, Chiemgau, 1979), *The Blue Flower*, landscape for Heinrich von Offerdingen (near Munich, 1995–1996), and *Novalis's Copse* (project for the University of Augsburg, 1998–1999). However, it must be noted that these cultural and literary references, borrowed for the most part from the Romantic movement, should in no way impinge on the viewing of the works they inspired. The cultural reference is no more than a pretext, a starting point, for works that are definitely of our day; the works do not presume any knowledge of this specifically German culture on the part of the onlooker—you and I. They are firmly grounded in today's world, they have a life of their own, and like any other work of art, they are receptive to any meaning or interpretation the viewer chooses to see in them.

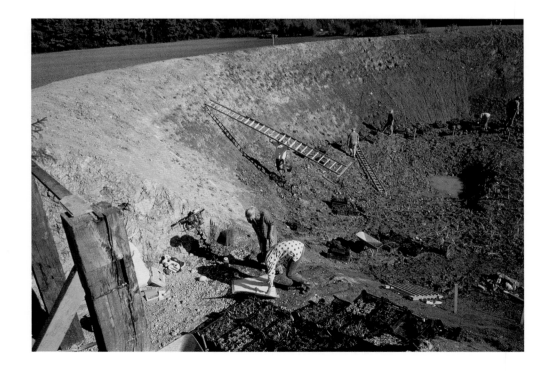

THE BLUE FLOWER
plantations for *The Blue Flower* project
Hermannsdorfer Landwerkstätten,
Glonn, near Munich,
Germany, 1995–1996

Nature is a living temple…

Charles Baudelaire

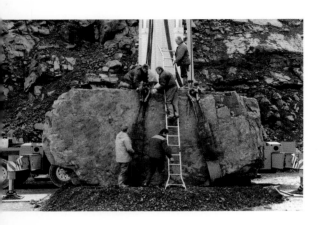

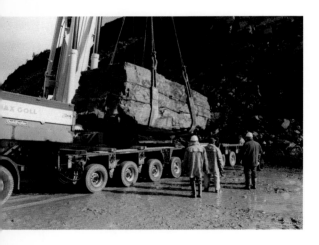

STONE–TIME–MAN
attaching straps to the quartzite monolith in
the quarry for the Forest Sculpture Trail
Wittgenstein-Sauerland,
Bad Berleburg, Germany, 2001
(above top)

STONE–TIME–MAN
transporting the quartzite monolith
from the quarry on a trailer
Forest Sculpture Trail, Wittgenstein-Sauerland,
Bad Berleburg, Germany, 2001
(above bottom)

These cultural references do, however, give an indication as to the inner emotion that nature inspires in the artist. Another typology of titles also forms a distinct group: one that assimilates the chosen locations and the living constructions he implants there with sacred sites consecrated for the worship of some pantheistic faith. *Winter Altar*, Chiemgau, Upper Bavaria, 1980; *River Altar*, Priental, Upper Bavaria, 1980; *Tabernacle*, Chiemgau, Upper Bavaria, 1980, and Dietenbronn, Bavaria, 1993; *March Altar*, Priental, Upper Bavaria, 1981; *Large Water Altar*, in the grounds of Pommersfelden castle, Bavaria, 1982—the list goes on. The use of fire, in the form of torches or votive flames (*Door*, Chiemgau, Upper Bavaria, 1980; *Large Water Altar*, on the edge of the forest, Chiemgau, Upper Bavaria, 1982; *Snow Fire*, Chiemgau, Upper Bavaria, 1981) as well as the frequent use of shapes reminiscent of doors, porches, veils, or hangings of leaves or flowers, add to this part-profane, part-sacred, religious atmosphere that draws heavily on the Romantic movement. This ceremonial aspect was evident into the 1980s, afterwards, it gradually disappeared: yet the magical aspect inspired by the Romantic world of the fairy tale remained as strong as ever. Apart from the recurrent themes of the door and the altar, another form of construction, which occurred very often indeed in this first phase of Nils-Udo's work, deserves mention here: elevated platforms and towers. Taking into account the ritualized appearance of the works of this period, we can see this as a metaphor of elevation. Elevation of the soul, exalting in the magnificence of the site; elevation of the work, built in homage to the grandeur of the myth of the landscape, and in affinity with it.

The doors, the porches, the mysterious paths that become entangled in moss and foliage, give a hint of what marvelous secrets lie beyond the image. The towers also open the visitor's perceptions to a different vision of the passage of time. We are transported into a universe where the faiths mingle and merge, where druidic altars stand next to votive constructions, incantatory structures (*Rain Tower*, Schlossberg, Freiburg, 1983), and fairy tale keeps, and there is a hint that all of these spaces, although there is no sign of human presence, are in fact inhabited. It seems as if, although in reality all we risk disturbing are a few deer, we might be intruding on beings from another world, who, just a few short instants before, occupied the very spot we are now standing in.

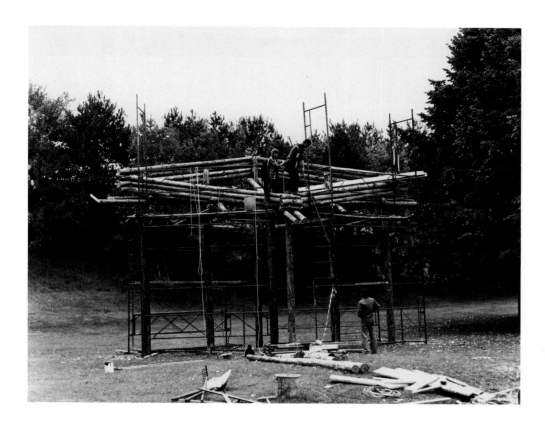

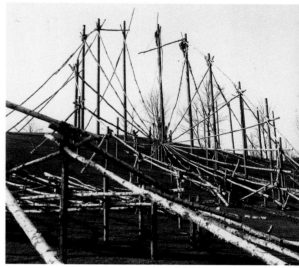

Nils-Udo's constructions, and the photographs that immortalize them (the role of the photographic image in this context is discussed in more detail later), take us to the heart of a mythical territory, a fairy-like world that is at of both Greek and Roman mythology (Pan, great god of nature), of animist civilizations where each natural element is inhabited by a spirit, of the courtly legends of Chrétien de Troyes and Gottfried von Strasburg—the world of Romantic dreams and the fairy tales of our childhood. All this is contained in the gigantic stone *Tower* (Der Turm, Bentheim sandstone and earth, approximate height of 21 feet (7.3 m), 1982) which Nils-Udo built in a forest clearing in Nordhorn in Lower Saxony—and on the summit of which, on the morning of the inauguration of the Second Sculpture Symposium, everything necessary for a mysterious banquet was laid out: chairs, a table, a white tablecloth, even the cutlery. Thus, it becomes clear that the concept of the rite is not intended in a narrow religious sense, but rather a much more pantheistic vision, in which festivities and celebrations enjoy a large share. Nils-Udo is definitely a *bon vivant*.

If the visitor returns to the clearing today, he will come across this massive monument in the heart of the forest like a relic of a former age, all the more impressive and strange since nature has reclaimed the space. By touching on the monumental in this manner, Nils-Udo seems on occasion to come close to the American Land Artists, who worked in the great open

WORK IN PROGRESS FOR THE PROJECT
THE FLYING FOREST
Parc de la Tête d'or, Lyon, France, 1984
(above left)

WORK IN PROGRESS FOR THE PROJECT
SPIDER
Munich, Germany, 1983
(above right)

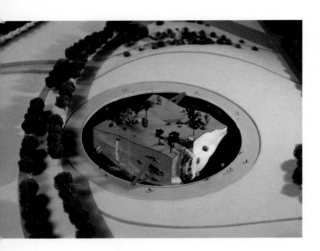

LANDSCAPES OF GERMANY
scale model for the international
landscape planning competition
Spreebogen, Berlin,
Germany, 1996–1997

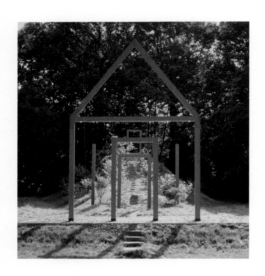

HOUSE
Troisdorf, near Cologne,
Germany, 1997

spaces of the United States. But it is clear that the context—the nature and the culture—of his installations is so different that no misapprehension is possible. Whatever the scale of the installation, at no point does it work against the landscape. In fact, the opposite is true: the creation adapts itself to the spirit of the site, and anticipates the development of the plant surroundings that will in the end give the work its definitive meaning. In 2001, some twenty years after his trail of forest sculptures in Wittgenstein-Sauerland (Bad Berleburg), Nils-Udo reworked the same type of monumental installation, but this time on an even more compact, massive scale, transplanting a quartzite monolith of 150 tons and framing the gigantic quadrilateral with a solid portico of pine trunks from trees felled by storms (*Forest Sculpture Trail*, Wittgenstein-Sauerland, Bad Berleburg). The title of this work speaks for itself: *Stone–Time–Man* (Stein–Zeit–Mensch). Once again, the encounter with nature reminds us that we are indeed part of the process of earthly cycles, and that by leaving a trace of human activity, our artifacts oblige us to face the fact that we belong to nature, while at the same time they remind us of our frailty. While a large part of the *œuvre* became increasingly light, affirming the move towards an ever more insubstantial materiality, the monumental creations are also an important aspect of Nils-Udo's work—installations in urban and peri-urban areas.

Such installations can simply highlight elements found on site, such as the sods of turf that seem to break free from the lawn in oblique slabs to fly to the roof of a nearby building (*Flying Turf!* Musée Zadkine, Paris, 2000), or a corner of forest elevated on a sloping, thirty-foot- (10-m-) high platform in a wooded part of the Parc de la Tête d'or in Lyon (*The Flying Forest*, 1984). Among the other works are large-scale mineral or plant installations inspired by the magic of fairy tales, such as *Sleeping Beauty*, created in front of the Museum National d'Histoire Naturelle in the Jardin des Plantes in Paris (1999). The works can even go so far as to recreate genuine landscapes from scratch, for example the *Novalis's Copse* at the university in Augsburg (1998–1999) or *Blue Wood* in Maglione, Italy (2001).

the death of the trees

Before the industrial era reached its height, the desire to tame nature was the source of a pitiless struggle. Man was persuaded of the omnipotence of nature, its capacity to regenerate itself, to reduce—in the shorter or longer term—all human endeavors to dust. In the end, nature would

reclaim her territory. But the demographic explosion and increasingly intrusive methods of exploitation of the land have shown that these old beliefs are likely to be proven wrong. Today, it is clear that human experiments have the potential to cause irreversible damage to nature. This new awareness obviously had an impact on the thinking of artists. It altered their attitudes and had an influence on their behavior and the directions they took in their work. As early as 1974, Nils-Udo, who has always been interested in tree species and the details of the plant life around him, observed—in Europe and around the world—that forests were beginning to die off because of atmospheric pollution and acid rain. In Germany and France— wherever his work took him—he found too many dead trees. In 1984, in the Somme estuary in Picardy, he created his first monument entitled *Death*, using dead tree trunks and large shreds of black plastic used in farming, like the sails of some funeral ship. This was the first in a series which also included *Raft* at Elancourt Castle in 1984; *Cross* in the Parc de la Villette in Paris, 1988, which used dead trees from the forest of Fontainebleau; and *Trees* (Bäume) in front of the Gasteig in Munich, in 1989. This pessimistic chain of thought had the potential to put an end to the creative activity of an artist whose sole matter was nature itself. But while Nils-Udo was sharply aware of the danger man was inflicting on nature, we can state—without paradox—that his work was very much an attempt to reflect the essence of humanity. The message is perfectly clear in a comment he made on one of his works, installed in 2000 in a forest in Auvergne, devastated by a terrible storm: "The tree's roots are our roots; its fate is our fate. Its life and death are our life and death."

BEECH WITH IVY
reed frame
Parc de la Courneuve,
Paris, Saint-Denis, 1994

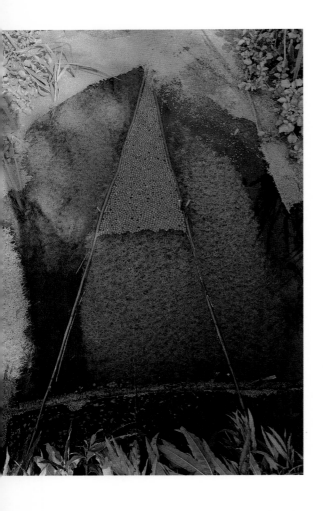

SORB APPLE STREAM
hazel switches and sorb apples
Danube marshlands, Bavaria, 1993

beyond the myth of "natural" nature

Once this has become clear, we can understand why the eternal question of "natural" or "artificial" nature has no place in Nils-Udo's creative process. The question of whether or not a given landscape is untouched by man has no bearing on his small-scale installations. He can find wild nature wherever there is plentiful greenery, even in a park.

His first installations took into account the human factor, the problems and difficulties faced by the farmers of his native Bavaria. Wherever man comes into contact with the omnipotence of the plant kingdom, even where it springs from nothingness—such as in Central Park in the heart of New York, in a studied composition, or even in the placing of rocks—the phenomenon of nature is real, and cannot be separated from culture. During one of Nils-Udo's his visits to New York—where his friend, the American artist Alan Sonfist, was campaigning for the preservation of untouched green spaces—Nils-Udo noted in his journal the following observation, which transcends time and space: "Claude Monet in New York? In Central Park, with Nils-Udo. Yes!" Keep in mind that in the Book of Genesis, Eden is a garden—this first, primitive nature was designed as a tamed, domesticated nature. Claude Monet himself ended up creating his famous garden in Giverny to continue his work "from nature," works which were later to be upheld by modern theorists as examples of "pure painting." Nils-Udo regularly uses the title *Paradise Garden* (Paradiesgarten), which refers at once to the first garden and to a text by Novalis. The title indicates the spirit and principle of a creative process where nature and culture go hand in hand. Nature is understood as a biological and physical entity, but the aspects of myth and literature do not go unnoticed.

photography

When, at the beginning of the 1970s, Nils-Udo first started working in and with nature, he did not entirely give up pictorial representation. The sculptures he devoted himself to from then on were characterised by the variations and evolutions of the living material. He always carried a camera with him wherever he went, in order to capture these modifications on film, to record the life of the plant sculptures in their element. But, contrary to the offhand treatment of photography by the British Land Artists, who claimed their shots were no more than a documentary archive, Nils-Udo used the

camera with superb mastery: in fact, his photography took over the role vacated when he abandoned painting. The black-and-white shots he first presented are technically and aesthetically perfect. From the outset, photography was more than just a means of narrating the sculpture. It demanded respect as an entirely distinct art form fulfilling its own stringent aesthetic criteria.

The camera records the moment, but it is also the perfect instrument for illustrating a succession of moments, a synthesis of the evolutionary cycle of living things—the various phases of the living changes of the work, the decisive stages in its metamorphosis. The artist has wrought an effect on the landscape, has built something, put changes in place, before taking a step back and letting nature carry on its work while he observes the growth, life, and eventually death, the disappearance of all trace of his action, absorbed back into the cycle of nature. All he did was organize the creation of the work. In the second phase, it is the photographer who takes over from the sculptor. Early on, Nils-Udo once wrote, "With my camera, I retrace the course of the seasons and their effects on my creations, their growth and their decay…" The size of the formats he chose for his photographs echoes the grandeur of the natural sites where he works. In 1981, Nils-Udo won the highest award for color photography for the quality of his work at the third triennial photography competition in Freiburg. At the exhibition devoted to his work at the Musée d'art contemporain in Lyon at its annual October arts festival in 1984, the photographs on display were in two formats: sumptuous large format black-and-white shots and color photographs designed to illustrate the magnificence of the changing seasons. The photographs were hung on a clever principle of reversibility. When the visitor first entered the exhibition hall, all he saw were the black-and-white shots. Only when he turned back at the end of the hall did the color shots become apparent. This perhaps rather trivial detail can be seen as symptomatic of the essential change that took place within Nils-Udo's œuvre.

Color photography permits the artist to record the nuances of each instant, to recreate the variations in the atmosphere in which the physical reality of the sculptures bathe. At sunrise on a snowy meadow, the *Willow Circle* (Chiemgau, Upper Bavaria, 1979) suddenly becomes a flaming crown. For Nils-Udo, color became the vector and identifying mark of his work. His *œuvre* truly came into its own when it began to evolve towards lighter, more ephemeral installations.

GATE
ash, hazel, spruce, traveler's joy,
willow, snow
Upper Bavaria, Germany, 1980

Winter in the Alps in Chiemgau.
An entrance into the mountain forest.
I made an arch using two switches of ash
and a bent rod of hazel, tied together
with traveler's joy.
Next, I decorated the archway itself with
rods of willow and snowballs, and finally
I traced a line in the snow with long fir twigs.

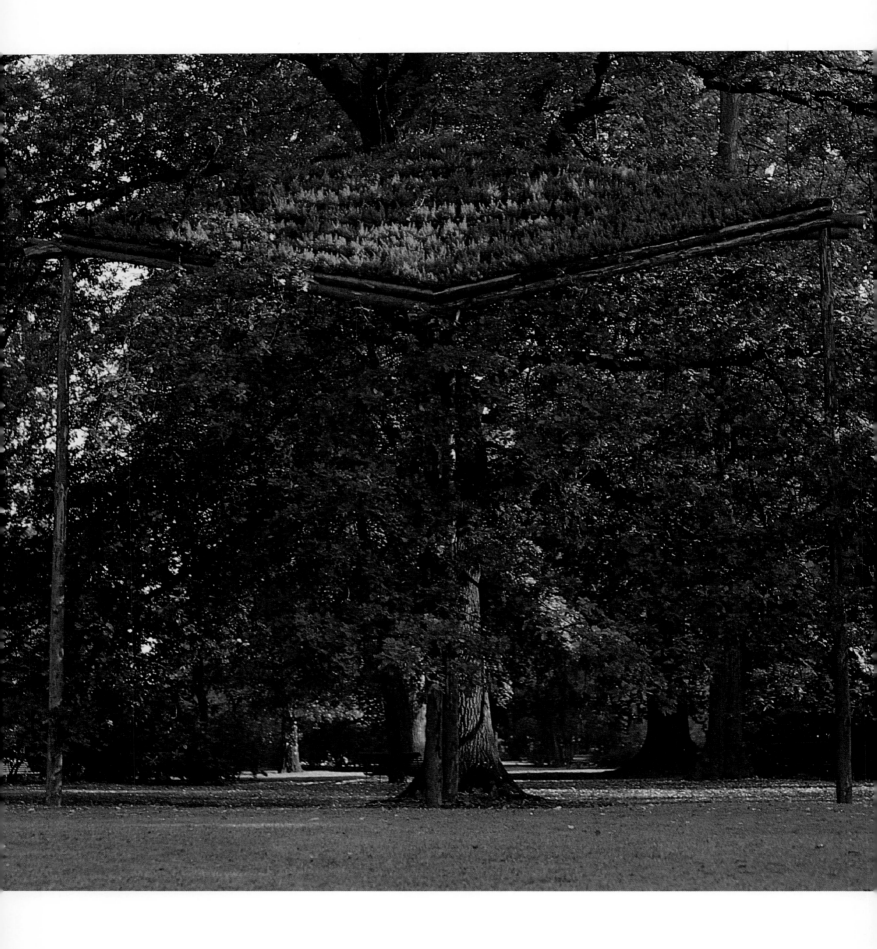

installations

In the mid-1980s, several short catalogs appeared recounting Nils-Udo's stays in various regions of Europe, in particular in France. They consecrated the development of a new way of working for the artist. Without giving up his sculptures in natural sites entirely, from then on, Nils-Udo chose to focus on the walk as an aesthetic process. The titles of the works created at this time indicate relatively long periods of artistic activity. The works were created by long stays on the site rather than as a trace of a passage. *Harvest*, a commission for the Centre d'art contemporain in Montbéliard, France, took twenty-one days at Ecquevilley in 1985. He also spent two seasons in Vassivière, Limousin, France, in 1986–1987. Invited as artist in residence, Nils-Udo had no planned project. One morning, he simply walked straight out of his lodgings, alone. He was a gatherer, not working on the land. And what he gathered were images. Nils-Udo did not bring any natural objects back to the cultural center. Photography was the finality of the work. The exhibition was made up of the results of each stay. The catalog published for the exhibition itself constituted the body of work. However, apart from the pictures, the catalog also contained a detailed diary of the artist's excursions, listing the modus operandi of what he termed "arrangements" or "installations."

UNTITLED
plantation of heather in an old oak
Strasbourg, France, 1986
(facing page and above)

harvests, arrangements, installations

What the camera recorded was the result of long hours of patient watching and waiting, observing, and, finally, assemblage. The interventions were extremely simple, often reminiscent of children's games. He would clear away the earth to expose intertwined roots, or set a frail craft of leaves or flowers adrift on a stream, sort leaves or crab apples by color, align Douglas-fir needles along a crack in the ice, or line up scarlet berries along a fallen tree trunk covered in moss, place sheets of ice from the edge of a nearby pond in the branches of an apple tree, hang snowballs from the bare branches of a tree. Miraculously, the work springs to life from nothing but the natural elements found on site. By simply bringing a few elements together, color bursts forth from the wintry landscape, raw like a wound, flashing like a flame.

Where an ordinary rambler would have seen nothing but gray, the artist reveals the hidden aspects of the landscape, whatever the season.

To Nils-Udo, there is no such thing as good or bad weather. In general, we contrast the beauty of spring to the gloomy aridity of winter. Nils-Udo's arrangements prove that, on the contrary, all seasons and all forms of nature are equally as rich, as visually stimulating. All you have to do is look closely, without preconceived ideas, and to take up whatever nature, and chance, have to offer.

Nils-Udo's arrangements are non-destructive. Without decontextualizing the various elements, he brings about a small modification, a slight shift, a combination of colors and plant or mineral elements. The artist's enterprise is halfway between calling the spectator's attention to certain elements and a process of composition and construction. By changing the point of view concerning something that is part of our everyday world, but which goes unnoticed, the artist in fact alters our way of looking at the world, suddenly revitalising our vision and stripping away the layers of habit that prevent us from seeing things as they really are. He thus induces us to go from a practical perception to a genuine aesthetic experience. He turns the most banal and ordinary materials into the elements of artistic compositions, and we realize that the catalog of natural forms that all civilizations have drawn on since the dawn of time for architecture and decoration, is right in front of us. The artist throws off the shackles of conventional creativity and rediscovers these fundamental truths. He acts as a mediator. Here, we have come face to face with one of the vital factors of any artistic process: the condition of creativity is the fruit of a reflection and action that cannot be anything but solitary. The only way to attain art is through intimacy. In this case, the intimacy is that of the rambler and nature. The role of the individual works is to share this intimacy with the onlooker, to give it a meaning that can be transmitted to other people. It allows the artist to share his vision of the world, his way of being in the world.

Following the conventions of the art world, which require the artist to list the techniques and materials used in the composition of a work of art (charcoal, acrylic on canvas, etc.), Nils-Udo gives his works extremely precise captions. They have a delightfully common touch, the choice of the *mot juste*, the use of familiar country names and the avoidance of the pedantic Latin taxonomies prized by garden centers. The viewer is able to share the artist's respect for a specific type of culture, indicated by his scrupulous regard for picturesque common names, (whether of plants (Bishop's Mitre,

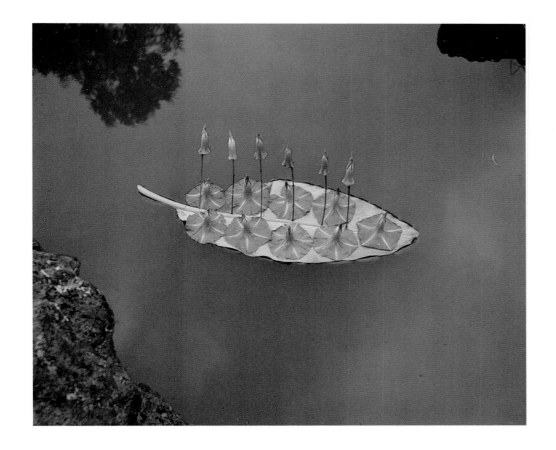

BANANA LEAF, BINDWEED FLOWERS
Réunion, Indian Ocean, 1990

Darwin's Barberry, Tongues of Fire) or the many places in which he finds them
(Bois des Marcelots, Barranco del infierno)). For him, this is another way to
highlight how man interacts with nature, in all cultures all over the world.
Observing nature during his rambles also helps him recognize, name, label,
and tame a world that opens before him in all its infinite variety and subtle dis-
tinctions. This is the great delight of the amateur botanist, as described by
Jean-Jacques Rousseau: "the enumeration, although so familiar to me,
nevertheless still brought me pleasure" (*Reveries of the Solitary Walker*, Second
walk). The most intimate phase of the artist's activity are the walk, the observa-
tions he makes, the actions that come before the arrangement. It might be
thought that this solitary occupation is the extent of the scope of the work. But
for the work to be comprehensible beyond the artist's own private sphere,
there must be an intention to communicate its meaning. The second
phase—the photographic record of the piece—is thus inseparable from the
first. Of course, photographic considerations play an absolutely vital role in
determining how the work is to be laid out. The concept of the ephemeral
composition *in situ* is justified by the fact that the work will afterwards be
recorded for posterity. In such procedures, the framing of the shot is central to

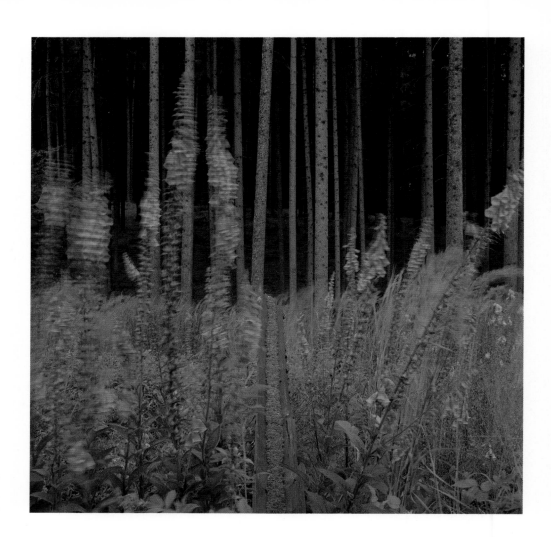

UNTITLED
spruce bark, red elderberries,
Dietenbronn, Bavaria, 1993

the composition. The final work is a conjunction of these two phases, and as such it would be unthinkable to cut or re-center the photograph for the requirements of publication; that would denature the work, a betrayal that would destroy the work's voice. The photographic record is not just a means of pinning down the ephemeral (or recording the changes that take place within an arrangement), it is actually the medium that invites us to enter the intimacy of the artist's walk and to share his private vision.

write on the sand, paint with flowers

Nils-Udo's installations are unsubstantial, and much more thoughtful than they might at first appear. The notion of the ephemeral implies working with time in highly uncertain conditions (sometimes the work can be demolished by a gust of wind or even trampled by an animal), but the artist also experiences privileged moments which he must seize—and learn how to anticipate such instants. The installation is often set up in anticipation of some natural event which will reveal the work's full potential: the ebb and flow of the tide, the gradual melting of a snowfall, the development of a play of light and the changes in intensity, color, and tone it produces. For example, in the detailed journal that accompanied the Ecquevilley catalog, the artist notes that a certain composition was designed for the first rays of the rising sun.

The photographic record provides a trace of the work. This is why the camera is the perfect instrument for immortalising a work that is itself no more than a fleeting trace, a moment—but one that is designed with a specific framing and centering of the selected and prepared space. The camera also helps to uncover the secrets of these micro-sites scattered in nature, discovered by the artist during the course of his rambles.

The photographs put us in direct contact with this factual and temporal reality, and at the same time they take us elsewhere. For Nils-Udo, the image lies between artifice and discovery as revelation. The image lies at the origin of an encounter. It is striking to note how the image requires the spectator's absolute silence. It releases the moment and the setting from the fortuity of their context, and transports the onlooker to a place where, without being denatured, nature discovers the faculty of becoming a theorized and constructed work of art. In this sudden silence, it takes on an astonishingly powerful and dreamlike quality.

Although photographs are technical compositions, they have the power to recreate an immediacy of feeling. They reinvent the conditions of a contemplative aesthetic experience, but, unlike painting, leave the viewer unburdened by artisitic technique and cultural context. The difference lies in the fact that painting is linked in our minds with a certain skill and a process of interpretation and transcription that demands patience, which we cannot help but ponder as we look at the picture. And yet photography is not that far removed from painting. It was working in nature that brought color to photography. Here, we must be perfectly clear in order to avoid any misunderstanding: the artifice of photography is not used, for example, to somehow change the reality it records, by saturating the colors or retouching the image during the development process. In fact, time and the reality of the work *in situ* are exactly those recorded in the photograph. Whether or not we understand the artistic act accomplished in the heart of nature depends entirely on this point. The colors of the photograph are a faithful reproduction of the colors of nature, which can, however, themselves teeter on the verge of artificiality. The artist can use the palette of hues supplied by plants to the point where the colors are saturated. It is here that we return to the concept of the painting, which underlies Nils-Udo's whole artistic expression: he remains above all a painter. A painter who paints in the spaces of nature. This is what makes his *oeuvre* different from that of the other artists working in nature. Nils-Udo places great emphasis on the quality of the image. This underlying pictorial aim brings about artistic creations that are composed, in both senses of the term.

a photographic and pictorial composition

In turning away from the easel for a while, little by little, Nils-Udo rediscovered ancient techniques for creating colors: using plant matter for pigment, pressing the juice from berries to dye balls of snow or ice, crushing poppy petals to produce red, dandelions for yellow, recreating all the tones of blue and green from the inexhaustible and bountiful supplies of the natural world. The lines underlying or structuring the forms he created are also borrowed from nature: the veins of leaves, branches, switches, reeds, bamboo, willow rods, etc. His notes are peppered with remarks that are typical of the painter, on the effects of symmetry, the purity of a line, or the way colors complement each other. His arrangements also display methods approaching painterly or graphic techniques, Like the use of color in large surfaces or in deft touches; shading; the way lines are distributed on the surface, oblique or curved. Nils-Udo thus puts into practice all the principles of artistic composition. The selection of the materials he finds on site attest to his love of geometric forms. This interest in form is apparent in all his work, from the sculptures *in situ* to the ephemeral arrangements.

While the term "centering" is more readily associated with photography than painting (although we know that many painters, such as Bonnard, "re-centered" their paintings), it is interesting to note that Nils-Udo on occasion introduces real frames here and there in the field of his shots. He makes them out of hazel switches, branches of willow, or lines dug in the soil (Mexico City, 1995; Samerberg, Chiemgau, 1996; Auvergne, 2000). This designed and superfluous gesture is clearly an explicit, playful reference to the traditional conventions of painting. Traditional figurative painting has often been defined as a window opening onto reality. The quasi-systematic use of a square format of photographic print (dating from his use of 6- x 6-in. format for his first experiments in black and white) means the framing of the photograph itself can be kept as neutral as possible, which in turn justifies the playful use of frames in the picture itself, a metaphorical nod in the direction of landscape or still life painting. Like the photographer, the artist's work is based on light.

This ambiguous game involving photography and painting is complementary. This becomes clear on close examination of the series of works entitled *Robinia Leaf Swing* (Valle di Stella, Italy, 1992–2000).

Using the same elements, and on the same site, by varying the centering and the distance, the artist produced a series of compositions organized

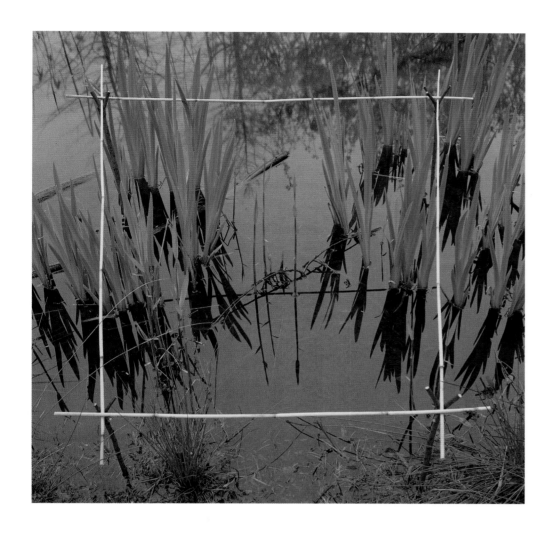

IRIS LEAVES
reed frame
Parc de la Courneuve,
Paris, Saint-Denis, 1994

in a meticulously formal manner. The forms all result from a subtle combination of plant matter that breaks the surface of a pond, or is suspended above and reflected in the water. The photographic record of these creations shows us a view that our own eyes automatically counter-balance in order to give us a strictly pragmatic interpretation of reality. Perception is an operation to filter reality—an operation carried out by the brain simultaneously with the eyes, to automatically recreate the proportional dimensions of the objects or beings placed in perspective in a given image. Our mind "cleans up" the image received by our eyes by automatically decoding the data. The eye of the artist, whether photographer or painter, neutralizes this filter. He grasps all the nuances of the image and renders them in all their complexity. Since its earliest days, photography has often been used as a tool to give the artist a more precise vision before he begins painting. Such is the case, for instance, of the abstract artist Ellsworth Kelly, who uses the camera to help him make the passage from reality to an abstraction

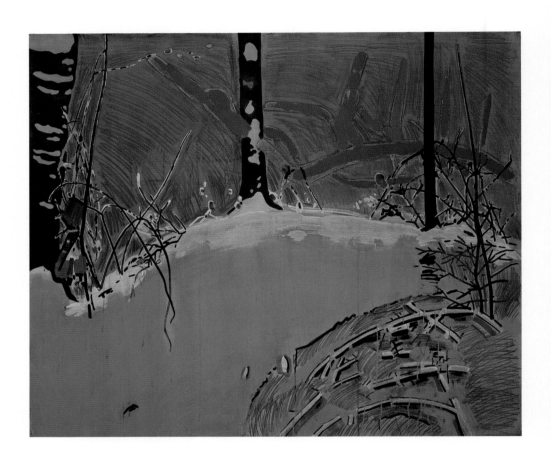

WINTER
mixed media on paper,
148 x 156 cm, 1995

deduced from it. For Nils-Udo, composition is not just a matter of arranging and reorganizing elements in their natural context, but also, from the outset, of taking into account everything that will be visible in the recorded photographic image—angles of incidence, reflections, diffraction—including all those elements independent of the photographer's will, that will end up present in the two-dimensional composition of the photograph through the play of light or the process of taking and developing the shot. Thus, it becomes evident why this way of setting up a composition, first on site through the handling of natural materials, and then via this photographic vision, should bring us back to the techniques of painting, which in fact underscored the entire enterprise from the very beginning. We should note that in the mixed-media works that brought the series *Robinia Leaf Swing* to a close, painting returns to a more traditional format, while the photograph, which served as a kind of matrix for the painting, is confined to a smaller-scale, square format, thus highlighting its role as referent. This method, which consists first of all in creating a composition in a real, living context, then fixing it permanently in a photograph, ended up bringing Nils-Udo back to painting. He reintroduced painting to his *œuvre* like a new metamorphosis of the image,

another possible form that the reconstitution of a living experience could adopt. As a result, the burden of tradition borne by this technique no longer blots out the work's direct contact with nature. Going against the tradition of the still life, we could perhaps call these works a series of "living lifes."

ICE
mixed media on paper,
152 x 156 cm, 1989

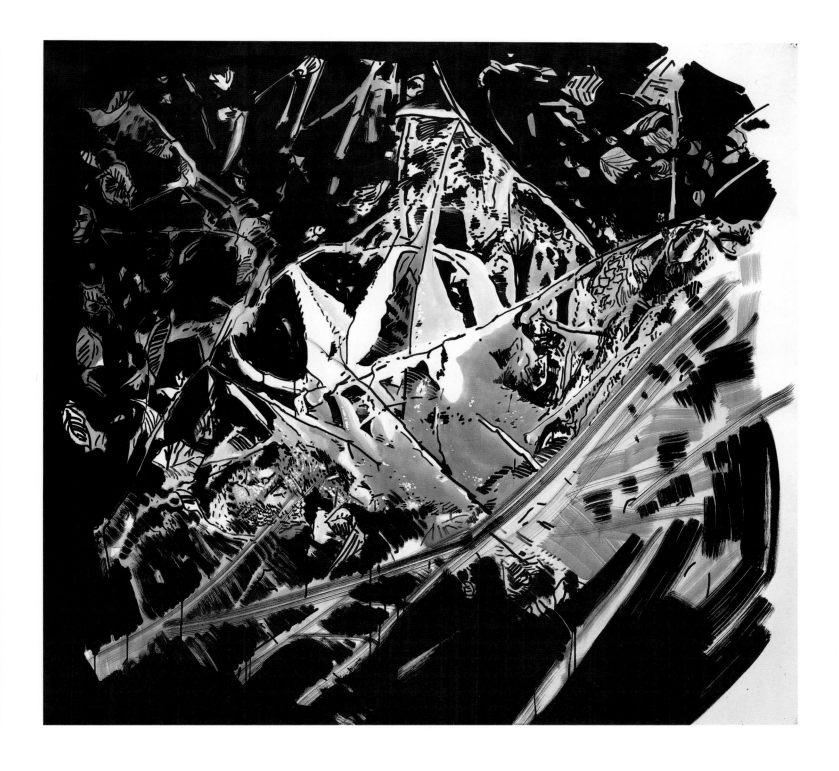

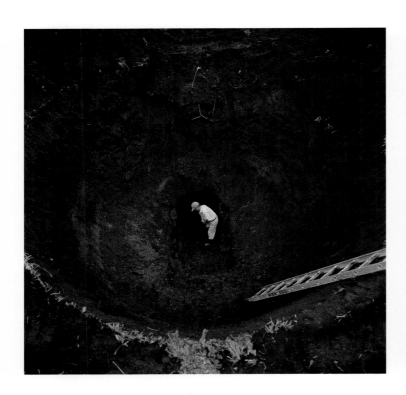
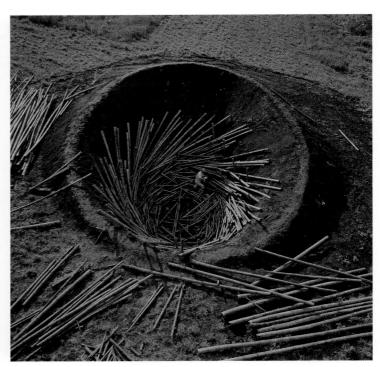

the nest and the human body

The nest is one of Nils-Udo's most famous constructions. This piece was created in 1978, during a period of work on the Luneburg heath in northern Germany. It was to be followed by a number of variations on the theme. It reappeared ten years later, in the park at Le Crestet, near Vaison la Romaine, France, in 1988. This version takes up the theme of the dream from Novalis's *Heinrich von Ofterdingen*. The nest was lined with flowering lavender plants, forming a perfumed blue ravine. Nils-Udo talks of the genesis of the first of these pieces in terms of a total immersion in the scents and sensations of the forest, which filled him entirely, giving him perfect insight into the plant and animal life that characterized the spirit of the place. He felt this to the point that he seemed to draw on a source of instinct—if not atavistic, at least natural—in his own inner depths, which compelled him to build this nest, giving shape to an object that was at once a womb, a refuge, a bed, a cradle, anything that gives us the feeling of our origins in the earth and reminds us that we are indissolubly, biologically bound to it, that we must fuse with it in the end. It is therefore hardly surprising to discover a series of photographs showing the artist, naked, curled up in a fetal position at the heart of his creation as if it were a chrysalis or a cocoon. This theme was to be more amply developed in later works in the forest of Marchiennes, France, in 1994–1995. In that case, Nils-Udo took a step back from such visceral involvement in his

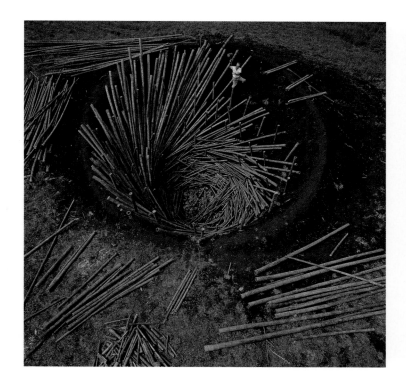
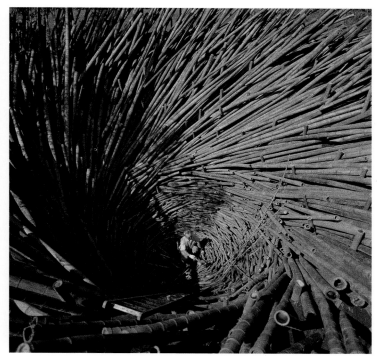

WORK IN PROGRESS IN "BAMBOO NEST"
Fujino, Kanagawa prefecture,
Japan, 1988

own productions. After the metaphor of his quest for his own innocence, the children featured bear out the idea of the primitive, even primeval candor of both nature and the creatures that issue from it. Some of the bodies photographed bear the color of flowers, others are still caked in mud, the clay of their earthly womb. Among them is a child-chrysalis. This series was continued by pieces created in Réunion in 1990 and 1998, and then in Upper Bavaria in 2001. All these works evoke the cosmogonic legends and founding myths that are transmitted from generation to generation in all human cultures, the belief that Mother Nature bears children. In popular literature, this myth is at the origin of the stories of wolf-children or infants who have grown up in the jungle, untouched by civilization. When Rudyard Kipling or Edgar Rice Burroughs write about such things, they help us believe in nature as a benevolent, protective force that brings forth uncorrupted beings. In the series of works produced in the forest of Marchiennes, the photograph of a small naked child covered in duckweed, lying on a raft of spruce branches, is entitled *The Frog*. This is the precise meaning of the name Kipling gave the hero of the *Jungle Book*—Mowgli. Pure coincidence? In any case, these works—at once playful and serious in tone—are the ones that indicate most explicitly the artist's desire to found a harmonious relationship between nature and humanity. For Nils-Udo, nature is never hostile. But man must retain the faculty of rediscovering a native candor. The first nest was clearly designed to play

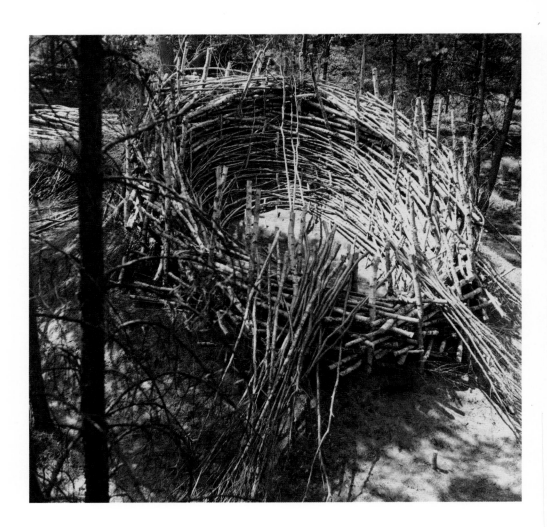

WORK ON "THE NEST"
Luneburg Heath,
Germany, 1978

with the conventions of scale, between dream and reality. Nils-Udo's work has never been closer to the world of legends than with this series, from the tales of the Brothers Grimm, Hans Christian Andersen, or Selma Lagerlöf, to *A Midsummer Night's Dream*. This is a world where forests take flight, where skiffs are made of flowers and gently cradle sleeping children; a world where curtains of flowers and doors of plants invite us to believe in the existence of passageways to the unknown, where snowballs grow on snowball trees, where fires burn in altars of ice... Depending on the onlooker's mood and temperament, he might see a paradise lost or an invitation to rediscover the carefree joys of youth. In nature, everything is reflected in everything else. There is no hierarchy of beauty between the infinitely huge and the infinitely minute. In the world of natural creation, like in mental reflection, no scale is beyond reach. Nests can shelter a human, ferns can bear a child. Nature gives birth, shelters, and protects. The fact that it lives its own life implies that it is constantly beyond our grasp. That is why it remains so mysterious, bearing in its bosom a curious potential for dreaming.

Most of Nils-Udo's works are characterized by their delicacy. This is principally the result of the materials he uses. Working for the most part barehanded, the artist has no need for technology to lay bare the beauty of nature. His techniques bring back to life the earliest awakenings of man's

BAMBOO NEST
bamboo nest constructed in 1988, over-
grown in 1994 by the bamboo plantation
Fujino, Kanagawa prefecture,
Japan, 1988–1994

artistic spirit, sorting and arranging whatever he managed to gather, which are still the dominant mode of aesthetic expression in certain civilizations. There are definite affinities between Nils-Udo's simple gestures and the refined subtlety of many so-called "primitive" cultures.

While he remains very much bound by the principles of Western culture, and although he unequivocally and clearly takes position within the context and the debate surrounding contemporary art, Nils-Udo, by the fundamental simplicity of his *œuvre*, can work in all four corners of the globe and all climates with the same sentiment of joy in nature. His artist's eye allows him to recognise the exceptional in any type of territory, without ever deviating from his project or polluting his art. This is certainly the result of his open attitude to other cultures—the fruit of his travels during his formative years as an artist. He has received many invitations to work outside Europe, which have given him the opportunity to develop his artistic vision without risking either its quality or its integrity, and to avoid any concessions to local folklore and the deceptive seduction of exoticism.

Whether in Central Park or on a volcano in Réunion, in India or the Namibian desert, the artist allows the grandeur of the landscape to speak to him, and repeats the simple gestures that open a path leading straight from the heart of nature to the heart of man.

WORK IN PROGRESS ON AN INSTALLATION
FOR THE FILMING OF AN ADVERTISEMENT
FOR THE LAUNCH OF THE PERFUME
MAHORA BY GUERLAIN (PARIS)
Namibia, 2000

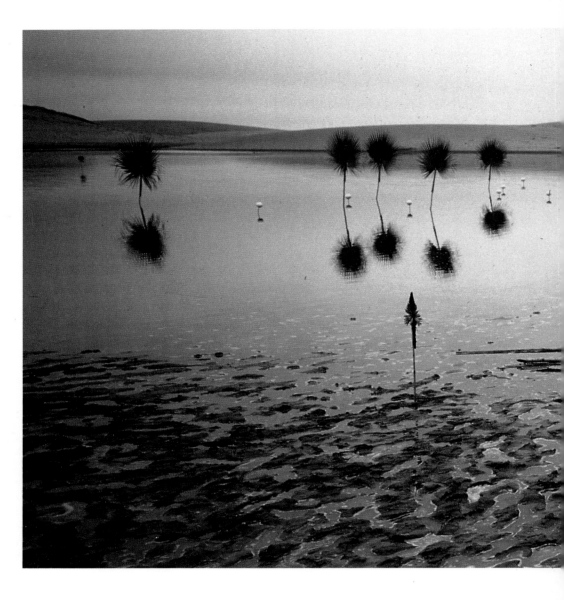

For so did

The red of her cheeks

Stand out against the white

As the three drops of blood

Stood out against the white snow

Chrétien de Troyes, *Perceval* 2

Nils-Udo's images are pregnant with meditative silence.

Reading the artist's working notes, we find this incidental comment: "When I had taken the photograph, I watched as the red slowly sank into the snow…" These words echo faintly one of the most poetic episodes in Chrétien de Troye's medieval romance *Perceval*. The young knight sees a goose with a wound in its neck, which flies away as he approaches, leaving three drops of blood in the snow. Gazing at the drops of blood, the hero is plunged into a deep trance, from which not even a physical assault by armed assailants can rouse him. He must wait until the snow melts before emerging from his meditation and returning to reality. The medieval knight is fascinated by this image: he sees a metaphor of his beloved in the fresh colors of the "three drops of blood, scattered in all the white." The fascination

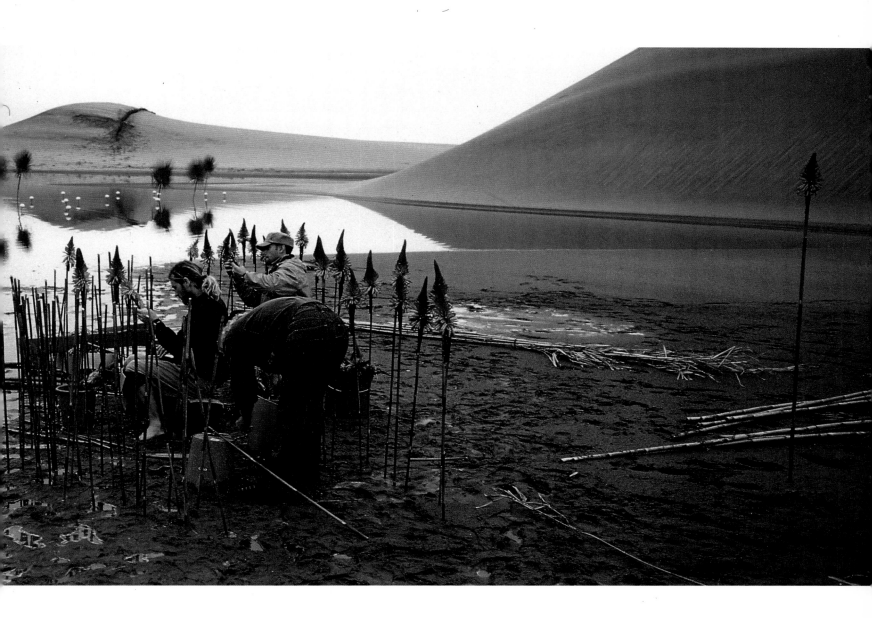

that binds Nils-Udo to nature—and which he transmits to us through his art—
is at least as intense. A natural scene that for Chrétien de Troyes provided a
superb metaphor for painting and the portrait of the beloved, is here
echoed by the painter, photographer, and lover of nature. This brief journal
entry shows a degree of absorption that goes far beyond the motivation for
his artistic creation. The red juice of pressed berries in the snow exerts a mysti-
cal enchantment on Nils-Udo that parallels the enchantment of de Troyes'
medieval hero. Nils-Udo's work lays this fascinating power bare for all to share.
The viewer is left to be absorbed by the enigmatic silence of the images that
Nils-Udo proposes.

2 From: Roger Sherman Loomis and Laura Hibbard Loomis, trans. and ed., *Medieval Romances*
(New York: The Modern Library/Random House, 1957), p. 154.

Nils-Udo selected biography

1950s Nils-Udo travels widely in Europe and the Middle East.

1960s Lives in Paris as a painter for ten years.

1972 Beginning of his work in and with nature. Creations and installations in many countries.

1973 Creation of the plantation-installation *Hommage à Gustav Mahler*, Chiemgau, Upper Bavaria (Germany).

1978 Creation of the monumental installation *The Nest*, Luneburg Heath, northern Germany.

1980 First prize at the international photography triennial at Freiburg (Switzerland). Large-scale projects planned for cities.

1982 Creation of the monumental installations *Water House* in the North Sea, *The Tower*, in Nordhorn (Germany), and *Large Water Altar*, in Pommersfelden (Germany).

1984 Creation of the monumental installation *The Flying Forest*, Lyon (France), and exhibition devoted to his work in the same city.

1985 First prize at the international Parc Éole competition in Brest (France). Exhibitions devoted to his work in Rennes (France), Paris, and Tokyo.

1986 Installations in Vassivière in the Limousin (France), on Sylt Island (off the coast of Germany), and in Strasbourg (France). Exhibitions devoted to his work in Montpellier (France), Salzburg (Austria), Montbéliard (France), and Tokyo.

1987 Monumental installations in Tokyo and in Coimbra (Portugal). Installations in Tel Hai (Israel). Exhibitions devoted to his work in Tokyo and Coimbra.

1988 Monumental installations in Vaison-la-Romaine (France), Paris, and Fujino (Japan).

1989 Memorial in Munich. Takes up drawing and painting again. Exhibitions devoted to his work in Rheims (France), Munich, and Tokyo.

1990 Plantation-installation in Caen (France). Installations on the island of Réunion. *La Réunion à Paris* exhibition, with a grant from the Ministry of Arts, Paris.

1991 Creations using the plants in Central Park, New York. Installation in Martinique. Exhibitions devoted to his work in Munich, Tokyo, Angers (France), and Évry (France).

1992 Installation at la Défense, Paris. Monumental installations in Aachen (Germany), Paris, Basle (Switzerland), and Brussels.

1993 Monumental installations in Wageningen, near Cottbus in Germany, and at the Château de Lagrézette. Exhibitions devoted to his work in Poznan (Poland).

1994 Works in the public parks of New Delhi (India). Monumental installations: *Maize* in Pau (France) and *A Thousand Daffodils* on the island of Rügen (Germany). Works on the theme of the human body in nature, with students of the Universities of Valenciennes (France), Lille (France). Project for a grand entrance to the town for the municipality of Évry. Works with nature in Fujino. Work in the Parc de la Courneuve, Paris. Exhibitions devoted to his work in Budapest, Lille, and Anzin.

1995 Projects working with nature for the CD-Rom *Eve* by Peter Gabriel. Root sculpture installation and an exhibition devoted to his work in Mexico City. Monumental installation in Glonn, near Munich. Exhibitions devoted to his work in Paris, Tokyo, and Bombay.

1996 Creation of Peter Gabriel's CD-Rom for the WWF Living Planet campaign on Vancouver Island (Canada). Monumental project for Expo 2000 in Hannover. Creation of a monumental installation in Salzburg. Exhibitions devoted to his work in Odense (Denmark) and Toronto.

1997 Monumental installation in Troisdorf, near Cologne.

1998 Monumental installation *Red Rock Nest* in California. Monumental installation *Novalis's Copse* for the University of Augsburg (Germany). *Art and Nature* exhibition in Los Angeles. *Affinities and Collections* exhibition in Escondido, California. Exhibitions devoted to his work in Toulon (France), Toronto, Waldkraiburg (Germany), and Geneva.

1999 Two creations for the University of Bayreuth (Germany). Monumental installation *Sleeping Beauty* for the exhibition *Parfums en Sculpture* at the Jardin des Plantes in Paris. Exhibitions devoted to his work in Aachen, Turin, Brussels, Rheims, Berlin, Toronto, Tokyo, and Vassivière.

2000 Installations in the Namibian desert for a new perfume by Guerlain. Monumental installation *Habitat*, Champs-Elysées gardens, Paris. Exhibitions devoted to his work at the Musée Zadkine in Paris, and in Geneva, Munich, Bérgamo (Italy), Strasbourg, Colmar (France), Sélestat (France), Bayreuth, Rosenheim (Germany), and Paris.

2001 Monumental installations *Stein-Zeit-Mensch (Stone-Time-Man)*, Forest Sculpture Trail, Bad Berleburg (Germany). *Bamboo Entrance*, Réunion. *Bamboo Valley*, St. Catherines (Canada). Monumental installations in Maglione, Piedmont, and Geneva. Exhibitions devoted to his work in Paris, Lanzarote in the Canary Islands, Turin, and Toronto.

2002 Monumental installations in the Neandertal valley and for the University of Moncton, Canada. Exhibitions devoted to his work and monumental installations at the Gunma Museum of Art in Tatebayashi (Japan), at the Iwate Museum of Art in Morioka (Japan), and at the Obihiro Museum of Art, Hokkaido (Japan). Exhibitions devoted to his work in Wasserburg/Inn (Germany) and Tokyo.

bibliography

exhibition catalog extracts

Neusüss, Floris M. "Nils-Udo." *Photography as Art—Art as Photography 2.* Kassel, 1977.

Thiel, Heinz and Andreas Vowinckel. *Zwei Steine sind nie gleich.* Neuenkirchen: Galerie Falazik, 1978.

"Nils-Udo, Sonnenskulptur." *Holz + Kunst, II.* Freiburger Symposium, Kunstverein Freiburg, 1979.

Bode, Peter M. *Kritik und Kunst.* Munich: Kunstverein Munich, 1980.

"Nils-Udo, Wasserhaus." *Kunstreport 4.* Berlin: Deutscher Künstlerbund, 1980.

"Nils-Udo." *8. International Print Biennale.* Krakow, 1980.

"Nils-Udo." *Cat. III.* Freiburg: Internationale Triennale der Photographie, 1981.

Osterwold, Tilman and Andreas Vowinckel. *Natur–Skulptur.* Stuttgart: Württembergischen Kunstverein, 1981.

Bischoff, Ulrich. *Cat.* Cuxhaven: Symposium Nordseeküste, 1982.

Cat. Bradford: Seventh British International Print Biennale, 1982.

Holeczek, Bernhard. *2.* Nordhorn: Internationales Bildhauer-Symposion Bentheimer Sandstein, 1982.

Nils-Udo. *Skulptur–Architektur–Natur.* Nordhorn: Städtischen Galerie Nordhorn, 1982.

Schneider, Eckhard. *2.* Nordhorn: Internationales Bildhauer-Symposion Bentheimer Sandstein, 1982.

Thiel, Heinz. *Cat.* Cuxhaven: Symposium Nordseeküste, 1982.

"Nils-Udo." *Deutsche Bildhauer der Gegenwart.* Kunstverein Augsburg, 1983.

"Nils-Udo, Regenturm." *Holz + Kunst, III.* Freiburger Symposion, Kunstverein Freiburg, 1983.

Schneider, Eckhard. *Positionen.* Nordhorn: Städtischen Galerie Nordhorn, 1983.

Besacier, Hubert. *Nils-Udo.* Lyon: musée St.-Pierre Art contemporain, 1984.

Morschel, Jürgen. *Nils-Udo.* Lyon: musée St.-Pierre Art contemporain, 1984.

Nils-Udo. *Nils-Udo.* Lyon: musée St.-Pierre, Art contemporain, 1984.

———. *Art et Paysage.* Bar-le-Duc, 1985.

———. *Cat IV.* Freiburg: Internationale Triennale der Photographie, 1985.

Faux, Monique and Jean-Blaise Picheral. *L'art et la ville.* Paris, 1986.

Nils-Udo. *Cat. Kaneko Art Gallery 1982–1986.* Tokyo, 1986.

Renard, Delphine "Nils-Udo à Equevilley." *Nils-Udo Récoltes, 21 jours à Équevilley.* Montbéliard: Centre d'Art contemporain de Montbéliard, 1986.

Durand, Régis. *Nils-Udo, Deux Saisons.* Vassivière en Limousin, 1987.

Kaneko, Tasaku. *Begegnung mit Nils-Udo.* Tokyo: Kaneko Art Gallery, 1987.

Sautivet, Marc. *Nils-Udo, Deux saisons.* Vassivière en Limousin, 1987.

Nils-Udo. "La Réunion à Paris". *Inventer 89.* La Villette/Paris: Vaisseau de Pierres, 1988.

———. *Cat. 5. Internationale Triennale der Photographie.* Freiburg: Museum für Kunst und Geschichte, 1988.

Fagone, Vittorio, Helmut Lesch, Nils-Udo, and Marienhof Brunnen. *Nils-Udo, Arbeiten aus den Jahren 1972 bis 1989.* Munich: Künstlerwerk-stätten Lothringer Straße, Kulturreferat der Stadt Munich, 1989.

Nils-Udo. "Natur-Skulptur." *Calendar 1989.* Tokyo: The Dai-Ichi Life Mutual Insurance Company, 1989.

———. *Cat. Kaneko Art '87–'90.* Tokyo, 1990.

Rüth, Uwe. *Material und Raum.* Essen: Galerie Heimeshoff, 1990/1991.

Von-Pine, Roselyṅe. *Un artiste, une île.* Réunion: Galerie Vincent, 1990.

Besacier, Hubert and Vera Botterbusch. "Der Grenzgänger Nils-Udo." *Bäume, Aspekte Galerie, Münchner Volkshochschule, Gasteig.* Munich, 1991.

Heigl, Curt. *Kunst und Kanal.* Munich: Rhein-Main-Donau AG, 1991.

White, Kenneth and Nils-Udo. *Art et Environnement.* Antilles: DRAC Martinique, 1991.

Draguet, Michel, Dieter Ronte, and Raymond-Marie-Balau. "Variations entre la feuille et l'arbre". *Nils-Udo/Bob Verschueren.* Bruxelles: Atelier 340, 1992.

Durand, Régis. *Le Printemps de la Photo.* Cahors, 1992.

"L'art renouvelle la ville." *Urbanisme et art contemporain.* Paris: Musée national des monuments français, 1992.

Albertazzi, Liliane. *Différentes Natures, Visions de l'Art contemporain.* La Défense, Paris, 1993.

Arte Sella. International Art Meeting, Documentazione. Sella di Borgo Valsugano, 1993.

Nils-Udo. *Cat.* Poznan: Galeria Miejska, 1993.

———. "Das Tal der Blauen Blume." *Beelden op de Berg.* Wageningen: Belmonte Arboretum, 1993.

Sayag, Alain. *Arrêt sur viaduc.* La Défense, Paris: EPAD, 1993.

Art Grandeur Nature II. St.-Denis, Paris: Parc de la Courneuve, Conseil général, 1994.

Trilogi, Kunst–Natur–Videnskab. Odense: Kunsthallen Brandts Klaedefabrik, 1996.

Nemitz, Barbara, ed. *Wachsen, Arbeit an den Künstlergärten Weimar,* 2 (Spring 1996).

Cat. 5. Troisdorfer Symposium StadtMenschNaturLandschaft. Stadt Troisdorf, 1997.

Jardin d'artiste: de mémoire d'arbre. Musée Zadkine, Paris: Les Musées de la Ville de Paris, 1998.

Piguet, Philippe. "Nils-Udo, À fleur de vie." *Nils-Udo.* Geneva: Galerie Guy Bärtschi, 1998.

Nils-Udo. "3 Projekte im Landschaftsraum." *Natural Reality. Künstlerische Positionen zwischen Natur und Kultur.* Aachen: Ludwig Forum für Internationale Kunst, ed., 1999.

———. "La Belle au bois dormant." *Parfums de sculpture.* Pau: Materia Prima, 1999.

————, Wolfgang Becker and Vittorio Fagone. *Arte nella natura (1972-1999). Supplemento al catalogo internazionale.* Bergamo: Galleria d'Arte Moderna e Contemporanea, 2000.

Nils-Udo. *Auf den Spuren der Wirklichkeit, Vorwort Heike Strelow, Ausst. Katalog.* Geneva: Galerie Guy Bärtschi, 2000.

Becker, Wolfgang and Yuri Kazunari Sasaki. *Nils-Udo Towards Nature.* Essays.

Matsushita, Kyodo News department of cultural affairs, Tokyo, Gunma, Museum of Art.

Tatebayashi, Hokkaido Obihiro Museum of Art, Iwate Museum of Art, Japan.

general reading

"Du Paysage." *Photographie, Mythes et Limites. Photographie Contemporaine en Bretagne.* Luxembourg, 1991.

Les Années 70. Paris: Éditions du Regard, 1993.

Grande, John K. *Art Nature Dialogues.* Canada, 1993.

————. *Balance: Art and Nature.* Montreal/New York/London, 1994.

Lagoeyte, Christine. *L'Œuvre de maïs de Nils-Udo à Laàs.* Pau: Bachelor's degree in Art History, 1994.

Cerver, Francisco Asensio. *Landscape Art, world of environmental design.* Barcelona: Francisco Asensio Cerver, 1995.

Durand, Régis. *Le Maïs, Nils-Udo – Laàs 1994.* Bordeaux, 1995.

Fagone, Vittorio. *Art in Nature.* Mailand, 1996.

Nils-Udo. *Nature–Corps.* Lille, 1996. (With an original silk-screen print in the first fifty copies).

Weilacher, Udo. *Zwischen Landschaftsarchitektur und Land Art.* Basel/Berlin/Boston, 1996.

Cerver, Francisco Asensio. "Interventions in Landscape." *International Landscape Architecture.* Barcelona: Francisco Asensio Cerver, 1997.

Grande, John K. *Art, nature et société.* Montreal, 1997.

Lechner, Georg. *Nils-Udo, New Delhi 1994.* New Delhi: Max Mueller Bhavan New Delhi and Goethe Institute of Munich, 1997.

Grande, John K. *Intertwining : Landscape, Technology, Issues, Artists.* Montreal/New York/London, 1998.

Nils-Udo. *Kalender 1998.* B.O.A. Munich: Videofilmkunst, 1998.

Sabor, Sabine. *Ökologische Perspektiven in der westdeutschen Kunst nach 1945.* Essay. Bochum, 1998.

Becker, Wolfgang, Régis Durand, Vittorio Fagone and John K. Grande. *Nils-Udo, Kunst mit Natur.* Wolfgang Becker, ed. Cologne: Wienand, 1999.

Faux, Monique. "Tadayasu Sakai, Nils-Udo," parc d'Éole Brest '89. *L'Art renouvelle la ville.* Tokyo, 1999.

Nemitz, Barbara, ed. *Lebende Vegetation in der zeitgenössischen Kunst.* Weimar, 1999.

————. *transplant, Living Vegetation in Contemporary Art.* Germany: Hatje Cantz, 2000.

Quaderns, no. 225. Barcelona: Col-legi d'Arquitectes de Catalunya, 2000.

Bartelsheim, Sabine. *Pflanzenkunstwerke, Lebende Pflanzen in der Kunst des 20. Jahrhunderts.* Silke Schreiber, 2001.

SNOECKS 2001. *Jahrbuch zu Literatut, Kunst, Reportages, Film/Foto, Mode/Design.* Gent: SNOECKS N.V., 2001.

Tiberghien, Gilles A. *Nature, Art, Paysage.* Actes sud / École Nationale Supérieure du Paysage / Centre du Paysage, 2001.

Burey, Philippe. *Rêves de cabanes ou l'Esprit de cabane.* Fouleix, 2002.

Jahrbuch Ökologie 2003. Munich: C.H. Beck, 2002.

Richardson, Phyllis. *Contemporary Natural.* London: Thames & Hudson, 2002.

Wolfgang Becker, Kazunari Sasaki, Yuri Matsushita, *Nils-Udo Towards Nature.* Kyodo News Departement of Cultural Affairs, Tokyo; Gunma Museum of Art, Tatebayashi; Obihiro Museum of Art, Hokkaido; Iwate Museum of Art, Morioka, 2002.

Wollmeier, Sigrid. *Natur-Kunst.* Künstlersymposien in Deutchsland, Michael Imhof, 2002.

articles

"Ein hölzerner Altar für den Gott des Maises." *Wachsen—Arbeit an den Künstlergärten Weimar.* Künstlergärten Weimar project, Bauhaus Weimar University, 2 (fall 1996).

Bode, Peter M. "Die Kunst geht in die Natur." *Abendzeitung,* Munich (September 20, 1996).

Hufnagel, Christian. "Die Welt zwischen Wiese und Wald für die Sinne belebt." *Süddeutsche Zeitung.* Ebersberger Neueste Nachrichten (September 20, 1996).

"Wenn Kunst in die Natur geht". *Ebersberger Zeitung,* (September 25, 1996).

Grande, John K. "Nils-Udo, DeLeon White Gallery Toronto". *Artforum International,* New York (November 1996).

Nils-Udo. "Notes de travail." *Le Courrier de l'UNESCO,* Paris (December 1996). (In thirty languages).

Cerver, Francisco Asensio. "Nils-Udo, Interventions in the Landscape." *International Landscape Architecture,* Barcelona (1997).

Wollmeiner, Sigrid. "Kunst im öffentlichen Raum: 'StadtMensch—NaturLandschaft'." *Junge Kunst,* no. 5 (1997).

Eggar, Robin. "All about Eve." *The Sunday Times Magazine,* London (January 19, 1997).

Andreas, Obst. "Ersatz für's Paradies." *Frankfurter Allgemeine Zeitung* (March 18, 1997).

"Grüne Welle aus Erde soll durch das Haus schwappen." *Rhein-Sieg-Rundschau* (June 21/22, 1997).

Wagner, Helmut. "Der Zauber des Einzigartigen." *Landshuter Zeitung, Straubinger Tagblatt* (July 16, 1997).

"Nils-Udo." *Cahiers intempestifs,* no. 10, St.-Étienne (1998).

Mays, John Bentley. "Environmental art quietly absorbing." *The Globe and Mail*, Toronto (January 29, 1998).

Rasle, J. "Nils-Udo. Un artiste en résidence." *Missives*, Paris (September 1998).

"Nils-Udo." *Kunstforum international*, no.147, Cologne (1999).

"Nils-Udo." *La Stampa*, Turin (March 15, 1999).

"Nils-Udo, à fleur de peinture." *Libération*, Reims (4, 1999).

Charl, Yvonne. "Bedrohte Wunder." *Aachener Zeitung* (April 22, 1999).

"Nils-Udo à l'ancien collège des Jésuites." *L'Est Eclair*, Reims (July 2, 1999).

Bauduin, P. "Jardins des délices." *Femina, Le Journal du Dimanche* (July 7, 1999).

Nils-Udo. "Kunst mit Natur." *Abendzeitung*, Munich (July 12, 1999).

Charl, Yvonne. "Ein Park wird zur Skulptur." *Aachener Zeitung* (August 12, 1999).

"Nils-Udo, très fleur bleue." *Libération*, Reims (August 16, 1999).

Grande, John K. "Nature Works!" *Sculpture*, Washington D.C. (September/October 1999).

Guinot, Robert. "Rétrospetive Nils-Udo: de l'art avec la nature." *La Montagne*, Clermont-Ferrand (October 21, 1999).

——. "Art et nature." *Le Berry Dimanche*, Bourges (October 31, 1999).

Charbonnier, Jean-Michel. "Nils-Udo en pleine nature." *Beaux Arts Magazine*, Paris (December 1999).

"Nils-Udo." *Art le Sabord*, no. 56, Quebec (2000).

Späth, Andrea. "Hommage an Mutter Natur." *Photo, Technik International*, no. 3, Munich (2000).

"Formationen aus Laub." *Kölner Stadt-Anzeiger*, no. 5 (January 7, 2000).

"Äste, Weidenruten, Heu und Menschlein." *Die Presse "Spektrum"*. Vienna (January 22/23, 2000).

"Nils-Udo." *Géo*, no. 253, Paris (March 2000).

"Nils-Udo: Kunst mit Natur." *Wasserburger Zeitung* (March 21, 2000).

"Kunst und Natur in Fotos, Bildern und Modellen." *Münchner Merkur* (March 23, 2000).

"Nils-Udo." *Bild, Kunstwerk Natur*. Munich (March 24, 2000).

"Nils-Udo, Verehrung für die Natur." *Chiemgau Zeitung*, Traunstein (March 25/26, 2000).

"Ein Plädoyer für die Natur." *Bayerische Staatszeitung*, Munich (April 7, 2000).

Müller-Mehlis, Reinhard. "Der Zeitgeist im Espenlaub." *Münchner Merkur*, Munich (April 10, 2000).

"Nils-Udo, Kunst mit Natur." *Süddeutsche Zeitung*, Munich (April 19, 2000).

Chahine, Nathalie. "De l'art avec la nature." *Terre Sauvage*, no. 150, Paris (May 2000).

"Luoghi di Kahlhamer fra storia e contemporaneità." *La Voce di Bergamo* (July 15, 2000).

"Musée Zadkine, Nils-Udo." *Pam Loisirs*, Paris (July 18, 2000).

"Nils-Udo alla Carrara, Galeria d'arte moderna e contemporanea." *L'eco di Bergamo* (July 18, 2000).

"Nils-Udo, la natura." *ADIGE*, Bergamo (July 19, 2000).

"Nils-Udo." *Arte In*, Bergamo (August 2000).

Russo, Guilia. "Il gusto della Oprandi e di Maranno." *Nuovo Giornale di Bergamo* (August 2000).

Van Ecke, Vinca. "Envolée de gazon et de photographies de Nils-Udo au musée Zadkine." *Le Monde*, Paris (August 2000).

"Nils-Udo." *Beaux Arts Magazine*, no. 196, Paris (September 2000).

Herpin, Julien "Retour à l'état de nature." L'Alsace, Strasbourg (September 28, 2000).

"Nils-Udo, la poésie des choses…" *L'Yeux*, no. 10, Strasbourg (September/October 2000).

"Nils-Udo." *Dernières Nouvelles d'Alsace*, Strasbourg (October 18–24, 2000).

"Nils-Udo, De l'art avec la nature." *Point Colmarien*, no. 153, Strasbourg (November 2000).

Coppeus, Stefan. "De Verganke Lijke, Naturkunstwerke von Nils-Udo." *SNOEKS*, Gent (2001).

"La Fundación expone la naturaleza hecha arte con los trabajos de Nils-Udo." *La Voz,* Lanzarote (2001).

"Nils-Udo: La presencia de la naturaleza." *Laisla,* Lanzarote (2001).

"Nils-Udo y el teatro de la naturaleza." *Canarias 7*, Lanzarote (2001).

Santana, Lázarro. "La Naturaleza Según Nils-Udo." *El Cultural*, Madrid (2001).

Sonntag, Isabella. "Der Herr der Natur, Kunst mit Natur." *Waess Sonderausgabe*, Planegg (2001).

"La Fundación César Manrique acoge una retrospectiva del artista Nils-Udo." *La Provincia*, Las Palmas (January 17, 2001).

"Nils-Udo." *Siegener Zeitung, Dies Werk steht für eine bessere Zeit* (September 19, 2001).

"Nils-Udo." *La Sentinella del Canavese, Il tedesco Nils Udo a Maglione*, Maglione, Italy, (September 20, 2001).

Grande, John K. "Threshold 2001." *Art Focus 72*, Toronto (November 2001).

Masannek, Karin. "Hölzerner Waldtempel mit Felsen-Monument." *Westfalenpost* (November 22, 2001).

"Nils-Udo." *Westfälische Rundschau, Quarzit-Skulptur stellt Vergänglichkeit von Mensch und Natur dar*, Wittgenstein (November 22, 2001).

"Nils-Udo, natur & kosmos." *Künstler im Atelier Erde*, Germany (December 2001).

Mousseau, Sylvie. "La fusion de l'art et de l'environnement." *L'Acadie Nouvelle*, Moncton (December 12, 2001).

Tiberghien, Gilles A. "Le jardin est un microcosme, une représentation du monde." *Le Monde*, Paris (December 25, 2001).

media

All the works featured in this book were produced on ilfochrome on aluminum, with the exception of the photographs on pages 10, 11, 28, 29, 80, 81, and 89 (acrylic and ilfochrome on Rives paper) and those on pages 148 and 149 (mixed media on paper).

My very special thanks to Ghislaine Bavoillot, Nathalie Démoulin, and Karen Bowen for their enormous patience and understanding.

Translated from the French and German by Susan Pickford
Art Direction: Karen Bowen
Typesetting: Karine Bécourt-Foch
Color separation: Eupro, Germering, Germany

Originally published as *Nils-Udo: l'art dans la nature*
© Flammarion, 2002
English-language edition
© Flammarion, 2002
ISBN 2-0801-0891-3
FA0891-02-VII
Dépôt légal: 10/2002

Printed in Italy by Canale